Journeys to Abstraction

100 Contemporary Paintings and Their Secrets Revealed

Sue St. John

NORTH LIGHT BOOKS
CINCINNATI, OHIO
www.artistsnetwork.com

Contents

Explores some of the most important choices to consider in creating abstract art.

Insights into 100 paintings revealed as abstract artists share their working processes.

Follow along step by step to create your own abstract works in a variety of media.

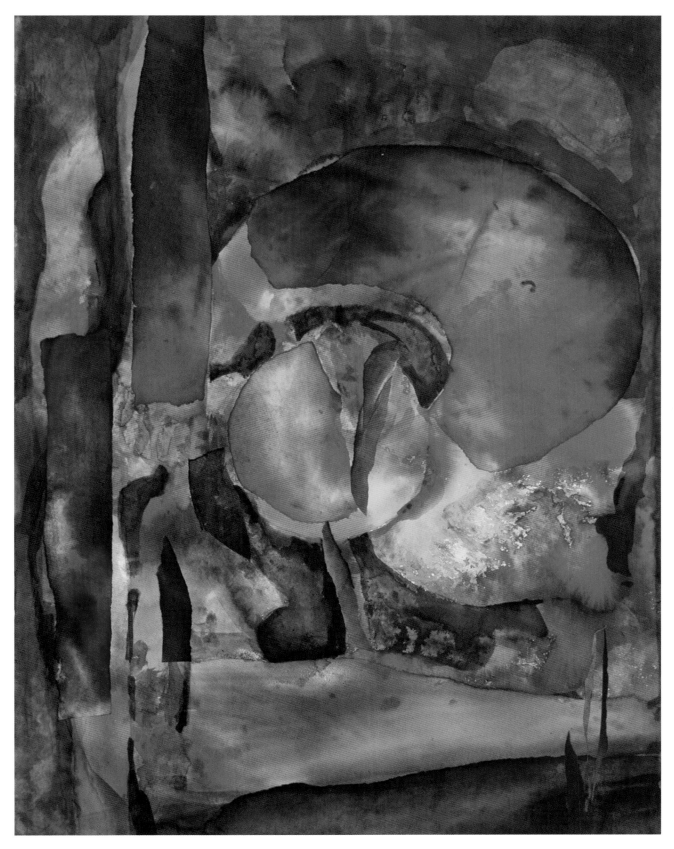

︿ **Heart Throb** • Betty Jameson
Acrylic and collage on Arches 140-lb. (300gsm) cold-pressed paper
30" × 22" (76cm × 56cm)

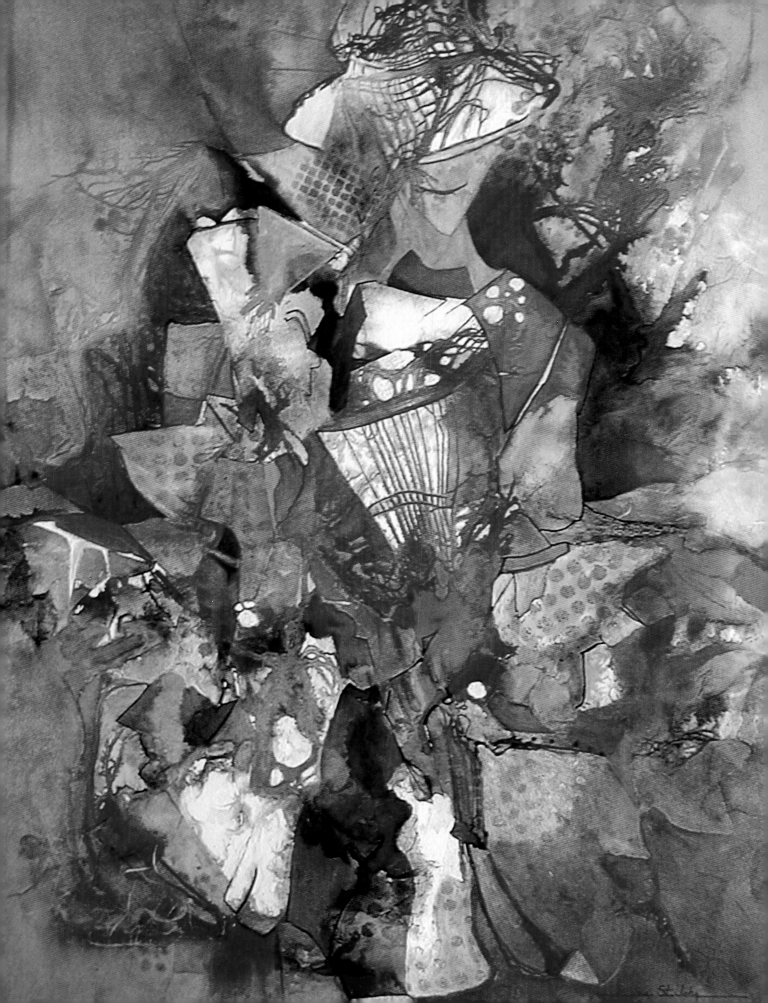

Introduction

Abstract painting can be challenging, and the biggest challenge is to do it well. Often, an abstract painting will not have a recognizable object to inform the viewer what the painting's subject matter is. But the viewer can respond to the painting's colors, shapes and values, and sense what the artist was trying to convey. The viewer can feel the mood of the painting. We don't have to know what a painting is if we know how it makes us feel.

Each abstract artist approaches painting from a different direction. Some artists simplify their images. Others severely distort simple shapes. And some artists limit the amount of information they include in their painting to a mere suggestion of their subject matter. Clearly, there is more than one way to paint abstract works. The choices are vast and nothing is wrong.

Have you ever been curious about another artist's process, and maybe even want to try it out yourself? Artists, myself included, learn from each other by observing how other artists do what they do. This book offers you the opportunity to peek through other artists' studio keyholes to view the creative process of abstract art. It is a source of ideas, techniques and methods from various abstract artists. Studying each artist's working processes can help you develop your own techniques for your abstract works. Then you can strike out on a path entirely of your own and develop your own style.

If you do not have drawing or painting experience, you can still learn the abstract methods without any complicated techniques. Even if you prefer to paint reality, abstract art can help you get motivated to develop your individual style.

So, let's start exploring the creative process of abstract art.

1 Choices When Painting Abstracts

Why choose to paint abstractedly in the first place? Abstract art can be incredibly liberating. For many artists, it is a form of therapy and a way for them to deal with emotions long pent up within themselves. Abstraction is free form and fluid and can be comprised of just about anything. The only limits are your imagination and your willingness to explore your own inner psyche.

So, where do you begin? When painting abstractedly, there are many things to consider. In this section, we'll explore some of the most important choices to consider in creating abstract art.

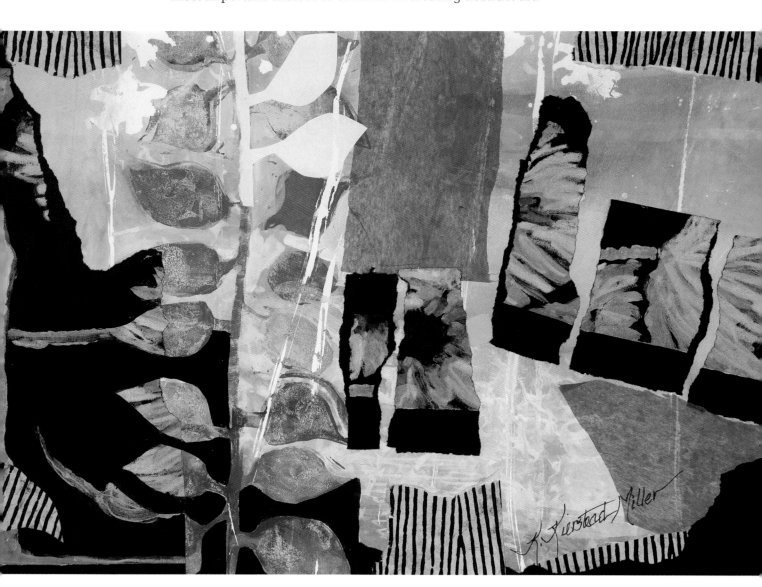

∧ Gucci Poppies • Karen Kierstead Miller

Get free desktop wallpaper and a bonus demo at artistnetwork.com/journeystoabstraction.

Realism vs. Abstraction

Realism (also known as representational art) is just that—art representing the world as it exists, with the subject of the painting clearly known. With abstract art, the subject may be very difficult to figure out, or it may not be known at all. Abstract art is less about the subject than the emotions and motivations the subject evinces.

In many ways, one could say that Realism and Abstraction are polar opposites. Realism is concerned with rendering an image as closely as possible to what you see with your eyes, while abstraction is about expressing concepts rather than exact depictions. Abstraction relies on ideas, emotions and themes, while Realism relies on the world presented before you.

The Realist Movement in French art began in the 1850s. The Realists painted people, places and objects as they appeared, with little to no stylistic editing. They relied on scientific logic and what could be observed with their own eyes. Realists studied how subjects were lit, and sought to portray with great accuracy the way light played upon whatever or whomever they were painting. They also concentrated on painting ordinary things encountered in everyday life. The Realist Movement elevated the mundane to become worthy subjects for great art.

Abstract art didn't really come into its own until the late nineteenth and early twentieth centuries. Until that time, most art was representational in nature. Movements like Impressionism, Cubism, and Fauvism contributed greatly to the development of abstract art.

It has been said that abstract art frees the viewer from the constraints imposed by realistic images. Since there is nothing recognizable in the most abstract pieces, the human mind isn't focused on rendering knowable objects. Instead, the mind can roam and the emotions felt can be examined.

Abstraction and Realism can be said to exist on a continuum, with absolute Realism on one end, and complete Abstraction on the other end. In between are works that can include elements of both styles. For example, you can have a painting where almost everything is rendered in exact detail and is true to real life, except for the focal point of the piece. Conversely, you can have a painting that is mostly a suggestion of forms, except for one part that is rendered exactly true to life.

Both Realism and Abstraction have a place in the art world. Neither one can really be said to be better than the other. It is simply a matter of personal taste. Some people like only representational or realistic painting, while others prefer the most abstruse of the abstract works. Still others may find something to like in both forms.

Some people believe that abstract art is a higher form of expression than more realistic art, but this is merely opinion. You could debate endlessly over the merits of each style. What not in question is that both styles are viable works of art.

How you decide to use Abstraction and Realism in your artwork is up to you. It depends on the goal of your work, and it most definitely depends on your mood and the emotions you're feeling. All of these are integral parts of any piece of artwork, whether abstract or realistic.

Let's say you decide that you want to paint the way your garden looks in the spring. Will you use only the colors that are present in your garden? Will you create just the slightest suggestion of form? Will you try to capture an impression of how your garden looks, or will you paint it as if it were a photograph? Pick up a paintbrush and some paints and find out!

Inspiration

Abstraction is fluid, and the push to create abstract art is everywhere. You can be inspired by just about anything in the world. Many artists draw inspiration from their environment—from the people around them, the places they've been, their own history and the emotions they feel.

Ideas on what to paint can come from people, nature, your emotions, or from all of these. An idea could be sparked by a quote in a book, something a friend or loved one said, or the natural world.

You might be out for a stroll with your dog and see a beam of light hit the leaves on the trees in a certain way that makes you want to capture the essence of that sunbeam. Or, you could be watching your family interact, and the strong emotions you feel at the time might drive you to your paints and canvas.

Imagine you are walking through the park on a crisp fall day. All around you the foliage is a mélange of oranges, yellows and reds. The air has a sharp bite that portends the onset of winter. How do you feel? Are you happy or melancholy? Take that emotion and the bright shades of fall back to your work space and see what you come up with.

Emotions

Feelings, thoughts and memories are sources of inspiration. Many artists get their cues from these. What shape do you imagine when think of anger? What color? Does it have a texture?

Images

Often artists draw inspiration for their own work from the work of other artists. Look at other paintings and try to isolate the emotions you feel as you are looking at the artwork. Examine why you feel this way, and take that back with you to include in your own work.

Photographs can also be inspiring. Maybe you like the way a photographer captured the laughing child in the picture as she plays with her dog. You can take a piece of that photo and create your own work around it, using your intuition as your guide.

Objects

Look at different objects around you and see if they spark any ideas for a painting. An apple is a basic spherical shape. The can of pop next to you is a cylinder. Each object can be distilled down to its basic shape and used in an abstract piece.

Shapes

Trying out different shapes can give you a fresh perspective from which to launch your work. You can try an odd shape like a dodecahedron or trace out a unique shape and see where it leads you. Experiment with different colors on the shapes. Dig deeper and see how different values work.

Patterns

Playing around with patterns and trying out different repeating styles is another good way to spark your creativity. You can create your own patterns, be inspired by the patterns on fabric, or look for them in the real world—the patterns created by the rows of different colored greeting cards at the gift shop, or the pattern on a checkerboard, for example.

Seeing

Painting abstracts is to choose a new approach to interpreting the world around you. In fact, you need to develop a new way of seeing the world around you. When you paint abstractly, you represent a distillate of your environment. For this reason, it is important to take a more detailed view of everything you encounter. You must learn to notice shapes, patterns, color, and to appreciate the various elements of what you're seeing.

Notice the Details

Most of the time, people wander through the world without truly seeing what is around them. They miss details like the pattern on the roof of the house they just passed, or the shape formed by the shadow of the elm tree in the neighbor's yard. Because abstract painting is a distillation of the artist's environment, details within that environment become very important when creating an abstract piece.

Find Shapes and Patterns

Shapes and patterns are elemental to the abstract artist. In order to paint abstract, you must teach yourself to observe the shapes and patterns in the world. As you go about your daily activities, notice the shapes around you—the triangles in the roof tiles, the spheres in the fruit dangling from a tree, or the free form shapes the shadows of tree branches and leaves make on the sidewalk.

Teach yourself to pick up on patterns. Look at the undulating pattern the waves make as breakers roll into shore, or the pattern a rock hitting the placid surface of still water makes. On a city street, look for patterns formed by the sidewalk, rows of buildings, or an arrangement of flowers in the park.

Pay Attention to Various Elements

Everything in the world has the elements of texture, color, and shape. For example, a leaf may be grainy and essentially oval shaped, or it might be smooth and shaped like a triangle. It can range in color from pale green to the deepest shade of red.

Rocks come in many different shapes and can be smooth like polished agate, or rough like the granite face of a cliff. The mountains in the distance may be triangular in shape and rough with scrub, or rounded and lush with trees.

Learning to pay attention to these elements is essential for the abstract artist. Simply seeing the shapes, textures, and colors in the world around you can serve as tremendous inspiration for your art.

Ideas for pieces will come to you as you notice all of the elements around you. Keep a notebook and make notes. Draw sketches of the shapes you see and note their textures and colors. You can also take photos.

Painting abstract changes the way you view the world. Once you have practiced focusing on the details, you will begin see them everywhere. You will look at the world in an entirely new way. Painting abstract opens up new possibilities and broadens the senses.

Symbols

Abstract artists sometimes use symbols in their work to lend their art the meaning they wish to impart. The use of symbols in art is elemental to human nature. From the earliest and most crude cave drawings, to the astonishing complexity of Egyptian hieroglyphics, people have been using symbols to connote different meanings for as long as the first man stood on two feet and walked upright upon the ancient African savannah.

The American philosopher Kenneth Burke aptly described human beings as a "symbol-using, symbol-making, and symbol-misusing animal." In fact, all language is, in the simplest sense, a collection of symbols. After all, a word is meaningless until you know what it is supposed to represent. Human beings think in symbols, and children begin forming symbolic arrangements as they engage in everyday play.

What Is a Symbol?

A symbol is anything that, over time, human beings have decided is a representation of some other thing. Symbols can be used to represent just about anything from physical objects to the most abstruse emotions.

The pre-arranged agreement on meaning is essential to the creation of a symbol. If someone does not know what a particular symbol means, then it ceases to have any relevance and, to that person, is no longer a symbol.

Why Do Artists Use Symbols?

Artists work in the visual realm, so it is natural that they make use of visual representations. This is especially true of abstract artists, who are in the process of distilling reality down to its elemental components. Artists can often get inspiration to create a painting around a particular symbol.

Symbols are also a way for the abstract artist to anchor his work in the world—that is, make it easier for others to understand the purpose of their art. Through the use of symbols, you can provide clues as to the meaning of your work. You can choose to use common symbols or more obscure ones.

Some Symbols and Their Meanings

Here are some common symbols of antiquity. They are generally well-known, with some small exceptions. From these, you may draw inspiration, and by using them in conjunction with color, create a piece of abstract art.

- **Circle**
 Represents eternity, infinity and a cycle. It is also a symbol for totality.
- **Chain**
 Symbolizes the cycle of life and the connection that exists between every living thing on the planet.
- **Ankh**
 An ancient Egyptian symbol appearing in many hieroglyphics in the walls of the pharaohs' tombs, it represents the physical world in harmony with the spiritual world.
- **Celtic Cross**
 Its earliest reference as a symbol relates to the Earth and her four quarters: North, South, East, and West. With the advent of Christianity, it came to symbolize the crucifixion, death, and resurrection of Jesus Christ, as taught in the Christian faith.
- **Figure 8**
 A symbol of infinity and also the balance of power between the sun and the moon.
- **Square**
 Represents the foundation upon which everything else is built, and symbolizes the material world and material security.
- **Spiral**
 A symbol of change and forward motion. It means growth and progress.
- **Pentagram**
 This five-sided star represents the power of the four elements of earth, wind, water and fire when bound together with the fifth element of spirit.
- **Triangle**
 Symbolizes creative focus of mind, body and spirit.
- **Butterfly**
 A powerful and ancient symbol, it represents the soul and also transformation.
- **Cat**
 A symbol of good luck as well as arrogance and diffidence. It also signifies a deep love of all things beautiful in the world.
- **Coyote**
 Represents cleverness and can symbolize a trickster.
- **Deer**
 A representation of maternal love, it also symbolizes grace and genteelness.

- **Dog**
 Represents companionship, loyalty and guardianship of home and hearth.
- **Dragon**
 Symbolizes the elements of fire, air and water, and the essence of life as it moves through nature.
- **Fish**
 Represents the water element. It also connotes fertility and largesse.
- **Horse**
 Symbolizes personal power in both the spiritual and physical world. It also represents great power molded together with great gentility.
- **Lamb**
 Symbolizes the innocence and vitality of youth. In the Christian faith, the lamb also symbolize Jesus.
- **Lion**
 Symbolizes the element of fire, as well as nobility.
- **Serpent**
 Long associated with the healing arts, it appears in the well-known symbol for doctors—a staff with a serpent curled around it (the rod of Aesculapius).
- **Acorn**
 Represents the potential of something, and also symbolizes youth and good health.
- **Dove**
 A symbol for peace and love.
- **Four-leaf clover**
 Best known for being the symbol for good luck, it is also said to represent health, wealth, happiness and true love.
- **Moon**
 Represents womanhood. It is also a measure of time, a symbol of introspection, and a representation of the realm of magic and mystery.
- **Dolphin**
 Symbolizes the interweaving of human intelligence with that of the animal world.
- **Frog**
 Represents transformation and evolution. It also can represent the advent of spring.
- **Ladybug**
 A symbol of good luck in love.
- **Lizard**
 A symbol of the nourishing powers of the sun.
- **Mouse**
 Represents the value of the small things in life.

Creating Your Own Symbols

Sometimes, abstract artists create their own symbols that have meaning only to them. These unique and very personal symbols will not mean anything to the rest of the world, yet will often be the driving force behind the artist's desire to create the painting.

If inspiration grabs you and drives you to create around a personal symbol, be aware that your viewers won't know the meaning it has for you. You can impact your audience in other ways, however. Through the use of color and shape, you can convey an idea of what impulses were going through your mind as you painted your work.

Colors As Symbols

Just as shapes and forms can be symbols, so can color. Even unaccompanied by anything else, a bold swath of color can have rich meaning.

A good example of this is the color purple. Purple connotes royalty. From that, you can search more deeply to find all of those things that accompany royalty.

Red is a color with many connotations. It is the color of blood, so it can symbolize life and vibrancy. It is also the color most often associated with anger.

Likewise, the color green can mean vibrancy and youth, or it can signify jealousy.

Color by itself can be used to represent many different things. Therefore, it is in itself, symbolic. By coupling color with the use of symbols, you can create a rich subtext from which to create your art. Experiment with different symbols and colors. Go with what feels the most right to you. You will know when it is right. It is simply a matter of developing that artistic sense.

Color

When artists paint, they often rely on color theory to choose colors for their art. Most color theory is based on the concept of logical arrangements of colors, such as on a color wheel, because the human eye interprets logical arrangements of colors best.

In color wheels or any other logical color continuum, colors are grouped as primary, secondary and tertiary.

The primary colors are red, yellow and blue. They are primary because all other colors are derived from them, and they cannot be created from other colors. They serve as the base colors from which all other colors are derived.

The secondary colors are green, orange and purple, and these can be made from mixing the primary colors. Secondary colors are so named because they cannot exist without the primary colors.

Finally, the tertiary colors are yellow-orange, red-orange, red-purple, blue-purple, blue-green and yellow-green. Tertiary colors are created from mixing the primary colors with secondary colors. They have a two-part name largely because they are made in this way.

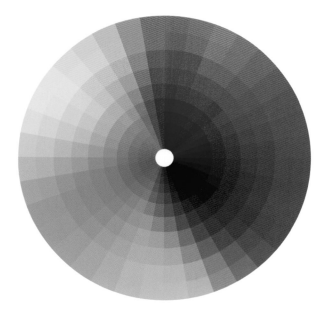

Color Schemes

Color schemes help to preserve color harmony—that is, to use colors in a way that is pleasing to the eye. Conversely, you may choose a color scheme that is displeasing as a means of expression in your work. There are three basic color schemes that lead to harmonious arrangements of color: analogous colors, complementary colors, and natural colors.

Analogous colors appear side by side on the color wheel, such as yellow-green, yellow and yellow orange. Often one of the three chosen colors is the main color. Because analogous colors are in the same color family, using them in your painting will give your work a soothing effect.

Complementary colors are any two colors that are directly opposite each other on a color wheel, like red and green, or red-purple and yellow-green. Opposing colors provides the most contrast. Accordingly, using complementary colors on your subject of emphasis will draw the most attention to it.

Natural color schemes are based on what you see in the natural world such as red roses on green stems, or the light blue of the sky merging with the deeper blue of the ocean. Color schemes based on nature will almost always be in total harmony because nature itself is harmonious. In fact, it is natural to seek harmony in all things.

Black and White

Technically, black and white are not colors, and you won't find them on the color wheel. Black is the absence of all color, and white is the combination of all colors. Black and white paint can be used independently or as a way to lighten or darken the colors with which you are working.

Shades

Every color has hundreds of shades, going from lightest to darkest. You can see this by going to your local paint store and browsing their paint collection.

Color Contrasts

The use of contrasting colors is a way to place emphasis on a particular area of your work.

Natural and complementary color schemes will offer the most contrast between the colors of your choice.

Play around with your colors to see which ones contrast well against each other. Use these in the focal point of your work. You can also use contrasting colors to direct attention away from a certain part of your art and add a little mystery to your piece.

Limit Your Palette

The number of colors from which to choose is staggering. Therefore, it would be wise for you to select a limited palette of colors with which to work. When you are choosing your colors, think of the overall theme of your painting. What are you trying to express? Choose colors that are reflective of this.

Limiting your palette will also force you to use the colors you have chosen to their maximum effect. You can choose different shades to play with, all while staying consistent with the color scheme of your piece.

Proper Blending of Color

Color blending is important for a polished look. Mixing the primary colors gets you secondary colors. Mixing a primary color with a secondary color will get you a tertiary color. And adding white or black will lighten and darken your colors respectively.

Conversely, you may choose colors that do not blend well for a more chaotic look. However, keep in mind that chaos is not just a matter of color choice. As with anything else, you must have a reason for your choices in your piece— even if you're the only one who knows what they were.

Color and Emotions

Why are so many doctors' offices painted blue? The reason is simple—blue is a calming color. The same can be said for green. Colors affect emotions. In abstract art, where the subject may be amorphous and not easily discerned, color choice is very important to lending feeling to your work.

The colors you use will affect the mood of your piece at the most visceral level. In other words, viewers will feel certain emotions when looking at your art without knowing precisely why.

Here is a list of different colors and the emotional effect they are said to have:

- **Red**
 Passion, excitement, love

- **Pink**
 Sensitivity, kindness, sweetness, romance

- **Yellow**
 Happiness, playfulness, optimism, spontaneity

- **Blue**
 Calmness, trustworthiness, loyalty, seriousness

- **Green**
 Safety, generosity, stubbornness, jealousy

- **Brown**
 Dependability, loyalty

- **Purple**
 Mysteriousness

- **Orange**
 Fun, dynamic

Experiment With Different Colors

Abstract art is about taking the road less traveled. It is about taking risks and going places in your mind where you have never been. This extends to your color choices as well. Don't be afraid to experiment with different colors. While harmonious colors are easier to look at, it may be the case that your work is about discomfort. Chaotic color choices have their place in the world of abstract art as well.

Contrast

Contrast is the arrangement of elements in a painting that differ from one another. The greatest contrast is seen when the differences between elements are the largest. Artists use contrast to direct attention to a particular area of the work or to create visual interest within the work. This is especially important to abstract artists since the subject of their work may not be readily apparent. Contrast also imparts a sense of excitement and dynamics. It can generate movement and flow within a work as well.

It is important for the artist to achieve balance when using contrast. Artwork with little to no contrast runs the risk of being boring, whereas artwork with too much contrast can be confusing and disjointed. To be sure, too much contrast can be the focal point of some artists' works, as they aim to challenge the status quo or to make the viewer uncomfortable. For the most part, though, it is best to keep a balance.

Contrast can be created using any of the elements of art. Most particularly, it can be created through the use of color, value, size, shape and texture.

Color

In order to create contrast using color, you must choose colors that are opposite each other on the color wheel— that is, colors that complement each other. Accordingly, a complementary or a natural color scheme works best for creating ideal contrast. The highest contrast is offered by the colors black and white, since black is the absence of all color and white is all of the colors merged together.

Value

Value is the degree of lightness and darkness as represented on a continuum. A single color may have hundreds of values, from light to dark. Contrast is greatest when light values are placed against dark values. To create good contrast using the same color, place a light value of the color next to an appropriately dark value of that same color.

Size

Placing small elements beside large elements also creates contrast. For example, you can take a particular design and place a large version of it beside a smaller version.

Shape

Contrast can be created with shapes as well. Place rounded shapes next to angular ones, such as circles or blobs next to clean-lined triangles or squares.

Texture

Texture refers to the visual perception regarding how an object or a design would feel to the touch. Contrast using textures can be gained through placing textures that appear rough close to textures that appear smooth.

You can use one or more of these techniques in combination to achieve a nice contrast in your artwork. The most important thing to remember is that too little contrast causes monotony, while too much contrast creates chaos. A balanced piece will feature just enough contrast to keep the work interesting.

Composition

Composition is to the visual arts what grammar is to the written word. It is the arrangement of the elements of a piece art according to the principles of art. It might help you to think of composition as rules of the road for artwork. A properly composed piece of art should flow and be recognized as a cohesive whole.

Composition is comprised of seven main elements: texture, form, line, color, value, shape and movement.

Texture

Texture is the sense or visual effect of what something might feel like to the touch. Texture is seen in fabrics and on natural surfaces; it can be reproduced in artwork by using repetitive patterns or lines to create that tactile sense.

Form

Form is the three-dimensional appearance of something. It is created by using two or more shapes. Form can be further delineated through the use of contrasting colors or textures.

Line

A line is a distance from one point to another. In art, line is often implied. That is, it is the direction in which a viewer's eye travels as it follows various shapes, forms and colors in a piece of artwork.

Color

Color refers to the use of various hues when composing a piece of art. Color is subdivided into primary colors, secondary colors and tertiary colors.

Value

Value refers to the use of lightness and darkness in a piece of art. Value can be seen across the whole composition through the use of shadow and highlight, or in part, the choice of dark or light versions of a color.

Shape

As opposed to form, shape is two-dimensional. It refers to the space as defined by edges that separate one flat surface from another. Shape can be geometric, such a square or triangle, or it can be naturally occurring, such as the shape of a rain drop, a puddle of water or a leaf.

Movement

A piece of art is said to have movement if the viewer's eye is able to flow from one area to another. This movement is precisely defined by the artist through the use of multiple techniques to coerce the observer's eye to take a particular path as he looks at the artwork.

There are various techniques for creating movement in a piece:

- **Anticipated movement**
 Depictions of living things in positions that would be unable to be maintained creates the sense that motion is about to occur and, therefore, engenders a sense of movement.

- **Fuzzy outlines**
 We perceive objects and living things that pass us at a great speed to be blurry. Accordingly, the use of fuzzy outlines mimics the blurring effect of rapid speed.

- **Multiple and overlapping images**
 Because the object or figure is seen in multiple poses, the impression of movement is there.

- **Optical movement**
 Pertains to the way the eye is led around an image dynamically in order to look at all of the different elements. Optimum optical movement is achieved through the use of curved forms that keep the eyes moving in a rotational pattern.

- **Optical illusions**
 Geometric forms cause the mind to interpret motion where there is none. This is done through repeating patterns and shapes.

When to Stop Painting

Knowing when to stop painting is something instinctual that develops the longer you have been making art. Over time, you begin to learn the cues that tell you that it is time to put down the brush and declare the painting complete. This is probably the most difficult aspect of learning to create art. If you continue painting after it is time to stop, your work may lose its vitality and freshness. In the words of painter Robert Genn, "Eighty percent finished is better than two percent overworked."

Surface Condition

One cue to look for that will let you know it is time to stop painting is the state of the surface on which you are working. If you're working with paper, for example, you may find that it is getting thinner and worn down. It is really time to stop at this point, since any further work could rip the paper and destroy your piece.

Size of Brushstrokes

The size of your brushstrokes will give you a clue as well. If they are getting progressively smaller each time you revisit the work, you are most likely finished, and it is time to stop.

Self-Expression

Another way to gauge when your painting is complete is to look at it and ask yourself if you've expressed to the fullest what you wanted to express in that work. If the answer to this question is yes, then you are finished, and any more work will sap the life from your art. If you have nothing more to say, then you ought to stop painting and declare your work complete.

Other cues that it is time to hang up the brush and paints include:

- tiredness
- loss of focus
- repeated mistakes

Many artists are very finicky about when they consider their work to be finished. This might be the case with you. You might find something that needs correction. It might be a color, shape, line or balance of paint, and your first instinct will be to go in and correct it the moment you notice it. Before you do so, walk away and come back later and look at it again. Take your time to see what you have painted. Work at this until you feel you have exhausted all the possibilities the painting offers.

Whatever the case, developing that instinct that lets you know that your painting is complete is crucial to creating great artwork. The more you pay attention to the cues that let you know you're finished, the more quickly this sense will become second nature.

Connect With Viewers

As an artist, you communicate with viewers through your art. Indeed, the reason you create your art is to express yourself, and expression implies communication. Effective communication also requires some understanding on the viewer's part. Consequently, it is natural to consider how the people viewing your work will react to it. Will they "get" it? Is it necessary that they do get it? Or will it be enough if they are moved in some vague way?

People often have a very visceral reaction to abstract art—they either like it or they don't. However, few people stop to examine why abstract art may trigger such a reaction. For some people, it is purely a matter of opinion, and no further examination is warranted. But other people may be reacting negatively to abstract art because of different reasons.

By its very nature, abstract art is difficult to identify with and understand. Some people are very uncomfortable when confronted with something that they are not immediately able to comprehend. Such people will frequently claim that they do not like abstract art, and that is a perfectly defensible position to take. Other reasons people might be intimidated by abstraction are its ambiguity, the lack of points of reference, and the lack of familiarity it engenders.

It is not necessary for everyone to understand abstract art, especially in the same way as one can understand a narrative, or a realistically painted scene. Abstract art, even more so than any other type of art, is personal. You can create a painting that is only meant for you and those who are close to you. Such a work may not appeal to many, but will mean a great deal to its intended audience.

Abstract art is not only personal to its creator, it is personal for the viewer as well. It is fluid and open to interpretation. Someone may look at a piece you have done and feel things that you didn't necessarily intend for them to feel, or that you, yourself don't feel about your work. There is no right or wrong way to interpret abstract art.

Similarly, it is not necessary that everyone in the world love abstract art. While their reasons for disliking abstract art may be that it makes them uncomfortable or because they find it intimidating, it could be just as likely that abstract art has no appeal for them.

Having said that, remember that your art is a form of expression, and your work won't be successful if it does not express your point of view adequately. This does not mean that everyone must understand what you meant in the literal sense. However, they should be able to glean the emotions and the undercurrents your work creates within the human psyche. If you are able to do this, then your abstract art will indeed be an expression of yourself that will move others.

2 The Paintings

Abstract art is a type of art that has no boundaries within the real world. Shapes can meld together and different colors can either flow together to make a harmonious pattern or design, or clash in violent frenzy. Abstract art is about engaging the emotions of the viewer, free of the distractions that painting immediately recognizable objects presents.

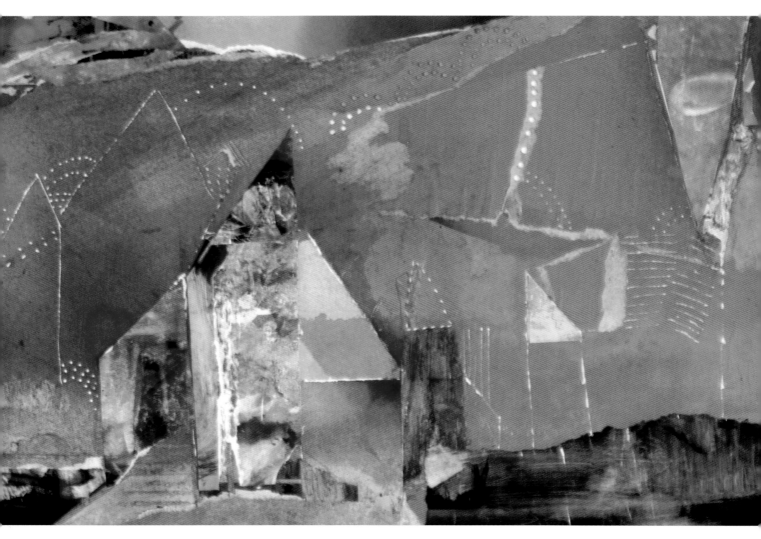

⌃ **Under Construction** • Mira M. White
Watercolor and mixed media on 4-ply museum board • 10" × 15" (25cm × 38cm)

Get free desktop wallpaper and a bonus demo at artistnetwork.com/journeystoabstraction.

Delda Skinner

This painting was created on heavy-weight, hot-pressed Strathmore illustration board. I used Shiva Casein color including Cobalt Blue, Cadmium Red Scarlet, Cadmium Orange and Golden Ochre.

I wanted to paint the idea that as long as "the center" holds, everything will maintain its part of the whole. This was the result.

∧ **The Center Is Holding** • Delda Skinner, NWS, SLMM
Casein on Illustration board • 15" × 15" (38cm × 38cm)

Betty Braig

Archives was begun by assembling materials for pouring an acrylic wash of warm earth colors of Burnt Umber, Portrait Pink, Brilliant Purple, Yellow Oxide and cool colors of Cobalt Blue, then spattered with Sap Green mixed with Titanium White. The paint was mixed and shaken in a 6 oz. bottle of one-third paint and two-thirds water, then set aside. I also used a large container of water with a dipper, a spritzer, sponge, paper towels, spatulas and two acrylic brushes (¼-inch [6mm] and ½-inch [12mm] flats) for tapping to spatter paint. I waxed the edges of the board with paraffin to prevent bleeding.

The pouring of the paint was done over a plastic wallpaper tub. The board was lightly tilted to encourage a flow. First I poured water over the board in the direction that I wanted the movement to go. Next I poured the colors with the darker values outside of the pivotal light area. During the pouring, I manipulated and tilted the board, then laid it flat to stop the flow. I then spattered paint by tapping two acrylic brushes loaded with pale green and blue over the damp surface for texture and let it dry. During the drying process, the acrylic pigments separate from the water and create a granulated texture.

After the board was dry, I drew the spiral design starting with the center circle. The spiral was a real design challenge because it is predictable. A roll of paper became my model for the inner circle. At this stage, I started painting value washes and images with watercolor paint. The linear spiral was static and lacked drama. I broke it up by introducing layered spiral shapes, intuitive linear movements and edges.

A layered shape is painted by changing the value of the surrounding undercolors. For instance, the dark shadow spiral between the light spirals was created by glazing blue and brown or scarlet red to the existing pink underwash.

I painted images with watercolors in different values of the acrylic underpainting to strengthen the harmony of the color palette. The light areas were intensified on the scroll edges. Value work was continued by glazing in shadow shapes and the cool dark background to create a feeling of mystery. Some images are recognizable. Others are abstract hidden messages for the imaginative viewer to read.

The finishing touches were considered while viewing the painting at a distance on an easel. I thought about the smells of the place, the excitement of the moment of discovery, and the mystery of connecting with the clutter of images found in the paint. I felt energy in the spatters and spirit lines. I detailed them with Derwent watercolor pencils. I finished by glazing a warmer color around the scroll area and signing my name with a compatible color.

Archives was composed from my imagination and made visible with abstract images that form a design. The content is to bring the viewer to a special place of discovery that otherwise would have gone unseen in this visual abstract conversation.

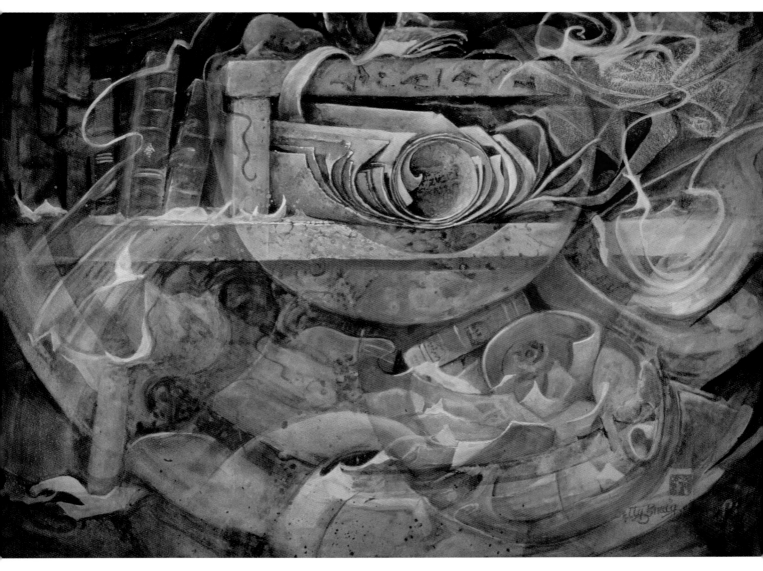

△ **Archives** • Betty Braig, ISEA, MOWS
Mixed-media on Strathmore hot-pressed watercolor board • 20" × 30" (51cm × 76cm)

Carol DeBolt Eikenbery

When I began this work, I was working in a series of seed pods and natural plant forms. I drew interesting shapes to create a good solid design, and once I found one that worked well, I drew the design lightly on my Crescent cold-pressed watercolor board with 2B and HB pencils. I cut a sheet of clear contact shelf paper to the same size as my board and rolled it across from top to bottom, smoothing out air bubbles as I went. This created a frisket for my design.

I could see my design through the contact paper and began cutting out the shapes with a craft knife where I wanted to pour paint. The parts still covered would remain the white of the watercolor board.

I prepared my fluid acrylics in small containers, adding a little water so they would flow easily. Using a protective layer of plastic on the floor, I began pouring Quinacridone Gold, then Crim-son and then Turquoise, turning and tipping the board to direct the flow. I also used a spray bottle of water to diffuse the paint in some areas.

Once I was satisfied with the distribution of paint, I laid the board on dry newspapers. I textured some of the wet paint surface with plastic wrap, bubble wrap and pieces of mesh. I then placed an old piece of Plexiglas on top of it all and weighted it down. After twenty-four hours, I removed all weights and texturing items and allowed the painting to air dry before I continued.

When the paint was dry, I carefully removed the frisket contact paper to reveal a stained-glass effect. Then, following my initial value sketch, I began to define the shapes and bring out the design with opaque paints, which I created by adding white and/or black gesso to the fluid acrylics.

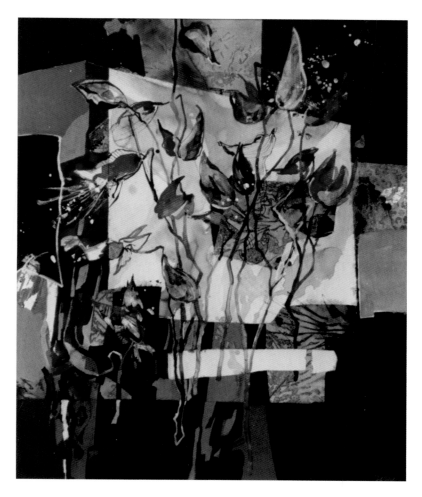

Milkweed Pods •
Carol DeBolt Eikenbery, AWS, NWS
Acrylic on Crescent cold-pressed
watercolor board
38" × 32" (97cm × 81cm)

Edith Marshall

Designing collages has become an important technique for me. It is totally an intuitive way of working. No forethought, no photos, no sketches and no pre-made plans whatsoever. When the piece is finished, it is what it is. Fun to do!

I love to work over a failed piece. Since it has already failed, I can't make it any worse. I intentionally failed my start for this piece by gluing on a random scrap of paper I would otherwise probably never use. I glued the piece into the upper left corner, which is where I generally begin to work.

The first thing was to get rid of the random piece of paper by painting over it. This subdued it and sparked the idea of glazing, which I love to do with transparent watercolors.

I used pre-painted tissue paper or my glazing technique, leaving some tissue papers white, others lightly painted and others opaquely painted. I layered the tissue papers just as I would layer transparent watercolor. The gestures were pre-painted on tissue paper and moved around for placement. More collage pieces were added and tissued over wherever needed.

I paid attention to composition, balance and color palette—all while working the piece as a whole.

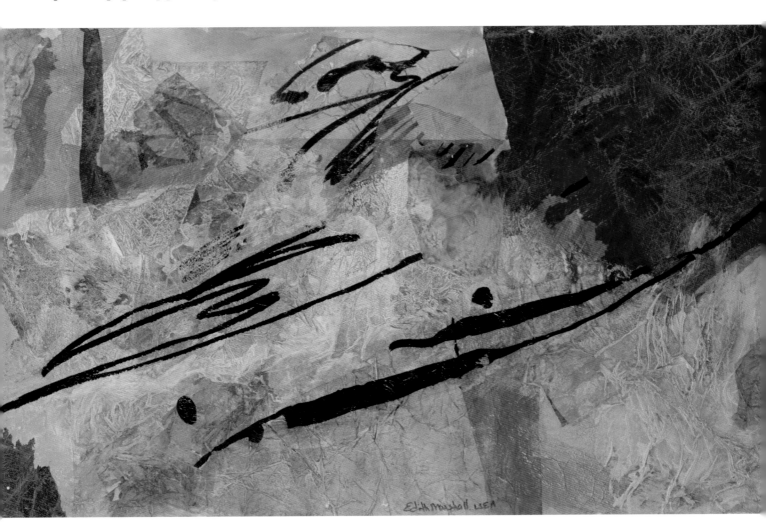

∧ **Another Language** • Edith Marshall, ISEA
Watercolor and collage on Arches paper • 26" × 40" (65cm × 102cm)

Katharine A. Cartwright

The foundation for my work is the intended concept, which derives from my unique relationship with the world. When a concept forms, I explore it for years by creating a series of paintings that result in concept expansion and nuanced meanings. *All Cracked Up XXI* is part of the *Fragility* series of paintings that uses fractured eggshells as a metaphor for the effects of pressure upon life, the human psyche and our investments.

As psychological portraits, each painting in this series relies upon the transformation of ordinary eggshell fragments into a single complete entity that possesses a unique personality or mood. This is achieved by imposing a highly chromatic design onto the arrangement and creating directional focus that, in some instances, adds the time dimension. Luminosity is the desired effect in most of these paintings, because it implies a lifeforce which is the essence of the new entity that emerged from the fragments.

I began this painting by selecting a full sheet of Arches 140-lb. (300gsm) cold-pressed paper, which I soaked in lukewarm water for a half hour and then stapled to a board where it dried flat. Next, I used graphite paper to transfer the design I'd drawn of a pile of real eggshells onto the dry watercolor paper. (When I create the design, I always alter the reality of what I see to create a pleasing and dynamic abstract composition.)

Next, I selected three to five hues of transparent watercolor paint for my palette. This limited palette provides the advantage of unifying my work. There is no formula for the colors that I select, but I always try to include both warm and cool colors as well as complements to get a maximum effect. I use transparent hues to intensify luminosity.

After my design was drawn and the palette determined, I tried to imagine how to lead the eye through my composition. Once I determined the path, I masked over the lightest eggshells that marked that path with clear packing tape. (This tape may only be used on Arches 140-lb. (300gsm) cold-pressed paper, since it's too sticky to use on other papers and weights, and will destroy the surface of the paper.) I laid the tape down in strips and cut along the edges of the eggshells with an X-Acto knife. I was very careful not to cut through the paper. Next I peeled away the residual tape. I learned this process from artist Susan Webb Tregay.

I began painting the receding eggshells first. In order to create luminosity, I painted one shell at a time by first wetting the paper in that area and then dropping in paint and mixing hues as I dropped them in. I often use a dry brush to swirl the colors and create sphericity as well as luminosity. This helps me avoid a muddy look. I moved along the entire painting using this process until all the shells were painted. The lightest shells were painted last, after I peeled back the protective tape. Once all areas were completed, I applied washes over the broad areas that needed to recede more into the background. After the entire painting was dry, I completed it by painting all the tiny cracks on the prominent shells.

All Cracked Up XXI • Katharine A. Cartwright, NWS. MOWS >
Watercolor on Arches 140-lb. (300gsm) cold-pressed paper • 27" × 19" (69cm × 48cm)

Get free desktop wallpaper and a bonus demo at artistnetwork.com/journeystoabstraction.

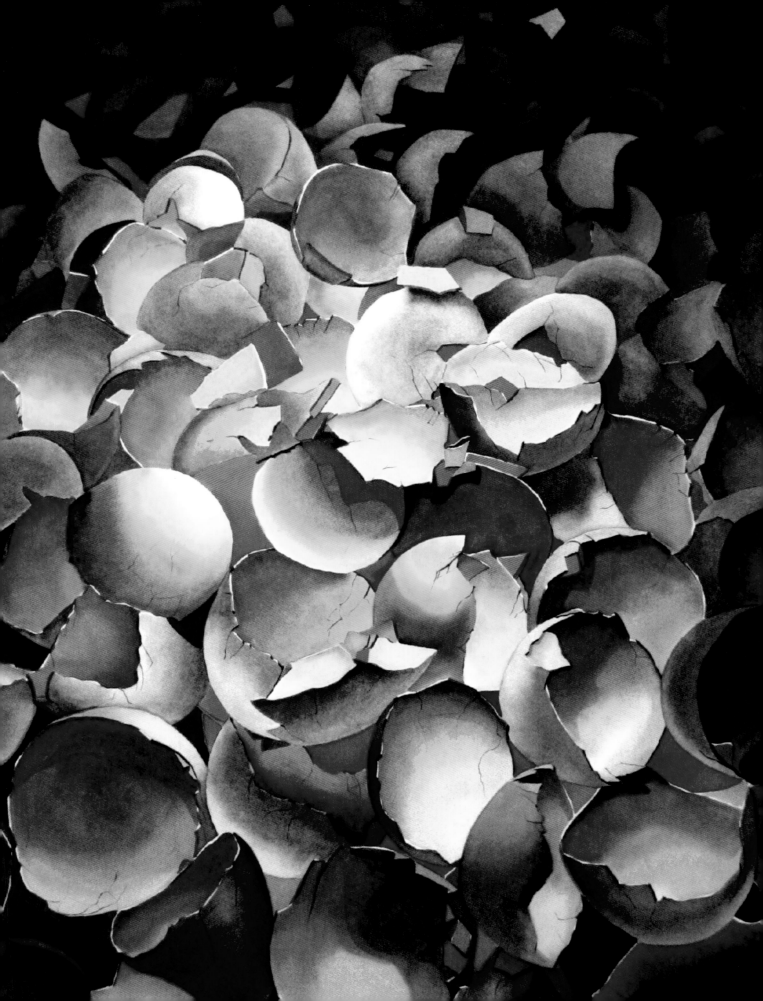

Lana Grow

I had a special memory in mind when I created this piece. We have a cabin up in northern Minnesota and often enjoy lovely sunsets there. I wanted to paint something that represented the awesome visual experience and the organic feast we always have at our cabin.

I began with Fabriano Artistico hot-pressed paper. I used a kitchen plate to draw the circle the size I wanted on a piece of medium-weight plastic for a stencil. I knew I would be eventually adding that plastic to my paint to get the texture I wanted in the yellow-gold area.

I began with wet paper and Golden fluid acrylic colors, randomly adding yellow, green, blues, purples and other colors. I allowed the first layer of transparent colors to dry. Then came the yellow circle with the plastic. I added the paint and laid down the plastic circle while it was wet, allowing it to partially dry. I couldn't let it dry all the way, as it might stick. I then worked at layering some opaque colors. I dropped facial tissue on the surface to give the organic texture.

I decided on a cruciform design and brought in some layering to form leaves that would be dripping from the sun. This painting is all about organic texture shapes. It began to evolve and I looked for the shapes to tell me where to outline them.

My last step was to use my gold leaf Krylon Metallic pen. It seemed to tie all the shapes to read as one. I finished it up with a thin layer of Golden polymer medium thinned down with water. This gave the piece an even sheen. Then I sealed it with Golden UV varnish.

Sun to Earth Revealed • Lana Grow, AWS, ISEA ❯
Mixed media on Fabriano Artistico hot-pressed paper • 30" × 22" (76cm × 56cm)

Lynne Kroll

I chose 3M 600-grit dry sandpaper as the substrate for this painting because its surface is a paradox—silky smooth yet slightly abrasive, non-porous yet absorbent, charcoal matte finish yet slightly glittery. This sandpaper allowed me to explore unconventional water media combinations. My goal was to create fascinating and complex surfaces without using a paintbrush.

The non-porous surface of the fine-grit sandpaper repels water. To prepare the surface, I applied a thin coat of white absorbent ground so it would be compatible with water media. While still wet, I quickly covered the absorbent ground surface with a small piece of wax paper, applying pressure. I slowly lifted it, pulling some paint off of the damp sandpaper and exposing a rich new surface. When the acrylic ground dried, the possibilities were infinite. The surface had an amazing tactile quality and an illusion of color depth that my brush alone could never have painted.

Intuitively, I enhanced the patterns, shapes and forms with graphite, pastel, watercolor and Cray-Pas.

When surfaces were smooth and slick, I provided contrast by stamping and incising with sharp tools and imprints. If surfaces appeared to be watery, I diluted dishwasher rinse aid and sprayed it on the absorbent, ground-dampened sandpaper. I then dropped transparent, granulating, metallic, and/or interference watercolors and watched amazing compositions evolve.

I mixed my own egg tempera with egg yolk and pigment, which I applied sparingly to further enhance the textural depth and richness. Finally I was able to use very fine watercolor pencils to intensify the darks, and highlight the whites. The pencils literally melted into the fine grit of the paper.

∧ Garden of Earthly Delights • Lynne Kroll, AWS, NWS
Mixed media on 3M 600-grit dry sandpaper • 11" × 14" (28cm × 36cm)

Carole Kauber

Emerge I • Carole Kauber, NCS
Mixed media on Arches 140-lb. (300gsm)
watercolor paper
• 32" × 18" (81cm × 46 cm)

This painting was inspired by my recent trip to Morocco. I based the imagery on some of the photographs I took while vacationing.

In this painting I worked with a variety of watercolor media: Dr. Ph. Martin's hydrus watercolor and drawing inks, Winsor & Newton watercolors, Robert Doak's fluid watercolors and Golden fluid acrylics.

In the beginning, I floated watercolors over a thin layer of water that defined a specific geometric shape. I then placed a geometric piece of wax paper over that colorful wet shape. The wax paper, if kept smooth, helps to define a geometric shape while adding hints of textural effects. Once that area was dry, I added new shapes and colors.

Other applications of color were allowed to merge with existing shapes and forms. Spattering paint to several areas created an earthy textural effect. What emerged were unexpected colors and forms.

To me, the exciting aspect of painting is the experimentation. It leads me into the unknown and forces me into new territories. Once the forms have been sufficiently resolved and the desired landscape images take shape, I refer back to the photograph to add details that add to the overall image.

Karen Kierstead Miller

Before a drop of paint hit the picture plane of the *The Conductor*, I brushed the surface with matte medium to prevent staining and to allow easy movement of paint across the surface of the Arches 140-lb. (300 gsm) hot-pressed watercolor paper.

I painted the initial framework in a flurry of high-key blue and purple wide-brush watercolor washes, intentionally leaving important areas of white paper to serve as quiet spaces in the composition. Watercolor brings rich transparent layers into play while quick- drying acrylics allow spontaneous bold color statements.

A structure of black and purple acrylic was pulled across the paper with a squeegee. The squeegee allowed large amounts of black paint to be moved across the paper easily, creating a strong uninterrupted movement of high contrast. (Excess paint can easily be removed from the matte-medium-coated paper if the structure becomes too strong.)

After that was dry, I made a playful series of white hash marks with water-based Caran d'Ache. I used white crayon to break up the wide structural sweeps of black. The same white crayon was used on the edge of the white quiet spaces to share written poetic verse.

As the painting reached completion, I painted lines of deep purple script to underlay the final expressive moment where a fluid calligraphy line was introduced. A plastic squirt bottle was instrumental in application of the wildly emotional white acrylic lettering line that portrayed the movement of a conductor's baton.

Calligraphy or suggested lettering images can unlock compositions, providing a surprise element for the viewer to contemplate, and the final panache that the artist needs to say, "I'm done!"

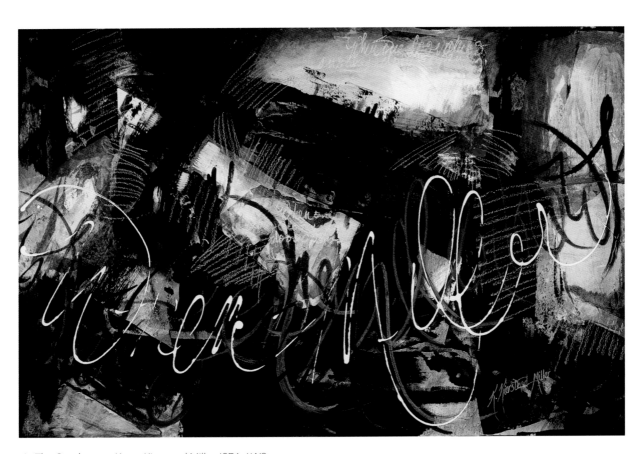

∧ **The Conductor** • Karen Kierstead Miller, ISEA, LWS
Mixed media on Arches 140-lb. (300 gsm) hot-pressed watercolor paper • 18½" × 26" (47cm × 66cm)

Sharon Stone

This painting was started by pouring yellow, orange and turquoise ink on Arches 140-lb. (300gsm) cold-pressed paper. After pouring the inks, I placed numerous objects on the wet ink to make textures and patterns. I used wax paper, Saran Wrap, two different sized plastic square needlepoint frames, rug- hooking framework, wire mesh and some fabrics with pattern.

When the painting was dry, I removed all this and discovered wonderful textures and patterns. I then stamped with bubble wrap and a textured fabric to add a little more interest. I also put the needlepoint frame and the rug-hooking material back on the painting and sprayed white airbrush paint through them with an atomizer to make the pattern show more.

At that point, there was the beginning of a nice wedge composition or possibly a cruciform. However, the painting had no color dominance. It was half warm and half cool, so I had to decide which it needed to be. The turquoise won, so I add more turquoise shapes.

I have really been working recently to make my paintings have more value, so I added dark turquoise and black acrylic shapes. It was pretty unorganized at this point and needed some quiet areas and big shapes, so I put in some gray. I added textures to the grays by spraying them with alcohol, then using wax paper and some stamping over part of it. I also painted behind some of the shapes that were left behind after it dried. The gray also covered more of the orange.

The painting was very dark, so I painted in some shapes with white acrylic to make the whites weave through the painting. Then I added pieces of collage from a small painting that I had started that had a great pattern, and it all came together.

⌃ **Journey** • Sharon Stone, SWS
Mixed media on Arches 140-lb. (300gsm) cold-pressed paper • 22" × 30" (56cm × 76cm)

Annell Livingston

I have been working with grids since the early 1990s. When I lived in Houston I created grids made up of only squares. I thought of the grid as a metaphor for the urban experience. My studio was downtown, and the sounds that came into my studio were sounds of trucks, buses and cars. My work was based on the observation of the light in the city reflected off of man-made materials. Upon moving to Taos, New Mexico, my work included the addition of the random diagonal line, which creates compositions of squares, triangles and some unexpected shapes. It is the diagonal line which allows me to think of the landscape of New Mexico—river, mountains and sky. It is not that I expect the viewer to see what I see, but it is to explain where my inspiration comes from.

Charting the grid: I use a Prism colored pencil, which acts as a resist to put my drawing on the paper. I might use a white pencil or a comple-mentary color to the finished painting. When you work with watercolor in the traditional way, first you put the drawing on the paper, then you wet the paper with a sponge. You often lose your drawing. But with the use of a resist, the drawing remains.

Wetting and reclaiming the paper: The paper must be perfectly wet on both sides before it is "reclaimed," and all excess water is squeezed out from underneath. There should be no shiny spots or reflections when the paper is held up to the light. If the paper has the perfect amount of wetness, the paint will not spread when it is applied.

Beginning the painting: Gouache was mixed with water to the consistency of thick cream. The underpainting was applied with a 2-inch (51mm) German wash. Then the painting was finished with a combination of Winsor & Newton watercolor and gouache paints.

∧ Eternal Cycle • Annell Livingston
Gouache on Arches 140-lb. (300gsm) rough watercolor paper • 30" × 30" (76cm × 76cm)

Joan Burr

After laying out random colors of acrylic paint on my palette, I used a medium-sized brayer to apply paint to my primed canvas. When the paint was almost dry, I carefully laid textured paper towels over the red, blue and green areas. I gently pressed the paper towels on the surface and removed them, leaving a textured imprint.

My intent for the painting was to show the beauty of colors and textures. The colors flowed together and were exciting. I decided to go with the flow.

I painted black paint on an 8" × 10" (20cm × 25cm) piece of glass and drew lines into the paint with my finger. I pressed Mulberry paper onto the glass and used the brayer to transfer the image. Next I lifted the paper and set it aside to dry. Paint was dripped onto another sheet of damp Mulberry paper to be used for collage. This Mulberry paper accepts color nicely and leaves soft edges.

I tore old paintings that had strong colors into interesting shapes. The weight of the paper and colors made a nice contrast to the softer Mulberry pieces. I adhered the different shapes and colors to the canvas. I poured red paint on part of the surface for a different texture and raised effect.

A black line was painted on to tie the edges together. Pieces of sheet music were used to add some white areas along with the edges of the collaged shapes. The cool background colors caused the warm reds to come forward like a crescendo. The painting gave me the feeling of a symphony. (This painting can be hung in any direction.)

I find much joy in experimenting with abstract painting. To me abstract impressionism painting is intuitive. The artwork seems to tell you what to do next, helping you to express yourself visually.

Lyrical • Joan Burr ❯
Mixed media on canvas • 20" × 16" (51cm ×41cm)

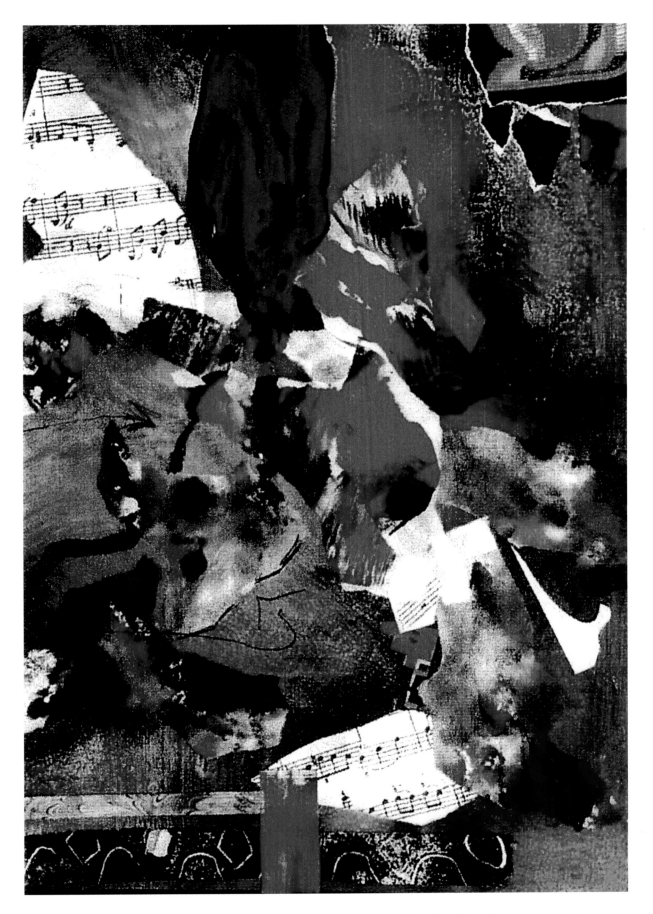

Barbara Millican

‹ Bridge Werk • Barbara Millican, AWS, NWS
Acrylic on Arches cold-pressed paper •
30" × 22" (76cm × 56cm)

Bridge Werk is an example of treating a complex subject in a simple way. Because I had no intention of painting a realistic bridge, I chose a more humorous title to indicate the feeling of such a construction.

Perhaps the subject matter emerged from my subconscious because of recent bridge disasters and the rebuilding of such in our area. The abstracted image could be the construction of a bridge showing girders and supports, or perhaps the destruction showing the breakthrough on the left side.

I paint intuitively brushing watercolor and/or acrylics on freely. In this particular painting, the strokes are more ordered, using geometric and organic shapes. Architectural shapes intrigue me, but I rarely use them in a literally interpreted way.

I like the use of a high-horizon composition with the drama of the wide, almost empty space below the subject. Some of my colors can seem literal (the blue for the sky, for example), but I chose that to simply complement the more earthy and subtle tones of the structure. This is basically a high-key work so that the viewer is not overwhelmed with the thoughts of a bridge disaster.

This painting was done on Arches cold-pressed paper with predominantly acrylic paint.

Gracie Rose McCay

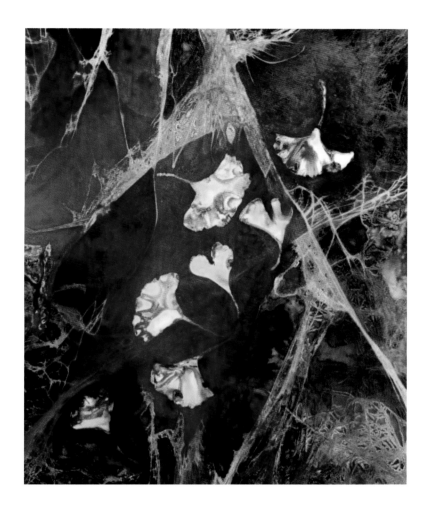

Gingko Rain • Gracie Rose McCay
Watercolor on Yupo • 26" × 20" (66cm × 51cm)

Gingko Rain was created on Yupo, a white synthetic paper. I placed real gingko leaves cascading down the Yupo, then carefully stretched cobweb webbing over the entire sheet of paper, pinning it securely just at the edge of the paper. The webbing helped to hold down the leaves, although they still did not lie perfectly flat.

I dampened the webbing either by spraying or lightly touching with a wet brush. Then I chose my watercolor hues and mixed them for spraying. I chose the basic primary colors—red, blue and yellow—and sprayed the entire piece alternately with these. The colors mixed and blended on the piece, creating some secondary hues. Because the leaves were not flat, paint ran under them and created some designs within the leaf shapes.

When the paint and webbing were dry, I removed the webbing and the leaves.

In the final step, I used colored pencils to enrich the shapes and colors in the painting. The pencils also covered some white areas of webbing, adding to shapes or creating new ones. I did not use pencils on the designs within the leaves, as they seemed completed by the paint and the paper working together.

This painting is now owned by Lynette and Thierry Liberge of Martinsville, Indiana, and is used here by their permission. My thanks to them for allowing me to use it in this publication.

See the Demonstrations section for Gracie's step-by-step process to creating a similar painting.

Toby R. Klein

An intricate design, as in *Crossing Time & Space*, creates a more complex and time-consuming piece. I began this process by drawing out my design for the open areas on a large sheet of tracing paper and kept this with me as a guide through the completed piece.

Using several sheets of 4-ply archival board, I measured and marked the board at different increments, starting at ¼ inch (6mm) through ¾ inch (19mm). I then cut each piece using my mat cutter because of the thickness of the board. After completing the cutting process, I laid out the strips on a large sheet of plastic. In an intuitive manner, I painted and textured these strips with a variety of liquid and fluid acrylic, including metallic colors. Because of this, many people think the entire piece is made of metal strips. The painting was done in this manner so that all sides and ends of the strips are covered with paint. After I finished the painting process, the strips were left to dry.

This is when the detailed construction of this piece began. For the background, I used a piece of archival mat board supported by a piece of archival foam core. Then referring to my design, I began by laying out different sizes of the painted strips. The number used depended on the size of this piece. I measured to be sure the strips were straight, leaving different sized spaces between them, and then glued them to the background board using gel medium. The next layer was placed in the opposite direction and, again, measured to be sure they were straight.

As I built up this piece, I alternated the layers from horizontal to vertical, working around the open spaces I designed. I mixed in a metal strip or two on each layer using my textured copper, brass, aluminum or titanium. I supported each strip, which is very important, with pieces of archival board to create a strong finished piece of art. As each piece was cut, the raw edges were painted along with the boards used for support.

When I completed this process, the fun began. It was time for embellishing this piece. Texture and shapes from intriguing parts of watches, metals and glass, along with the repetition of color, line and value, added to the overall balance and unity of the design.

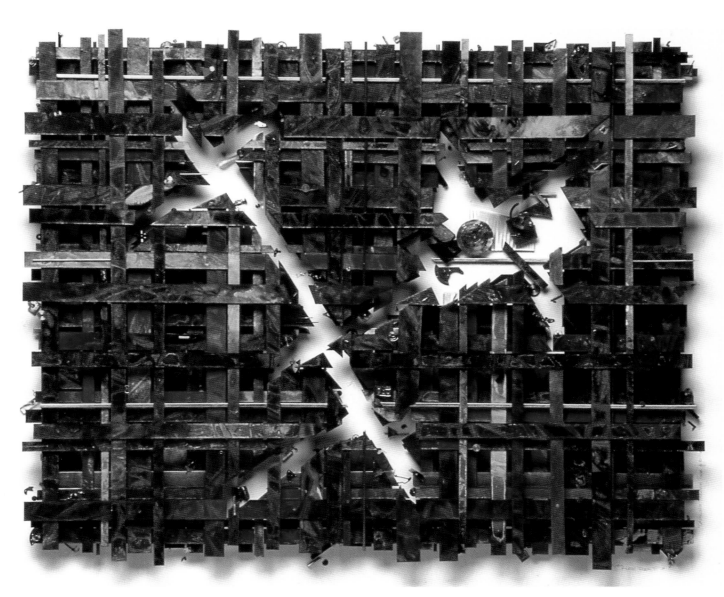

∧ **Crossing Time & Space** • Toby R. Klein, ISEA, ISAP
Collage and acrylic on archival board • 30" × 36" (76cm × 91cm)

Fredi Taddeucci

Passageways was painted on Yupo, a plastic synthetic type of paper. Since the surface is slick, it does not easily accept paint.

For this painting I used Nova acrylic paints. The colors used were Phthalo Turquoise, Venetian Red, Ultramarine Blue and Titanium White. I used a process called *twinning*. The procedure is to use one warm color and one cool color. One is a staining color and the other is a sedimentary color. Apply one color over the whole surface of the Yupo paper. Apply the other color sporadically on the same sheet and spray with water. Place a blank sheet of Yupo paper over the first sheet and lift the sheet slowly. You can get magical effects with this procedure. Lifts can be made smoothly using a rocking motion, or you can drag the paper. Then the decision has to be made whether the painting should be done in a realistic portrayal or as an abstract.

My first application was made with Venetian Red with a sporadic application of Quinacridone Turquoise and then sprayed with water. The second sheet was placed over the first sheet and lifted off. Dry masking tape was used to divide the space. When applying acrylic paint on Yupo, use a ¾-inch (19mm) or ½-inch (12mm) flat and a quick back-and-forth motion. This gives you a smoother and denser paint surface. In places where the paint was still wet, I used a decorative paint edger with different edges on all four sides (purchased at a paint supply store) to drag through the wet paint. I stamped with a checkerboard stamp and a lettering stamp.

At one point, I decided I did not like what was happening to the design and taped off a large rectangular shape and a narrow long triangular shape. I soaked the taped-off areas with isopropyl alcohol, let it soak for a while, and then scraped the color off with the edge of an outdated credit card. Not all the paint was removed but most of it came off, revealing a warm reddish cream color and leaving a mottled look that I liked. I removed the tape and darkened the areas around these scraped-off areas. I added a lighter shape moving from the right into the large scraped-off area. I added a sweeping curve at the bottom of the painting to lead the eye into the painting and darkened the squares on the right bottom and right top. I darkened the spaces on either side of the triangular shape that had the paint scraped off. I left a band across the upper light areas just slightly darker than the light area. I liked the mottled look left from the scraping-off of the lightest areas and repeated some of it with squiggly lines made with a liner brush. I added the bluish and orange circles to the light area.

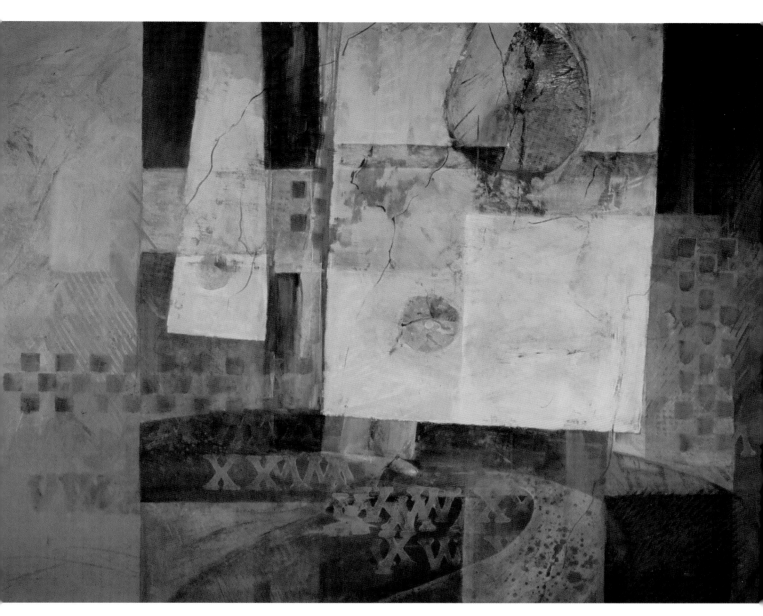

∧ **Passageways** • Fredi Taddeucci, ISEA
Acrylic on Yupo • 20" × 26" (51cm × 66cm)

Kendra Postma

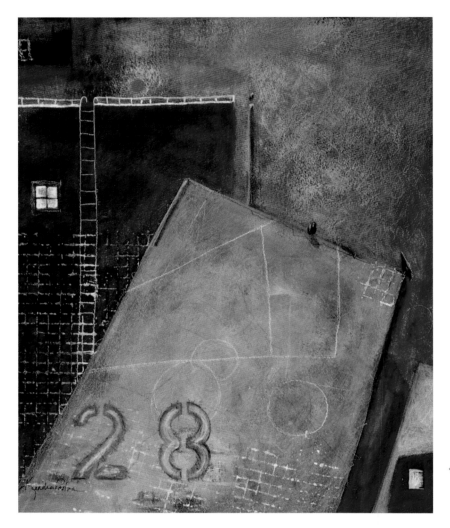

This painting was done over an old painting on 300-lb. (640gsm) Arches watercolor paper. I like to use an old painting as a background for a new and improved painting. This way I do not throw away an old work, but use it to add character to a new one. On top of the old painting, I used my "magic mix," which consists of four parts gesso, two parts matte medium and two parts water. I keep this in an old dish soap bottle. The mixture is transparent enough that you can still see color and shapes from the old painting.

I then pulled out some nice big shapes and filled those in with acrylic paint. The painting was still wet when I laid a rubber grid on top with plastic wrap weighted down with old magazines.

Then I let that dry before I pulled off the grid. (The rubber grid is used to stop area rugs from moving.) I kept going over the shapes with acrylic paints that I had watered down. I used a blue-gray for two of the buildings and a nice black with some magenta for the building in the back. (I will sometimes scrub off layers of paint.)

The background has a nice warm Golden Ochre, as well as orange, magenta, and yellow colors. When the paint was dry, I drew or colored in with watercolor crayons of the same colors plus white. Then I stenciled in the number 28 with some acrylic paint and went over that with my watercolor crayons. The final additions were the white lines and the orange sun.

Betty Jameson

Using Golden fluid acrylic paint in squirt bottles, I selected Quinacridone Gold, Crimson and Phthalo Blue. Working quickly, I squirted the Quinacridone Gold on first in sweeping circles, followed by the Crimson. Then I squirted a line of Phthalo Blue across the top. Using the straight edge of a plastic scraper tool used to apply mastic to tile, I quickly pressed and scraped going left to right and top to bottom of the paper through the Phthalo Blue. I repeated this, wiping off the residue of acrylic each time from the scraper. I also left a 1½-inch (38mm) space of white paper between each scraping (called *legs*). When paint seemed too thick in places, I used the serrated edge of the scraper like a comb to whisk through the paint.

When the acrylic was dry, I mixed up a medium gray using white and black gesso. Looking at what I had done, I could see a coat shape. I painted the gray around the "coat," leaving some of the white legs peeking through. Then I lightened my gray with more white gesso and painted two irregular bands over the coat shape, weaving in and out of some lines and shapes. Finally, using white gesso, I strengthened the white areas at the edges of the sleeves and down the front.

Since the background blue suggested oceans, and some of the shapes looked like other earth features—such as fish and mountains, I named the piece *Earth Coat*, representing the Earth's crust.

⌃ Earth Coat • Betty Jameson, ISEA, TWS
Acrylic on Cresent mat board • 20" × 26" (51cm × 66cm)

Carol DeBolt Eikenbery

When I began this work, I was working in a series of seed pods and natural plant forms. I drew interesting shapes to create a good solid design and, once I found one that worked well, I drew the design lightly on my Crescent cold-pressed watercolor board with a 2B or HB pencil. I cut a sheet of clear contact shelf paper to the same size as my board and rolled it across from top to bottom smoothing out air bubbles as I went. This created a frisket for my design.

I could then see my design through the contact paper and began cutting out the shapes with a craft knife where I wanted to pour paint. The parts still covered would remain the white of the watercolor board.

I prepared my fluid acrylics in small containers, adding a little water so they would flow easily. Using a protective layer of plastic on the floor, I began by first pouring Quinacridone Gold, then the Crimson and Turquoise, turning and tipping the board to direct the flow. I also used a spray bottle of water to mist or diffuse the paint in some areas.

Once I was satisfied with the distribution of paint, I laid the board on dry newspapers. I textured some of the wet paint surface with plastic wrap, bubble wrap and pieces of mesh. I then placed an old piece of Plexiglas on top of it all and weighted it down. After twenty-four hours, I removed all weights and texturizing items and allowed the painting to air dry before I continued.

When the paint was dry, I carefully removed the frisket contact paper to reveal a stained-glass effect. Then, following my initial value sketch, I began to define the shapes and bring out the design with opaque paints, which I created by adding white and/or black gesso to the fluid acrylics.

Get free desktop wallpaper and a bonus demo at artistnetwork.com/journeystoabstraction.

Testae • Carol DeBolt Eikenbery, AWS, NWS
Acrylic on Cresent cold-pressed watercolor board • 40" × 33" (102cm × 84cm)

Judy Hoiness

Before I apply paint to the paper, I tear irregular shapes from blue painter's tape. I use the wide width tape because it allows me to tear large and small shapes. The torn shapes are placed randomly. As I am working, especially near the end of painting, I begin to pull off the tape.

The areas of white left by the tape can remain white, or be painted or be completely be taken out. More often than not, these are exciting little shapes and help me carry white to the very end of the painting process. In this painting, areas that were covered by tape are the large white horizontal shapes at the top and the small irregular shapes in the Cobalt Blue and Cobalt Turquoise area on the left of the painting.

I never do any pre-planning on paper for my work. My mental plan was to have linear areas in black to enhance bright, light shapes. By keeping the colors light in value, I can add shapes on top or lift out shapes easier. To create the black lines, I used a 1½-inch (38mm) flat, manipulated to create various line widths, and a Loew-Cornell Miracle Wedge, size 12.

Next I selected Cobalt Blue, Cobalt Turquoise, Quinacridone Magenta, and Aureolin as my open palette. I squirted them directly from the tube onto the wet area of the watercolor paper. Quickly, I began to push and mix the paint. I have been applying paint directly to the paper in this manner for many years. For a few areas, I did use a small amount of butcher paper as a surface to mix some paint. It was then picked up, turned over and pressed on the dry and/or wet watercolor paper. These surprises are delightful and set my imagination in motion. In this painting, the first layer of paint on the rabbit was done in this manner.

Some of the animals in the painting were painted while others were lifted. The large fish was lifted with a hydrophilic sponge near the end of the painting process. The fish was cut out of butcher paper. Other purchased stencils were also used. After a stencil area was lifted, I used a damp brush or the clean sponge and blurred the area. (By using a hydrophilic sponge, you can lift the paint and not push it into the paper.) I am fond of this painting/lifting technique. I feel the contrast between the painted and lifted areas is exciting.

The small gestural script on the right was done with a no. 2 script liner and a tool made from pop cans. Two final touches were added. I took the script liner brush and quickly placed more black lines in various areas. The word "EXTINCTION" was placed near the top right of the painting. I used several tools, one being a fine-point brush and a C-2 calligraphy pen nib in a pen holder. I used a small pointed brush to load the paint into the pen nib.

Save Habitat and Species #10 • Judy Hoiness, NWS ❯
Transparent watercolor on Strathmore Aquarius II 90-lb. (190gsm) paper • 30" × 22" (76cm × 56cm)

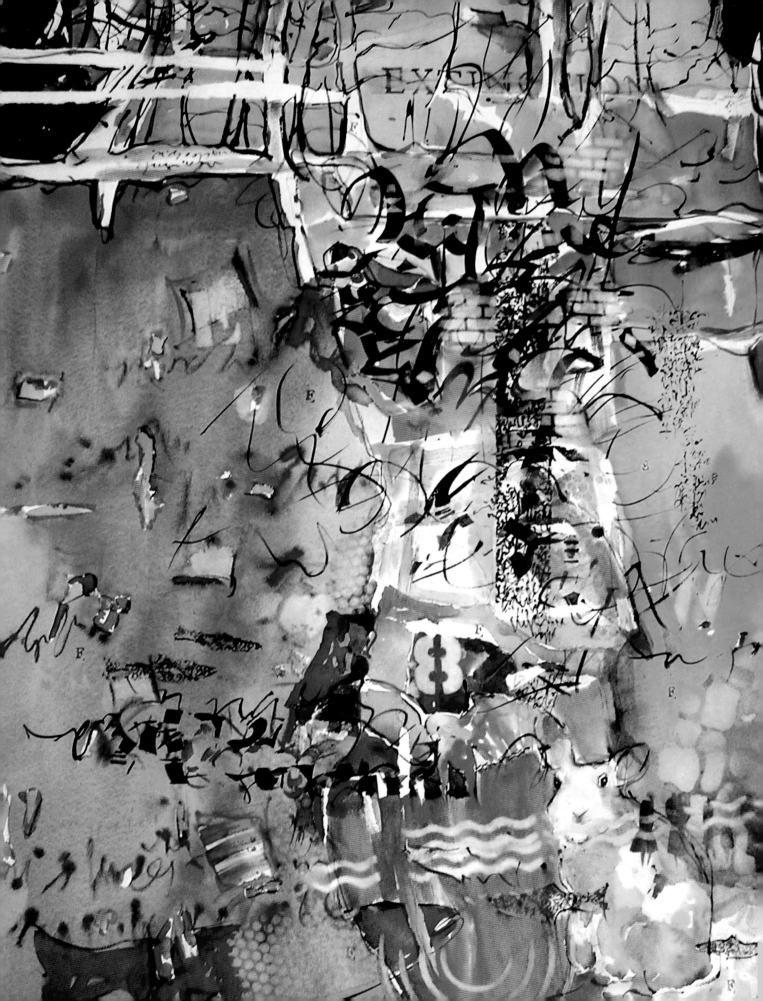

Carol Z. Brody

Party Papers, Ribbons and Confetti II is part of a long, intricate series I was inspired to do after working in collage. I wanted to see if I could create that same look using only watercolors.

I began this work by wetting the entire surface of a piece of Arches 140-lb. (300gsm) cold-pressed paper very well, several times, letting the paper really soak up the water and expand. While it was glistening wet, using a 1½-inch (38mm) brush, I floated in colors—blues, yellows, oranges and purples—stroking in the general direction of the "papers," and filling the page. This was the soft underpainting.

After drying the first stage with a hair dryer, I began to "find" the shapes for the papers, often using my hands to visualize their placement. I wanted the shapes to work together, carrying the viewer's eye through the painting in one large, sweeping gesture. The shapes were formed, one by one, as I negatively glazed around each one and then dried it with a hair dryer. Occasionally I drew a shape before glazing, just to be sure of it.

After many of the shapes were defined, I began to decorate them with patterns. Some of these were carefully painted in, while some were sprayed or lifted through screens and doilies. Finally, when I was satisfied that the shapes were working, I carefully drew in the ribbons and the confetti shapes and painted them in. At this point, I decided to add some warm red to excite my colors further. Although I try to reserve light areas early on and make use of them as I paint, here I needed a small amount of white paint to correct a few of the patterns which had become too dark.

As the painting progressed, I spent a great deal of time looking at it, on the floor with a mat around it. In the end, I believe I achieved what I had set out to do. The pieces seem like scattered, torn wrapping papers from some party, and the painting has an energetic, joyous, even riotous feel to it.

Party Papers, Ribbons and Confetti II • Carol Z. Brody, NWS >
Watercolor on Arches 140-lb., (300gsm) cold-pressed paper • 30" × 22" (76cm × 56cm)

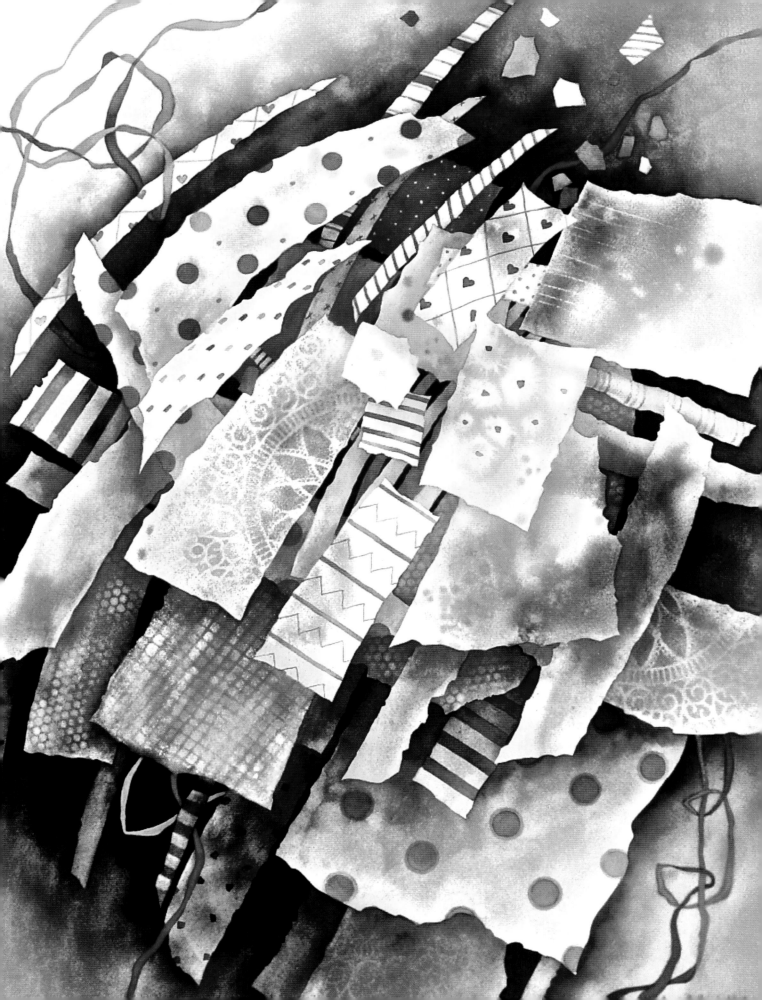

Mark E. Mehaffey

This series of works was my considered response to our economic recession, specifically the recession in my home state of Michigan. Rusty metal is a symbol for living in the past. The geometric shapes of squares and rectangles are symbols for not being able to think outside our little boxes. The brightly patterned fish swimming above it all symbolize our new direction—a more sustainable, economically fair and socially kind society. The rusty metal has morphed into representations of many ancient cultural relief sculptures, a change brought on by expanding my thinking globally. This work is conceptually motivated, the formal arrangement dictated by the idea.

Once the concept was firm, the drawings were executed directly on a pieces of stretched Arches cold-pressed watercolor paper. The images were drawn from the top down: the fish first, then the whimsical flying wing shapes, the monoliths, the sprayed rectangles, then the entire relief sculptures and the anchoring checkerboards.

The pieces were then painted from the bottom up in exactly the opposite direction. A warm temperature dominance was predetermined. It is this warm dominance that helps keep all the various parts of these complicated paintings together. All those neutralized oranges, browns, golds and warm grays also act as the complement to some of the cools added to the fish. This complementary bounce creates a visual energy that an analogous color relationship would not have.

Using a mixture of Burnt Sienna, Quinacridone Gold and Sepia (along with Ultramarine Blue and Cobalt Blue to act as a neutralizer) everything was carefully painted bottom to top with various sized brushes. The large rectangles immediately under the monoliths were stenciled off and sprayed with a mouth atomizer. Before the fish and their drop shadows were painted, the paintings were sprayed with a warm gray to push back everything but those highly saturated fish, helping to pop them out for the viewer.

‹ Blue Monolith #4 •
Mark E. Mehaffey AWS, NWS
Transparent watercolor on Arches cold-pressed watercolor paper •
27" × 35" (69cm × 89cm)

Monolith #7 • Mark E. Mehaffey AWS, NWS ›
Transparent watercolor on Arches cold-pressed watercolor paper • 34" × 27" (86cm × 67cm)

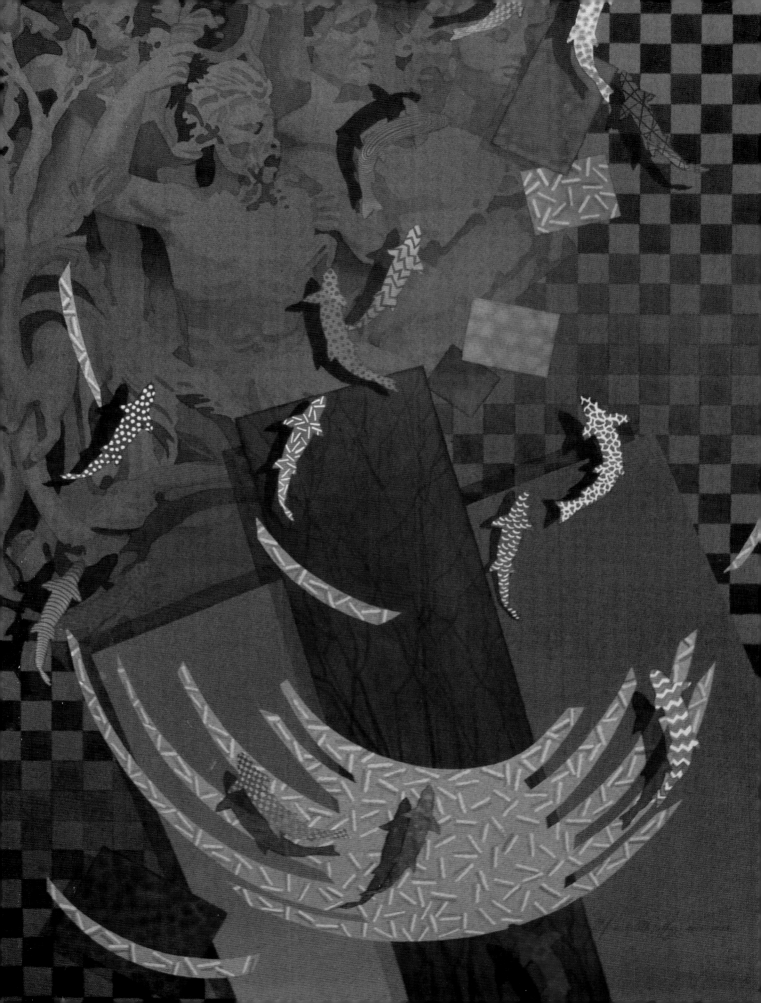

Jan Filarski

This painting is on a 20" × 20" (51cm × 51cm) cotton-duck stretched canvas, which I painted flatly all over with white gesso. When this was dry, I covered it with brown gesso.

Next, I collaged pieces of a recycled watercolor painting I had previously done onto the canvas, forming a square shape within the square canvas. Both the reddish-brown of the brown gesso and the Burnt Sienna in the watercolor painting went well together. I adhered these pieces with acrylic gel medium and weighted the paper down upon the canvas so it would dry flat.

I enjoy collage and find the gradations found in using recycled watercolor paintings to be one of my favorite papers to use in the collage process. I then applied random ripped pieces of painted watercolor paper on top of the first layer, adding some depth.

Next, I painted detailed shapes and lines on both the canvas and the watercolor paper with acrylic paint, being careful not to cover up all the brown gesso of the first color layer.

I thought the painting could have been done at that point but maybe needed just a little something else. I mixed up many colors and came up with a strange shade of green, which I dropped onto the canvas with my fingertips. (I have since found that art stores sell such colors, calling them "sludge," made by mixing together all the leftover batches of paint.)

I set the painting on newspaper on the floor and stood above it with the mixed green paint, thinned to the consistency of buttermilk. I found that when I dropped the paint from a height of 3 or 4 feet (1m) it landed on the painting in almost perfect circles. I did have to touch up a few circles with a brush.

I tried one last idea. I drew a shape with white chalk upon the painting. If I didn't like the shape, I could brush it off with a lightly dampened paper towel. I had some patterned paper cut in strips, and the colors and lines looked good with the colors in the painting. I had to taper the edges of the strips to fit inside the shape I had drawn. I liked the effect of looking through the new patterned paper to see the color and activity in the painting below. I adhered this layer of paper with acrylic gel medium and determined I was finally done.

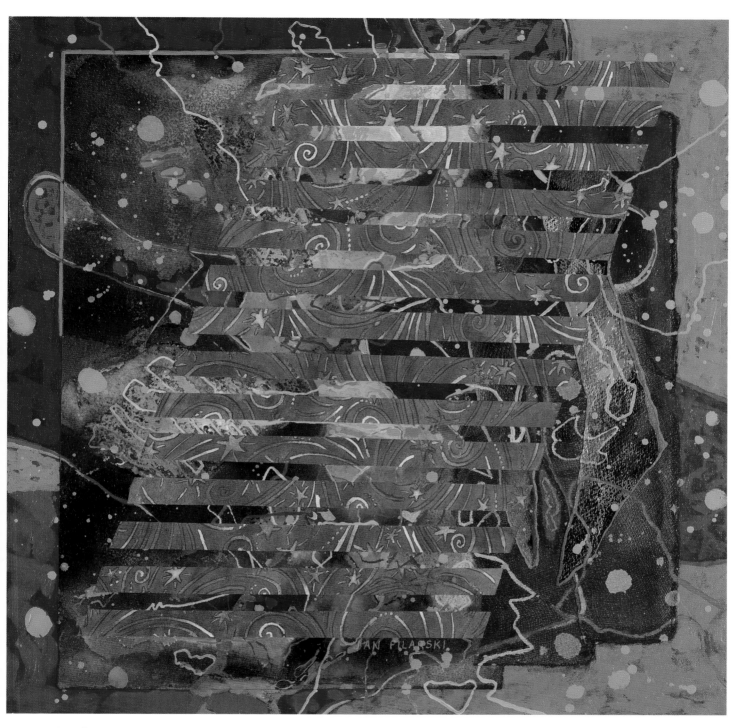

To the Stars • Jan Filarski
Acrylic and collage on cotton-duck stretched canvas • 20" × 20" (51cm × 51cm)

Cheryl D. McClure

I had just finished working on a two-panel painting that I liked, and wanted to continue the exploration of my trip to Umbria, Italy, with this painting as well. *The Green Heart* of Italy was done on four wood panels with encaustic and mixed media.

At first, I thought I might arrange them in a different mode, but then later discovered that the panels are 3 inches (8cm) off if turned in certain directions. So, I just lined them up—all 36" × 12" × 2" (91cm × 30cm × 5cm)—in a horizontal overall arrangement. I used an encaustic gesso coating on them to start off with a back underlayer, as I didn't think I wanted a dark painting.

Then, after marking all over the pieces with Conte crayon, I put medium on all the panels. I rummaged through my collage stuff and found some quotes that sounded interesting to include, so I added them to two of the panels. This is best done before adding the medium as you cannot write with the usual pencils or chalks on top of the medium. (Sometimes knowing where you are going with a painting can be as much of a problem as not knowing.) Of course, as I applied the medium I changed my mind as to where the two panels with the writing would go.

I started tossing out a lot of found papers and pieces of junk I collected on trips. I just kept tearing and cutting the pieces of paper out and laying them down. At first nothing really looked good or showed promise at all. It is a little difficult to explain how a collage process goes after the fact. Mostly it is trusting that you will find the right value, color or shape that will work—or you can just cover it up and start over. I find that many times, the layers add to the quality of the surface that I love so much.

While rummaging through my papers, I ran across the printed copy of the umbrella pine photo I made on my trip to Umbria. I have used it several times, but this is the first time I have used my photo as a transfer, and also added to it with crayon.

I had some other collaged elements from that same trip. I used pieces of a tourist map, a wine bottle label and foil cap, as well as the painting and some oriental papers with encaustic wax paint. There is not much encaustic paint on top of the collaged elements. First I lay down the pieces and then I have to decide whether to add the medium or color over and fuse them. If it doesn't work out, I can heat it up and move it or paint over it later.

I have to say, working with wax and collage elements is easier in that they don't go blowing and moving around quite so easily. But you can easily end up almost covering what you want to remain visible, so you have to be careful—or do a lot of scraping back.

Get free desktop wallpaper and a bonus demo at artistnetwork.com/journeystoabstraction.

The Green Heart of Italy • Cheryl D. McClure, SWS, TVAA
Encaustic and mixed media on wood panel • 36" × 48" × 2" (91cm × 122cm × 5cm)

Charlene Edman Abele

When beginning, I usually work in a series using three or four full sheets, 22" × 30" (56cm × 76cm) Fabriano Artistico 140-lb. (300gsm) hot-pressed paper. Doing a series allows work to dry between layers, and I can work continuously.

Items I may use are isopropyl alcohol, a scraper, a comb, and also weaved fabric, wax paper, a roller and colored pencils for texturing. I use foam meat trays to make stencils, cutting and pressing patterns in the flat bottom of the trays.

Using a 2- or 4-inch (5cm or 10cm) hake brush with Golden fluid transparent paints, I layer several colors, gradually building shapes and texture, often scraping and removing portions of color with isopropyl alcohol. This allows many colors to show through.

I use dark/light colors, line, shape and movement in layering the acrylic paint. Occasionally I use equal parts of matte medium and water between layers, which help to keep paint from lifting too easily.

I am often very surprised to see the work as it comes to completion and how it turns out. I seldom have an idea in mind when I start. A finished painting for me should have good balance, contrast and energy. Does it create a mood or excitement? Now *Earth Story* is complete.

Finally, I varnish with one or two coats of equal parts matte medium, gloss medium and water, allowing at least two hours between coats.

∧ Earth Story • Charlene Edman Abele
Acrylic on Fabriano Artistico hot-pressed 140-lb. (300gsm) paper • 22" × 30" (56cm × 76cm)

Dottie Holdren

<Study in Pink • Dottie Holdren
Watercolor and mixed media on Rives BFK
paper • 30" × 22" (76cm × 56cm)

The paper I used was Rives BFK printmaking paper. I used spray bottles to apply diluted water-colors, forming several layers through stencils that I made myself. Divisions were created to achieve the composition of large, medium and small shapes.

There was a small amount of texture thrown in as a focal area. Textures were created by spraying over pressed-down tape from a music cassette. Watercolor pencils were used to enhance, define and connect the shapes together in a pleasing manner. Very little brushwork was used to complete this painting.

See the Demonstrations section to follow Dottie's step-by-step process for creating a similar painting.

Marie Renfro

I wet an Arches 300-lb. (640gsm) sheet of cold-pressed watercolor paper with a large Robert Simmons brush called the Big Daddy. I like to generously wet the paper so that I won't get any hard edges that I might not want to keep. I try to keep my edges as loose as possible, as long as I can, so that I have choices. The other brushes that I use are the Robert Simmons Skyflow and Goliath. I feel using larger brushes makes me looser, and I get wonderful flowing strokes of paint.

I use Golden liquid acrylics, and for this painting I started with Hansa Yellow Light. I covered the top right side of the paper with loose strokes of the yellow color and continued the stroke across to the left side and then down the center of the page. (I always start my underpainting with my lightest and cleanest colors first while the water is clean.) I then picked up some Hansa Yellow Medium and put strokes of that color nearby the lighter yellow. After that, I used some Quinacridone Gold and Raw Umber for the other areas of the painting. My goal is to let the colors do as much mixing on the paper as I can. I actually poured some of the gold paint on thick enough to build up texture.

I then dipped a dried plant stem into India ink and drew some lines to make the grid marks on the paper. I like a rustic branch rather than a pen because I can get more interesting line quality. I also like to let some of the lines hit wet paper and fuse with the other colors and shapes. After these colors were dry, I glued on some purchased khaki-colored paper which had letters and numbers on it. I like to tear it into pieces so that you can't see any of the full numbers or letters on it. I also used gold foil and heavy paper made in India for surface texture. Sometimes I glue the paper on before I start the painting and sometimes after I have done the underpainting. For glue, I use a 50/50 mixture of Sobo glue and distilled water. If I am collaging a heavy piece of paper or other found object, I use gel medium for the glue. I apply the glue to the back of the paper, and then when it is in place, I cover the top of the piece of paper.

My format was a cruciform composition with the weight at the bottom. After all the collaged materials were dry, I began to do glazes of color over the areas that needed adjustment. I can bring up the color or reduce the intensity with glazes of the same colors I used in the painting. I always make my colors bridge the paper and touch on three sides, so a bridge effect is easy to achieve.

When I tear paper for collage, I use three pieces of each kind of paper and also three different-sized pieces. By composing in threes, I get a very nice asymmetrical balance in the painting.

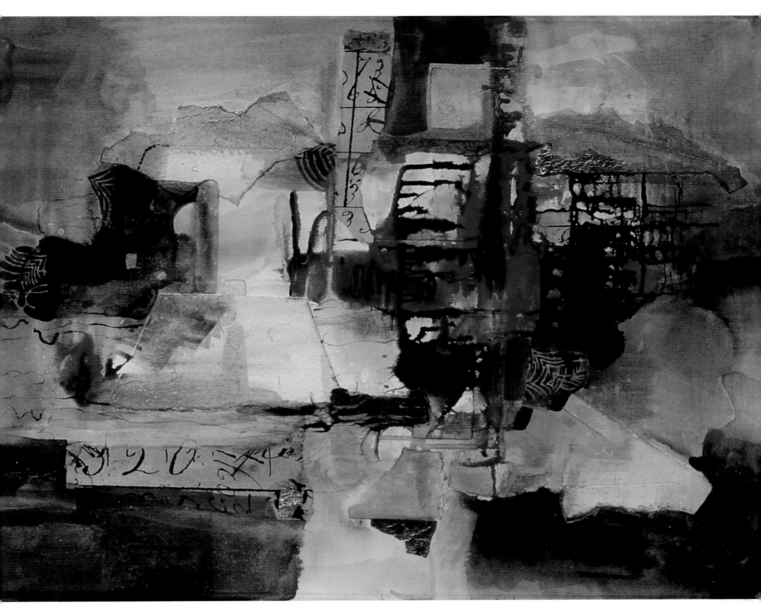

▲ Golden Gate • Marie Renfro, SWS, TVAA
Acrylic and collage on Arches 300-lb. (640gsm) cold-pressed watercolor paper • 22" × 30" (56cm × 76cm)

Jane E. Jones

I took a photograph of poppies with a lot of background leaves. Since the poppies were red-orange, I decided to use that for my main color. I drew the realistic image with a fine-point Sharpie pen onto 90-lb. (190gsm) index paper the same size as my watercolor paper. An abstract image was also drawn on another sheet of index paper the same size as my watercolor paper. The abstract image was drawn from one of my marbled cards. The lines and shapes from the card gave me the rhythm needed for the poppies.

Next, I put these two images together using a light box to see if the shapes were repeated with variety, and if the two images related to each other. On my watercolor paper, I drew the realistic image with an extra-fine Sharpie pen. I then drew the abstract image on top of the realistic image with a 2B pencil. I laid the paper on a smooth Formica board (also called tile board), after wetting both sides of my paper thoroughly with a natural sponge and making sure there were no dry spots or bubbles under the paper. I didn't remove the excess water with a sponge, but instead left the paper untouched until the glisten or shine was off. I used a tissue to take the water off of the edge of the paper so I wouldn't get bleed-backs, or blooms.

Using a 1½-inch (38mm) or 2-inch (51mm) natural-hair flat, I applied the paint very loosely using one of the safe color schemes. I used analogous colors of yellow-orange, orange, red-orange, red and red-violet, as well as the complement of the middle color, which is blue-green, then used a discord on either side of the complement, skipping blue and green and using yellow-green and blue-violet. I used all these colors in the underpainting, making sure not to go over a no. 3 value.

While the paper was still wet, I found the abstract shapes by painting around the shapes that were losing their edges. Using the dominant color red-orange, I painted around the main flower, but over the buds and middle-ground flower to bring the large flower forward. Next, I painted around all of the flowers and buds with the red-orange, losing the edges. I pushed the background back by adding blue-green. This grayed the background.

Next, I found the leaves and background abstract shapes with all of the other colors. I added more blue-violet to push the background back further. Then I had to move all of these colors through the main flowers, buds and middle-ground flower. I was always conscious of leaving lights in my main flower and leaving the center of interest very dark against the lights. I separated each shape, abstract vs. real, with gradations of value and color, always thinking of their functions being flower from leaves from background. I layered each color, always working wet-into-wet. (If I need to leave an unfinished painting, I put a wet—not too wet—terry cloth towel under the painting and sandwich it with a tile board on top for twenty minutes. This is the perfect consistency of wetness to paint, which I call "painting on velvet.")

Then the fun starts—separating the real from the abstract, using gradations of color and value in every shape. I never mixed the colors on the palette, only the pure hue. I wanted the realistic image to be dominant, and the abstract subordinate.

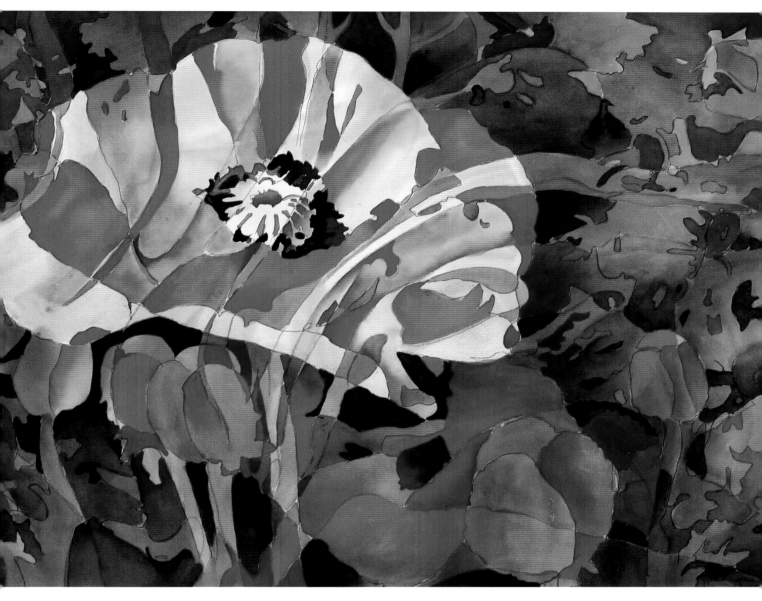

Full Bloom • Jane E. Jones, NWS, SWS
Watercolor on watercolor paper • 22" × 30" (56cm × 76cm)

Nancy Egol Nikkal

I work in series and always have a work in progress or a framed work in a current series hanging on the wall in the studio as inspiration for new works. I explore and expand the design, texture and color palette from one to the next. Everything is created in concert with music playing in the background. Many people say they feel the music when they see the *Jazz Notes* series.

I love mixed media. All my collage media is organized by color, texture and pattern, and includes magazine papers, photocopied papers, recycled drawings and prints and painted papers. Whatever paper appeals to me the most becomes the starting point for the next collage. After that, I locate media or create new papers.

I paint a palette of papers for each new collage, varying colors and textures, putting layers of new paint on top of old painted papers and painting on recycled magazine papers, fresh printmaking papers, etc.

Before I start a collage, I like to have color or tone on the substrate—the bottom level—and paint with thin acrylic using a palette knife, scraping and scratching to create different layers of depth and personal marks that are like a drawing as well as a painting. I paint all papers with a palette knife, varying the depth of the paint.

In the *Jazz Notes* series, I worked with Ivory Black acrylic paint and gloss glaze medium to create the background. While it dried, I painted papers in black to add to the substrate (if necessary), and painted more papers for the main collage.

My first step in every collage is to place papers, see how they fit, move them around to create the best positive and negative spaces, then glue the papers down and be amazed at how all the relationships change in the act of gluing down collage. I often repeat the process, layering new papers, adding paint or thin collage papers, etc. I am a layerist and love the process of layering.

I have worked seriously in collage since 1985 and love working with paper, creating with paper, and touching, tearing and gluing paper. At my collage website, www.stuffthatsticks.com, I write, "I can be very philosophical about glue. In many ways, my life is about glue. The site also includes information on the history of collage, tools and techniques, and a free painted-paper collage tutorial."

Jazz Notes Pink Green Black White includes a lot of my printmaking papers. I think one of the most wonderful things about mixed media and collage is that the process is fluid and there is so much potential for serendipity.

Jazz Notes Pink Green Black White • Nancy Egol Nikkal
Mixed media and collage on paper • 16" × 11" (39cm × 28cm)

Get free desktop wallpaper and a bonus demo at artistnetwork.com/journeystoabstraction.

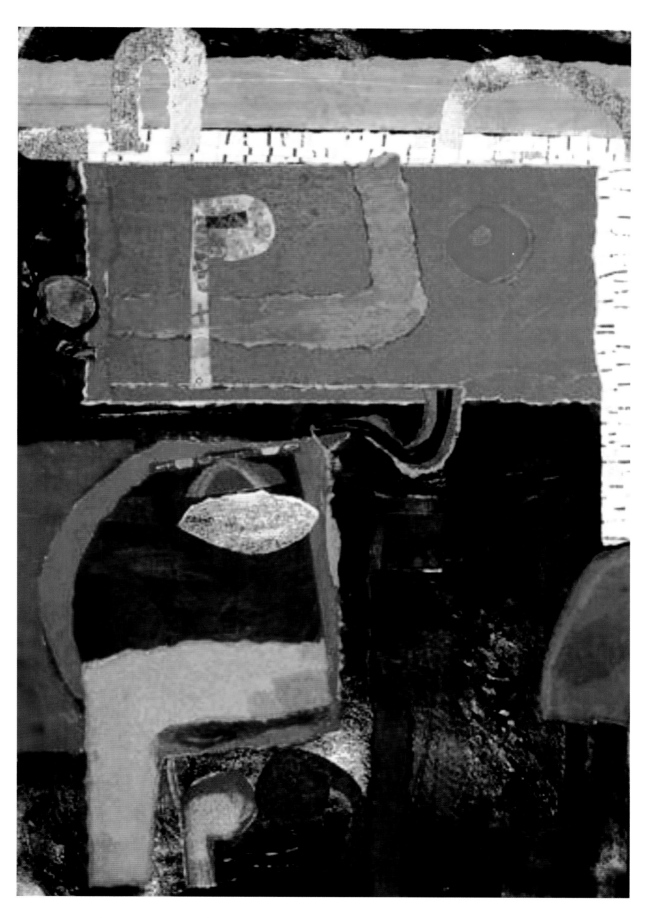

Marilyn Gross

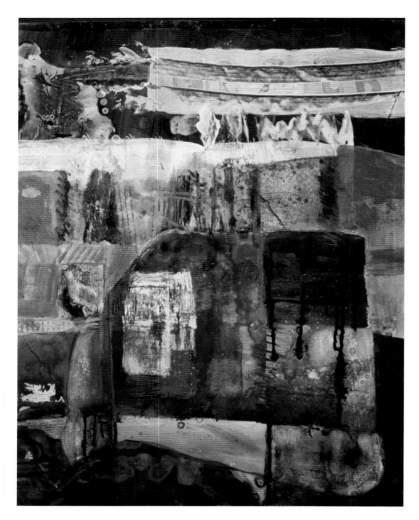

<Written in the Walls • Marilyn Gross, ISEA, SLMM
Acrylic on 140-lb. (300gsm) cold-pressed
watercolor paper • 29" × 23" (74cm × 58cm)

For many years, I have been fascinated by the lines, forms and images that remain on the exposed walls as a building is being torn down. These images leave evidence behind of what has transpired within these walls in the past. Wallpaper bits, paint colors, wall damage, etc., are all revealed.

This painting was done with liquid acrylics. It began as I begin all of my paintings—I chose a color and made a mark. That led to the next color and next mark, all chosen intuitively. The painting progressed step by step, layer by layer, with no preconceived idea of what it would be when finished. I use no reference materials. Each painting is a conversation between myself and what is happening on the paper or canvas before me.

As the layers progressed, and while the paint was still wet, I pressed textured materials (papers, cloths, stamps, etc.) in the wet paint, pushing and pulling the wet pigment as I went, revealing dried layers of paint below. The light passages in the painting were added with thinned-down gesso, which was later glazed with color when it had dried. Other shapes in the painting were scratched into the partially dry pigment with pencil and a pointed stick. Still other shapes were formed by negative painting (painting around shapes and in the process creating new shapes).

The painting is finished when I feel the colors, shapes and composition work well together. At that point, the title of the painting pops into my mind and it's subject is revealed to me.

Kendra Postma

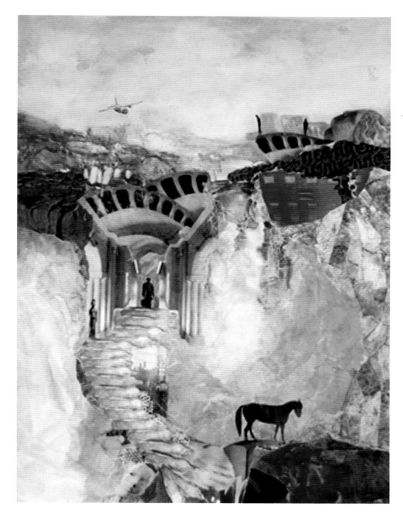

Journey • Kendra Postma, ISEA
Mixed media on Bockingford 250-lb. (535gsm)
watercolor paper
• 28" × 22" (71cm × 56cm)

The first step in painting *Journey* was to paint a wash of what I like to call "magic mix"—four parts gesso, two parts matte medium and two parts water. (I keep it in an old dish soap bottle.) I randomly poured and brushed this onto the surface.

Next, I scraped through this mixture with a cut-up credit card to give it more texture. I let this dry overnight and then applied watercolor paint in the loose form of a landscape with a high horizon. This was left to dry. I then applied various kinds of papers. I made some of the colored papers using art tissue paper from an art-supply store. To make the colored tissue "pulls," I applied watered-down watercolor paint onto the tissue paper and let that dry before applying it to the painting.

Sometimes I will make copies of my paintings and use that as my collage material. For instance, the steps are a figure from an existing painting, copied many times. I also like to use pictures from magazines, from which I make colored copies. I use the copy instead of using the magazine itself because it seems to blend in better and it will take watercolor paint very well.

After I had all the pictures and various papers in the correct positions, I glued them down with matte medium. After it was dry, I went back in with more watercolor paint. When everything was how I liked it, I applied the final additions of rice papers to hide some of the edges and a few white lines. The final step was to give the whole painting a coat of matte medium.

Georgia Mason

When I began this painting, I had no plan in mind. I choose my colors intuitively, and the work speaks to me as I go along. This painting was done on a full sheet of Strathmore Aquarius paper. The paper was sized using Liquitex gloss medium and varnish that was diluted 50/50 with water. After I coated the entire sheet of paper, I let it dry.

Using Liquitex or Golden fluid transparent acrylic paint, I put on many layers of paint, one at a time, letting them dry in between. I used 3-inch (8mm) hake brushes to apply the paint. I used one Hake brush for warm colors, one for cool colors, one for the gloss medium and varnish, and one for the white gesso. The first layer was Phthalo Blue. After letting that layer dry, I painted a layer of Alizarin Crimson. I repeated this process, the third layer being Yellow Orange Azo. While each layer was wet, I put in texturing marks, scratching, and spraying or dropping in isopropyl alcohol. I don't remember exactly how many layers of paint I put on this, but it was at least five layers.

When working in this layered manner, I go back down to the many layers of paint which are underneath with the scratching and texturing. Putting the diluted gloss medium and varnish on at the beginning protects the original paper. I occasionally put down a rectangular piece of paper towel and brayer over it to help soak up extra paint.

I started breaking up the full sheet into a grid format, painting over various sections with white gesso and Golden fluid acrylic paint mixed with black or white gesso. In some areas, I scraped into the wet paint using a small piece of matboard of varying widths. I used Quinacridone Burnt Orange, Alizarin Crimson, Ultramarine Blue, Phthalo Blue, Phthalo Turquoise, Quinacridone Violet and Yellow Orange Azo.

The white areas were painted using diluted white gesso with isopropyl alcohol dropped in while the paint was still wet. I mixed the gesso to be thick enough to cover, but not so thick that it totally covered the underpainting. The paint underneath shows through where the isopropyl alcohol is dropped, and through the thin layer of white gesso.

Continuing with the layers, I dipped small paint bottle bases into paint or white gesso and stamped onto the paper in various areas.

I created a design for stamping using a styrofoam meat tray. I dipped the stamp into white gesso or acrylic paint and stamped in several areas. Gesso that was more liquid created a more fluid stamp pattern than it did when dry. It is good to vary the method of stamping also.

I continued working with warm and cool colors, as well as darker values to pull the painting together. I used Caran d'Ache Neocolor II water-soluble crayons for linework in the top area, as well as in other areas of the painting.

Geometry of Life • Georgia Mason
Mixed media on Strathmore Aquarius paper • 30" × 22" (76cm × 56cm)

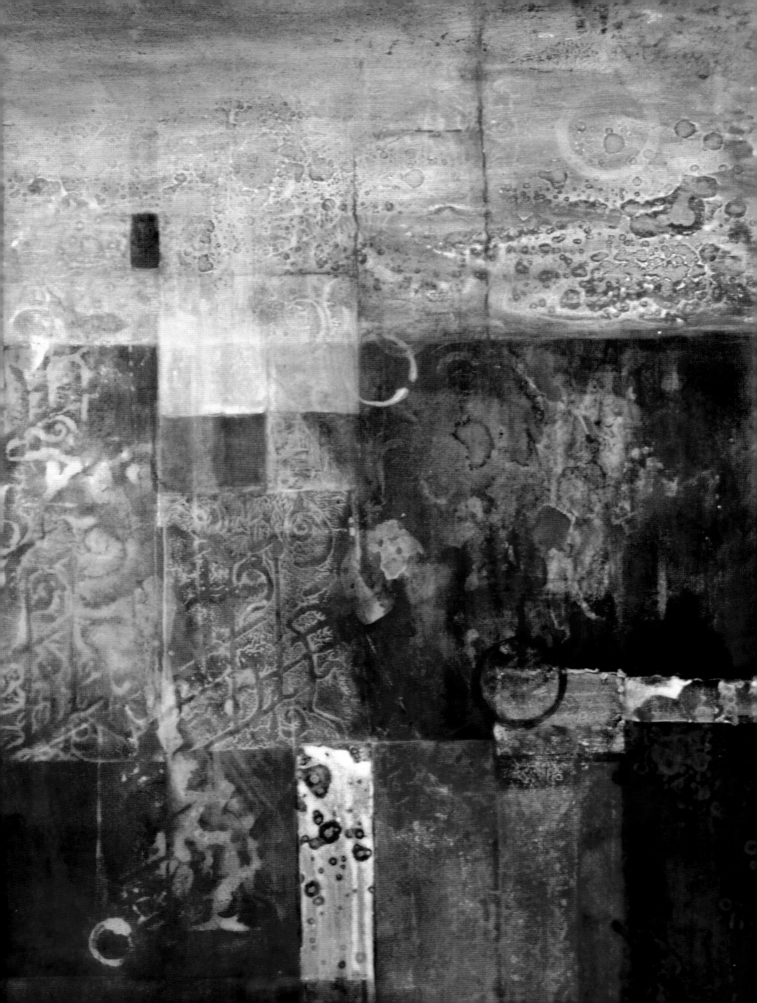

Shirley Wilson Blake

In starting this painting, I picked out the colors that I wanted to work with for dominance. The color dominance for *Making Your Mark* was lavender and warm gray with pops of red, soft yellow, aqua, acid green and black. I began with an underpainting of soft red-orange.

One of the reasons I love abstract is that you have only your shapes, colors and style to bring forth in your work, rather than the realistic approach of making things as they appear visually.

Whether I have an underpainting or not, my first layer covers the surface with midtones of my dominant colors. Most are very soft edged and blend well with the color next to it.

The second stage is to develop where I would like my focus to be and begin layering color over color to establish shapes and have more contrast in colors. Acrylic is a wonderful medium for working in this manner. Most of my work has numerous layers in it; however, I'm not attempting to texturize with products, as I would rather establish patterns via paint quality and style.

The layers are intentional in terms of keeping your eye moving over the surface of the painting. I find I usually pick the "golden section" composition in my work with the focal point being towards the middle of one of the quadrants of the paper or canvas. The small bits of color and shape in my work are achieved by pulling color off when a fresh coat is layered over a dry coat, scratching through a layer to reveal undercolor, or by painting a positive shape over the dry layer. I choose to use very little obvious technique, such as cheesecloth or bubble wrap, as it is more interesting to me to invent the shape and texture in the piece.

The final stage is to use the top layers of color and shape to help define the large shape in the piece. Mine seem to almost always veer towards a geometric shape. I tone down the bounce of color with more structure and usually a deeper value in the final stages of the painting.

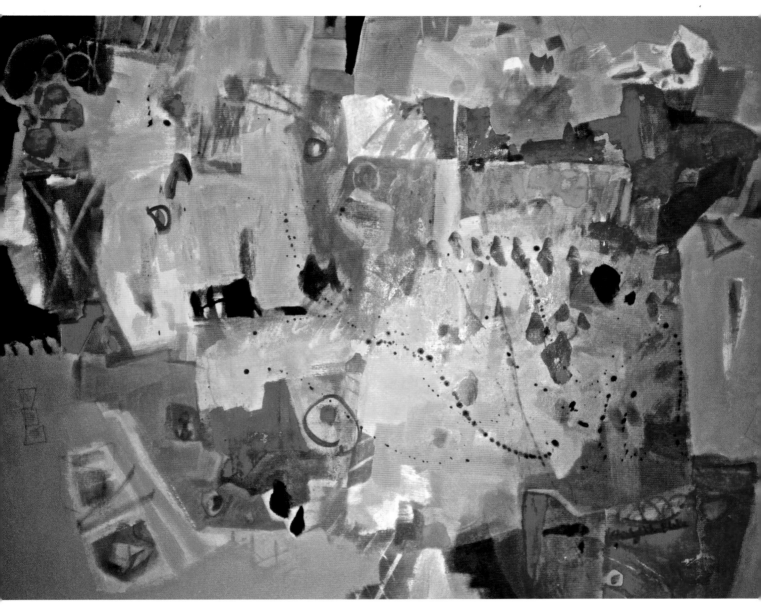

Making Your Mark • Shirley Wilson Blake, ISEA
Acrylic on canvas • 24" × 36" (61cm × 91cm)

Victoria Lenne

Abandoned began as an underpainting in watercolor. I allowed the colors to flow and mix at will on the heavily wetted Arches paper. I used earth tones to set the mood for what was to become a landscape, or perhaps it would be better to call it a "nestscape."

After the initial washes were allowed to dry, I used vine charcoal in white and black to block in structural elements with lines, which might suggest human habitation. Knowing that the integrity of the lines would be impacted with further washes, I did not worry about suggesting anything recognizable.

Using Liquitex gesso thinned with about 50 percent distilled water, I washed the gesso across the entire surface of the painting. I decided to use water instead of medium to thin the gesso, as it tends to create a more matte surface. Watercolor began to mix with the gesso, and the vine charcoal lines softened. Using a hake brush to apply the gesso mixture, I was careful not to use too many strokes in the application, maintaining the watercolor and charcoal lines. Get in and get out, as it were, and let it all dry. Because Liquitex uses a greater percentage of marble dust in its compound, I end up with a better visual texture of strokes and grittiness.

Once everything was thoroughly dry, I came back into the painting with acrylics thinned with water. Re-wetting the entire surface, I began to wash in colors that built the intensity and value of the subject matter. I allowed some of the washes to flow and sprayed other areas with 91 percent isopropyl alcohol to texture the washes. When I was satisfied with the overall movement of color and texture, I let it dry.

I began to build the nest with short strokes of acrylic paint, using colors that would visually describe dried sticks and grass. Once I was satisfied with the structure, I let it dry. Later, I decided to add the gold metallic accents to draw the viewer more quickly to the nest, appointing a sense of elegance to nature's way. At the very end, I decided to add the darker shadows and flowing areas of Aquamarine Blue. This heightened and accentuated the sense of disintegration after the nest had been abandoned. Not only does the color support this notion, it also flows into the other areas of the painting that take on a sense of disintegration.

Abandoned • Victoria Lenne, GWS, ISEA ❯
Watercolor and mixed media on Arches paper • 26" × 20" (66cm × 51cm)

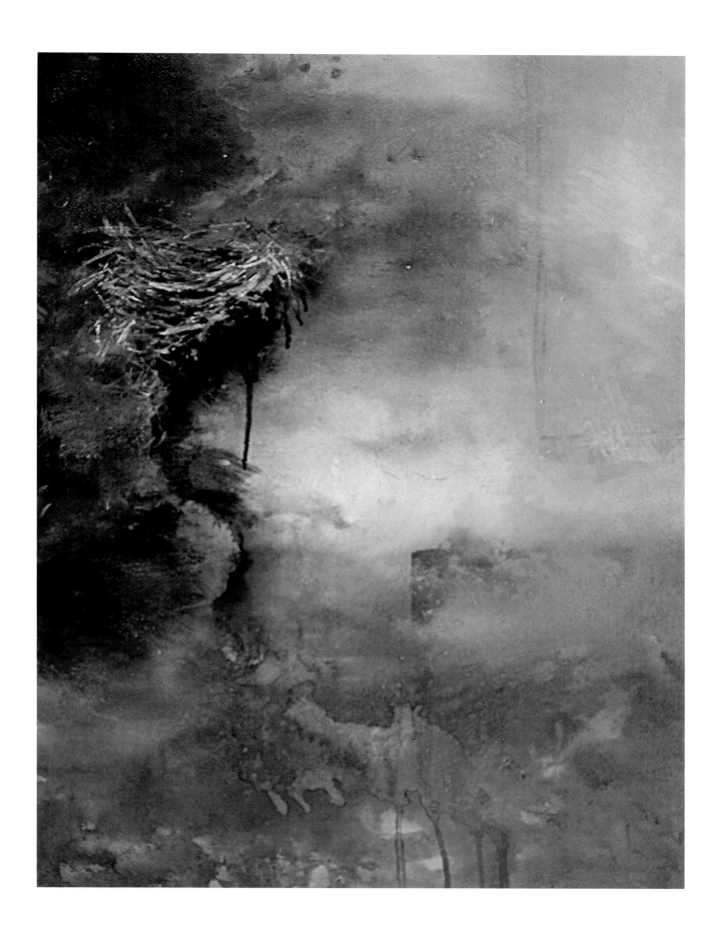

Carole A. Burval

My original inspiration for *Iris Abstract* was sparked during a canoe trip along the Namekagon River in Wisconsin. In this painting, I specifically chose to abandon realism, opting instead to evoke the emotional response of gliding quietly on a gentle river, reveling in the sight of hundreds of blue violet irises rising up from the soft sandy banks as spring unfolds. My plein air painting session occurred soon after my trip, when neither an iris nor a photo served as reference material; I trusted that the memory of this rare and exuberant experience would intuitively guide my creative decisions.

I began this painting by purposely choosing a split complementary palette that contained both warm and cool colors. I instinctively carved out subject-related shapes on the dry paper with water. While these areas were still wet, I dropped in various colors from the tip of a round brush and encouraged them to mingle with each other. This process created a subtle blending of colors that can't be produced by mixing colors on a palette. Since each small section was separated from the next by dry paper, I knew that the shapes would not merge. The process was reminiscent of creating a stained-glass window.

Once these sections were completely dry, I applied second and third layers to specific areas, using the same method. However, the water was placed in different designs on top of existing sections, allowing for more complex color tones and shapes. Negative painting was also employed to create the iris. Using the same palette and layering subtle complementary color allows for subtle tonal grays to develop in the painting. When necessary, I used a small brush to apply paint over the white paper lines that I had created.

Periodically stepping away from the painting and observing its progress helped me evaluate the success of my underlying intention. I wanted to convey the sense that these three beautiful compositional elements (river, flowers and sand) were so intertwined that any one of the three could not survive without the others. Cool blue and grayed colors, representing the water, offset the warmer oranges of the sandy riverbed and allowed for the creation of strong value contrasts to lead the eye through the painting while sustaining the design harmony which emulates the wonder of nature.

Watercolor palette: Burnt Orange, Burnt Sienna, Cobalt Blue, Green Gold, Permanent Orange, Phthalo Blue, Quinacridone Magenta, Ultramarine Violet

Iris Abstract • Carole A. Burval, TWSA, WHS, MDWS ❯
Watercolor on Winsor & Newton 140-lb. (300gsm) cold-pressed paper • 9½" × 7½" (24cm ×19cm)

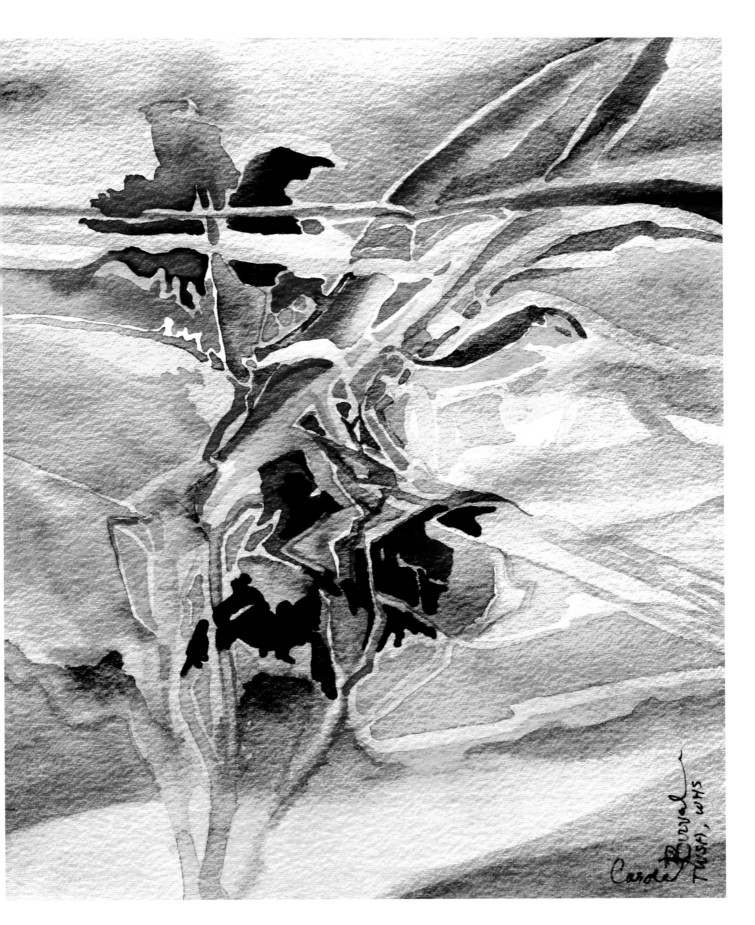

Elizabeth Ashauer

I used Arches 140-lb. (300gsm) cold-pressed paper for this painting. I chose three different transparent watercolors to use. I put each color in a spray bottle and added some water. Next, I sprayed the paper completely with clear water. Then, I sprayed the three colors on the paper in a cruciform design. The paints flow and make varied shapes on the damp watercolor paper. Immediately, I placed plastic wrap, wax paper and cotton gauze in different areas over the entire paper.

When this was completely dry, I removed those pieces of texture items. Then I started the process of collaging. Using matte medium as my glue, I placed various pieces of real sheet music, shapes from napkins, and the piano keyboard image on the watercolor paper. I made the keyboard from a photo I had and printed it on rice paper. I also glued on small shapes from dried reeds that looked like small music staff notes.

Once dry, I painted on the large treble clef which brought the whole painting together.

⌃ Music, Music, Music • Elizabeth Ashauer
Transparent watercolor and collage on Arches 140-lb. (300gsm) cold-pressed paper • 29" × 37" (74cm × 94cm)

Selma Stern

<Tree of Life • Selma Stern, AWS
Mixed media, acrylic, collage and ink on
Rives BFK printmaking paper • 30" × 22"
(76cm × 56cm)

Several glazes of gold acrylic were applied to Rives BFK printmaking paper. After three glazes were painted, I began to paint in some acrylic greens, turquoises and browns. Using inks, I applied calligraphic lines with a small liner brush. Other lines were also added. Several layers of acrylic were put into the painting.

A tree shape began to emerge. Using acrylics again, I began to emphasize this format. I also applied rice-paper collage at this time.

Since I work intuitively, when a shape that pleases me emerges, I reinforce it. I added to this tree shape with more inks, collage and acrylic paints. I then reinforced the golden background by applying another glaze of color.

Mary Lou Osborne

The process I use for developing a painting is to pour paints instead of using a brush. I find it produces very exciting colors and can be used on canvas or watercolor paper. I have poured on both with equal success. It is my goal to paint that which would create emotion. Sometimes that is a quiet and thoughtful mood and other times it is exciting and joyful. The first decision I make before starting a painting is to choose my colors. By pouring paints, it is important to choose colors that will blend together and complement each other. I have also found that the cool colors create quiet or thoughtful feelings, whereas the warm colors create excitement. I want each piece to exhibit a feeling of mystery to the viewer.

I have converted part of my garage into a "pouring room" with plastic on the floor for any drips or spills. I have four wooden stands—these can be old stools, boxes or any garage-sale item that is wooden, so you can staple to them. At this point, I have done a quick sketch just to give me a sense of design. For this painting, I used Fredrix Ultra Smooth Portrait Unstretched canvas. I mix my paints using Golden fluid acrylics, as they are very transparent. I mix them with distilled water and keep the mixture fluid, about the consistency of light cream. Close at hand is a pitcher of clean water, several brushes, paper towels and tweezers (in case something gets in the paint). I staple three corners of the canvas to different wooden stands, creating a hammock-curved canvas. I then position the wooden stands to control the run-off of the paint. I put a large plastic tub under the run-off area. The paints are then poured from my jars. I follow this with a small amount of water over the paint. I carefully dry it on a low setting with a hair dryer. Then I must decide if I want the paint to mix on the canvas or if I want to let it dry and then change the position of the canvas for more pours.

In this painting, I let each layer dry and then rotated the canvas to pour again. I made several turns and used different motions to get the shapes I wanted. After a few turns, I used a small viewfinder to block out all but the design. This can also be done between rotations. I lay the canvas on the floor and look through the viewfinder to decide where I want to pour next. I also keep a mat close at hand to put over the artwork to see how it will look framed. This helps me decide if I need to crop the painting. After completing the work, I mat and frame the piece. I use white chalk to decide where to frame the canvas.

This is such an exciting way to create a piece of art. Your work can never be duplicated, even by yourself. But remember, the unexpected is the norm.

^ Balloon Sail • Mary Lou Osborne, ISEA, SWA
Acrylic on canvas • 27" × 34" (69cm × 86cm)

Betty Jameson

For my support, I used a full sheet of Arches 140-lb. (300gsm) cold-pressed paper. I tore large, medium and small shapes out of rice paper. Some were curved and some were oblong. A thin line of water applied with a small brush made the tearing easier. I arranged the shapes on my Arches paper until I felt I had a strong design. Then I squirted the shapes lightly with water so they would adhere to the paper.

Meanwhile, I mixed single-color combinations of Golden fluid acrylic paint, Dr. Ph. Martin's acrylic ink and cold-water liquid dye, and water in plastic cups. For my lightest color, I chose a mixture of Golden Quinacridone Gold, Dr. Ph. Martin's Lemon Yellow acrylic ink, and Canary Yellow dye. For my medium color mixture, I selected Golden Napthol Red, Dr. Ph. Martin's Bright Orange acrylic ink and Orange-Red dye. For the darkest mixture, I combined Golden Phthalo Blue, Dr. Ph. Martin's Cerulean Blue acrylic ink, and Cerulean Blue liquid dye. I also made a mixture of Golden Ultramarine Blue, Dr. Ph. Martin's Deep Blue acrylic ink and Navy Blue liquid dye.

Before starting, I covered my working surface with plastic and placed strips of paper towels under my Arches paper. I pulled on surgeon's gloves, picked up the yellow mixture, and poured it over the surface of the paper. I quickly tipped the paper and moved the color with my gloved fingers, leaving some white and squirting with water to make the color run. I followed that with the red mixture proceeding the same way, blotting with the paper towels when necessary.

Next, I poured on the Phthalo Blue mixture, keeping most of it to the edges with a few splashes down the middle. I moved the blues to the outside edges with my fingers and didn't move the paper so the blue wouldn't overwhelm the other colors. I finished by pouring the Ultramarine Blue mixture judiciously and sparingly. After blotting in a few places, I let the painting dry until it was just barely damp, which can take anywhere from fifteen minutes to one hour, depending on the humidity. Then I carefully peeled off the rice paper and placed it on plastic to dry.

When all was thoroughly dry, I examined my design and decided to glue most of the rice paper back on, but offset it somewhat to create an echo shape around the edges. I used a watered-down mixture of Sobo glue, which I applied to the back of each piece of rice paper with a brush. Then I use a brayer over a paper towel to adhere the rice paper firmly.

When all was dry, I used a brush and dark blues to heighten the darker areas. I may go back and add some other colors to get rid of white spots and shapes that are distracting.

Heart Throb got its name from the large red heart shape in the center.

Heart Throb • Betty Jameson, ISEA, TWS >
Acrylic and collage on Arches 140-lb. (300gsm) cold-pressed paper • 30" × 22" (76cm × 56cm)

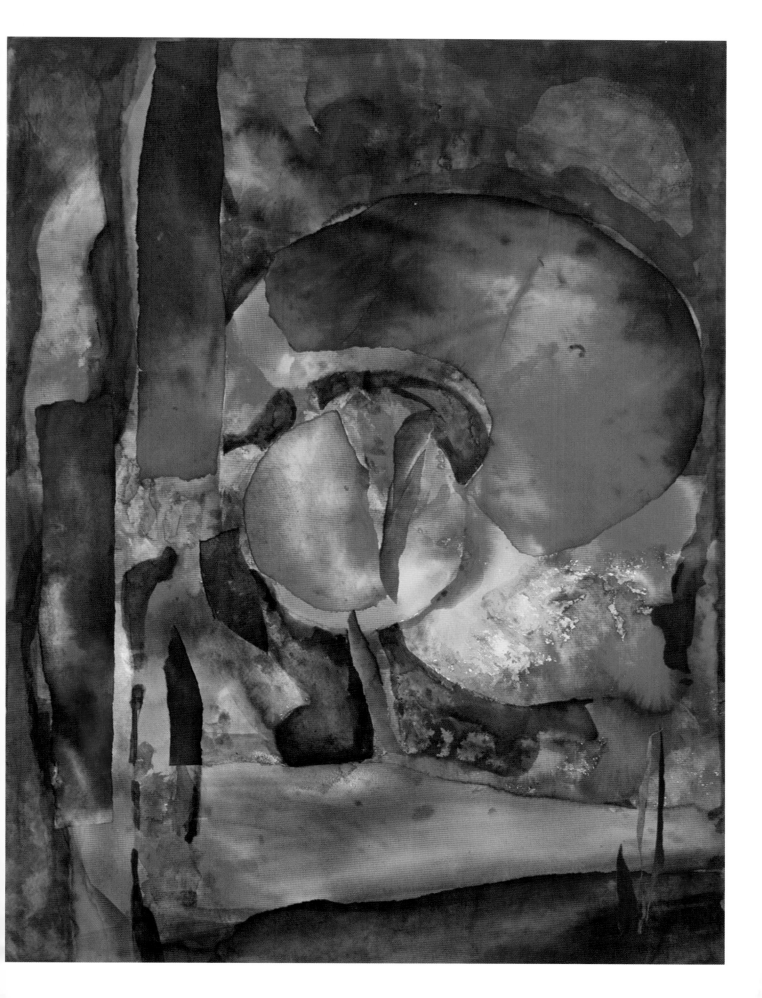

Carol Staub

This particular piece stemmed from having just completed teaching a workshop. I wanted to use the sample papers and demo pieces that I had taught in class. I started with a 20" × 20" (51cm × 51cm) stretched canvas (1½" [38mm] deep), which I then painted black with Bob Ross black gesso. The papers that you see on the left side, right side, and bottom, and in the grid were all prepainted using a combination of Burnt Umber, Titan Buff, Carbon Black, and white gesso.

The papers were torn and adhered to the canvas using Golden heavy gel gloss medium. As I arranged and adhered the papers to the canvas, I was careful to leave the inside edges of the papers unattached, thereby allowing me to tuck my forthcoming grid underneath and then adhere the grid as well as the edges of the other paper.

After all this had dried, I used a stamp (with acrylic paint) to place the number 5 in several places on the canvas. I then used a palette knife and applied thin layers of crackle paste to various spots on the canvas. After this was dry, I again used a palette knife to apply Liquitex Black Lava in various places on the canvas. The X and O as well as the numbers in the grid were applied with an oil pastel stick.

After checking everything and touching up here and there (mostly the Black Lava and Golden Crackle Paste) until I was satisfied, I let everything dry thoroughly. I then used a palette knife and covered the whole piece with a layer of Golden soft gel gloss medium. When this was totally dry after a few days, I added the finishing touch using the metal strip and the little set of keys.

⌃ Environmental Series No. 5 • Carol Staub, ISEA, ISAP
Mixed media on canvas • 20" × 20" (51cm × 51cm)

Carol Z. Brody

This painting is part of a series in which I have tried to create the look of collage using only watercolor. Painting it is like solving a puzzle, because I do not draw my shapes beforehand, and must "find" them as I go along. Here I have used a broader palette than usual, pushing myself to explore new color combinations.

I began this painting on a dry sheet of Arches 140-lb. (300gsm) cold-pressed paper, by working with a 1½-inch (38mm) brush, making large, slashing marks with water. Initially, I wet only the portions of the paper which have color in them, the "party papers," and then floated colors—pinks, yellows, magentas and browns—into the wet areas, coaxing them to run and mix into one another by tipping my board.

After this soft underpainting had dried, I began to "find" shapes, which became my papers, and I negatively glazed around each one to define it, drying it with a hair dryer afterward. I always use my hands to help me visualize a shape and where it should go, and occasionally will draw it lightly in pencil before painting it, always erasing the pencil afterward. When I had done many of these, I began to carefully paint in some of the patterns, using them to give direction and emphasis to the papers. Some designs were achieved by spraying or lifting through doilies or screens. At this point, I added a few greens to the patterns for contrast.

As I worked, I continually evaluated my painting, placing it on the floor with a mat around it. When I was satisfied with the papers, I carefully drew in the ribbons, revising them many times before painting them, so that they would have a casual feeling and look as if they were intertwined in some of the papers and in each other. The ribbons serve to add contrast to the somewhat rectangular shapes of the papers, and they help to carry the viewer's eye through the work.

I wanted this painting to carry a feeling of energy and somewhat chaotic movement in it, while conveying a sense of delight and discovery to the viewer.

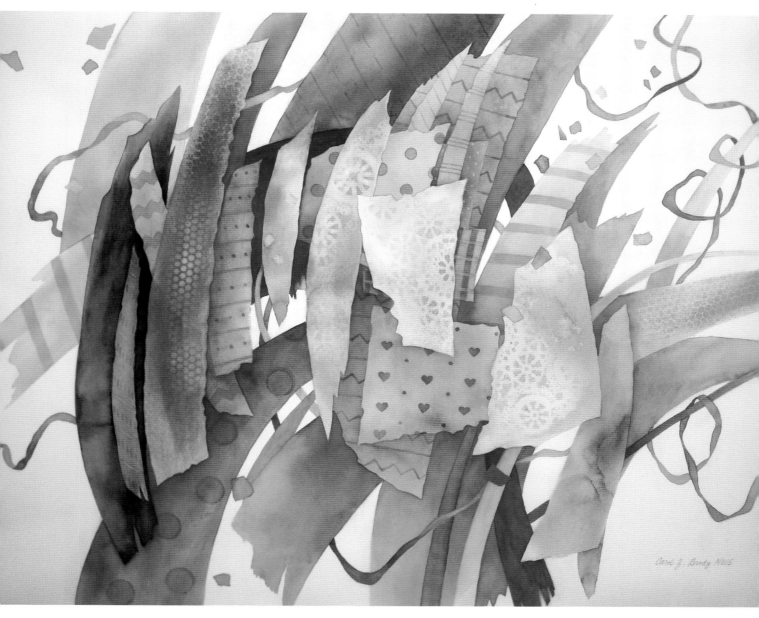

∧ **Party Papers and Ribbons III** • Carol Z. Brody, NWS
Watercolor on Arches 140-lb. (300gsm) cold-pressed paper • 22" × 30" (56cm × 76cm)

Laura Barbosa

I created *Stigmata* on Fredrix Gallery Wrap stretched canvas, medium texture and 100 percent cotton duck. This work of art is full of different color combinations and techniques. To start, I set up my table with all my materials, including ten soft-body acrylic colors, one palette knife (6¼-inch [16cm] blade), one quart of Liquitex modeling paste, one pint of Liquitex pouring medium, matte acrylic varnish, a paper plate, cellulose sponge, a paper cup for mixing and a glass of water for cleaning and thinning. Also don't forget an old rag for wiping the paste off your hands—it comes in handy.

Next, I decided the colors I wanted to mix together or put on my canvas. I chose Marine Blue to start. I put one tablespoon of modeling paste on my paper plate with a half tablespoon of acrylic color, then mixed them together with my palette knife. After I was satisfied with the color hue, I started spackling my canvas by smoothing the color mixture wherever I wanted it to go, repeating this step with different colors until the whole canvas was covered. (Remember when mixing white modeling paste with color, your color will always come out lighter.) I finished the first layer and laid the canvas flat. After it was completely dry, I gave it a coat of UV protective varnish using a damp cellulose sponge.

I have learned from my past experiences that using gloss medium is easy to do if you coat your surface with varnish first. This allows the medium to travel quickly over the surface for better control.

The last step was applying my gloss top design. I used dark purple acrylic paint and a half cup of gloss pouring medium and mixed them together in a plastic cup with my palette knife. After I let the air bubbles settle, I poured the liquid medium over one side of my colored canvas and allowed it to drip down to my desired length. After the liquid medium dried, I repeated it on the other side, using orange paint. The effect I wanted to achieve was better than I thought it would be, and *Stigmata* became a very popular abstract.

∧ Stigmata • Laura Barbosa
Acrylic and mixed media on canvas • 24" × 36" (61cm × 91cm)

Dolores Ann Ziegler

I started this painting on my favorite paper, Aquarius II, 80-lb. (170gsm). When using this paper, I always coat it first with matte medium. When the paper is dry, I coat it again with Golden Quinacridone Gold or Crimson. Once that is dry, I spray it with isopropyl alcohol and leave it to dry again. This gives the painting a sturdy background and layer that may become part of the composition.

To begin the flow method, I always start in the upper right corner of the paper. Now comes the drama of rich and deep color, while achieving balance and excitement.

The use of gold in several ways, such as spraying, painting and lining, now gives energy and freedom of expression. I used 1-inch (2.5cm) and 2-inch (5cm) watercolor brushes for that smooth effect.

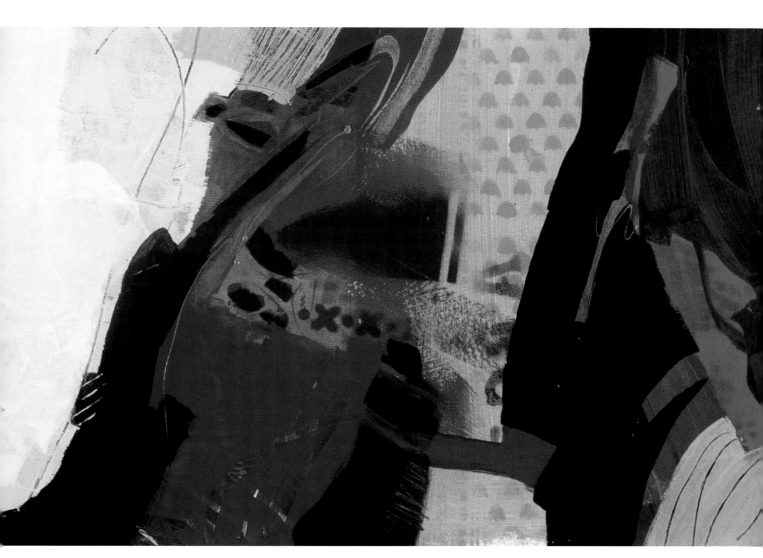

⌃ Flow • Dolores Ann Ziegler, AWS, NWS
Acrylic on Aquarius II 80-lb. (170gsm) paper • 12" × 17" (30cm × 43cm)

Jane R. Hofstetter

I began this painting as an abstract demonstration for my master painting class. One watercolor paper was a full sheet of Winsor & Newton 300-lb. (640gsm) rough paper, along with a 140-lb. (300gsm) hot-pressed sheet glued on top of it.

The smaller paper had been prepared first, following this process: I used a children's hard swimming pool outdoors with 4 or 5 inches (10–13cm) of water in it. I sprinkled powdered charcoal on top of the pool water. Then I painted clean water on the papers where I did not want the charcoal to stick, and smoothly pulled the papers across the charcoal-water surface in the pool. Then I swished the paper across the water. Many wonderful patterns were created. (When the papers are dry, it is necessary to spray them with workable fixative to hold the charcoal in place.)

Before I began painting, I used acid-free Yes! glue and weighted the charcoaled paper to the plain watercolor sheet for a week to be sure it was secure and flat.

At my class demonstration, I first taped off a 10" × 10" (25cm × 25cm) area on the hot-pressed paper using blue painter's tape. Then, I enjoyed using India ink and watercolor while spraying with water and letting the colors blend and run over both papers. When this was dry, I took off the masked tape area and let paint run into and out of the square area until I was satisfied.

The class saw a sunken pirate ship in the upper part of the painting and an opened treasure chest in the squared off area. Thus the title *Crosscurrents*.

Crosscurrents • Jane R. Hofstetter, NWS ❯
Mixed media on Winsor & Newton 300-lb. (640gsm) rough paper • 30" × 22" (76cm × 56cm)

Sheila Grodsky

I enjoy taking an old painting and reworking it, since it already has the germ of an idea and some color and textures with which to work. The original painting was painted on a full sheet of Morilla, which has a wonderful pebbly surface for acrylics. I had originally played with Golden fluid acrylics making spontaneous marks and gestures. It began to look like rocks and water on the edge of the sea. I put it aside to dry and forgot about it for a while.

When I pulled it out of my pile of works several months later, I decided to give it another chance, pushing the idea of rocks and water along an Eastern coastline. Using some reference material of my own, I began to glaze areas with thinned-down fluid acrylics. My palette consisted of Quinacridone Crimson, Quinacridone Gold, Phthalo Turquoise, Sap Green, Cerulean Blue, Yellow-Orange Azo and gesso.

Each time I laid down a glaze, I sprayed it lightly with isopropyl alcohol, allowing each area to dry. As I worked, the shapes of underlying rocks emerged. The rocks developed so that they appeared to stack up and create a feeling of perspective and distance.

At this point, for the sake of composition and color distribution, I cropped the work so that it had a slightly different format. I painted a dark sky for dramatic effect. As I did so, distant hills were carved out with opaques. To make opaque tints, I mixed the acrylics with white gesso.

The foam-and-wave effect was achieved by pouring this wash of gesso over the edges of the rocks and then spraying with isopropyl alcohol. In some areas, paper towels and tissues were pressed into the paint layers for texture.

Near the completion of the work, it still felt spontaneous and wet, which is what I had hoped for. I did some fine-tuning with dark glazes for contrast where the values were too close.

This painting expresses my love of the interaction between the forces of nature, so awesome and beautiful. It catches the moment when a wave breaks against a rugged shore while teaming with sea life within.

Get free desktop wallpaper and a bonus demo at artistnetwork.com/journeystoabstraction.

Coastal Layers • Sheila Grodsky
Acrylic on Morilla paper • 20" × 22" (51cm × 56cm)

Dianne S. Trabbic

The words "water media painter" tell the tale. I am not a purest. I will use any means to achieve a successful painting.

This painting started out as watercolor on Waterford l40-lb. (300gsm) cold-pressed paper. It was a total disaster. I put it into the bathtub, which Waterford paper accepts with softening effects, and scrubbed it off. I had a sort of purple-blue overtone. After letting it dry, I started to outline subtle shapes using charcoal. I also used a rigger brush with palette gray and drew lines to indicate movement. At this point I had nothing to lose. I started to paint negatively around the shapes I had drawn with grays mixed with Holbein Rose Madder and Viridian. With Cobalt Blue and Cadmium Orange, I painted more negative shapes, leaving the purple-blue overtone as my positive shapes.

As the painting progressed, I continued to paint negatively using Chinese White. I always try to keep my outside shapes simple using the open composition theory of "leaving the smaller shapes to the interior." Using lost and found lines with charcoal, I established my original shapes. Spots of color and line were also achieved with Caran d'Ache crayons. These crayons are great for sparking darks and adding a little dash of excitement.

Saving and reusing things that make marks is one of my favorite things to do. I used the bottom of fiber egg cartons as a stamp in this painting. The brushes I use vary. I like the lighter-weight ones, usually a 2-inch (51mm), a 1½-inch (38mm), and a ¾-inch (19mm) brush. The ¾-inch brush is a favorite of mine.

When I'm working with a painting, I bring it into the living room with a mat around it. As I walk by it I will glance at it. After a couple days of doing this, I will see something that doesn't fit or could be improved upon. There is a danger in doing this, because painting it into the ground is a great possibility. By using restraint, one can overcome this.

Pushed By The Wind • Dianne S. Trabbic, AWS, OWS >
Mixed media on Waterford l40-lb. (300gsm) cold-pressed paper • 30" × 22" (76cm × 56cm)

Get free desktop wallpaper and a bonus demo at artistnetwork.com/journeystoabstraction.

Ginnie Cappaert

This mixed-media painting is created on a gallery wrap canvas. However, I have done the same technique on Winsor & Newton 300-lb. (640gsm) hot-pressed watercolor paper. I start my pieces by collaging directly on the canvas with pieces of paper torn into large and small pieces, including scraps which will be painted over but will leave an element of collaged texture, as well as marbled and decorative papers. I adhere these to the canvas surface with a gel medium and allow it to dry. After the collaged papers are dry, I then create more texture to the base by mixing a little gesso with a lightweight joint compound (found at the hardware store). I spread this mixture with a spatula onto the canvas, taking care around the collaged papers. I then create shapes with the mixture, scrape out lines, press bubble wrap and window screening into the mixture while it is still workable—all to create more texture. I then allow this to dry.

Now the painting starts. Because I call these mixed-media paintings, I feel unlimited as to the types of paints I can use. I start intuitively painting layer upon layer of different acrylic paints, usually starting with black or brown colors and lightening the shades as I go. I also love to use metallic paints, oftentimes drybrushing them into areas of the painting. Usually my palette is earth-tone colors. Sometimes I use my hands to spread the paint, sometimes I use brushes or scrapers to apply or remove layers of paint. Usually thirty layers later, I have a very subtle yet strong composition of color, line and paint. I also scrape, rub and soften or delete areas of the paintings to create subtle variations in the colors as well as soft and hard edges.

Because I am a journal writer, I often like to include thoughts and words from my journal into my artwork. The large space in the center is written on directly with a charcoal artist pencil. I also have found pastel pencils, markers and other artist pens work as well. As I am working, I find that I have areas like this that I want to keep, so I spray it with a workable fixative so that it does not smudge.

I take soft pastels, oil pastels or other mark-making supplies to create circles, dots, lines, etc.—all to enhance the overall composition and to keep the viewer's eye traveling throughout the piece.

Many of my pieces contain little books and keys to symbolize knowledge and secrets. To make the little book, I use decorative papers and old book pages to bind a miniature book. I then tie it with wire or string and attach a key, either old or purchased. This little book is then glued onto the canvas as a finishing element. All sides of the gallery wrap canvas are then painted black so the piece is finished on the edges and does not need to be framed.

The artwork is then sprayed with an art varnish to protect the piece.

Get free desktop wallpaper and a bonus demo at artistnetwork.com/journeystoabstraction.

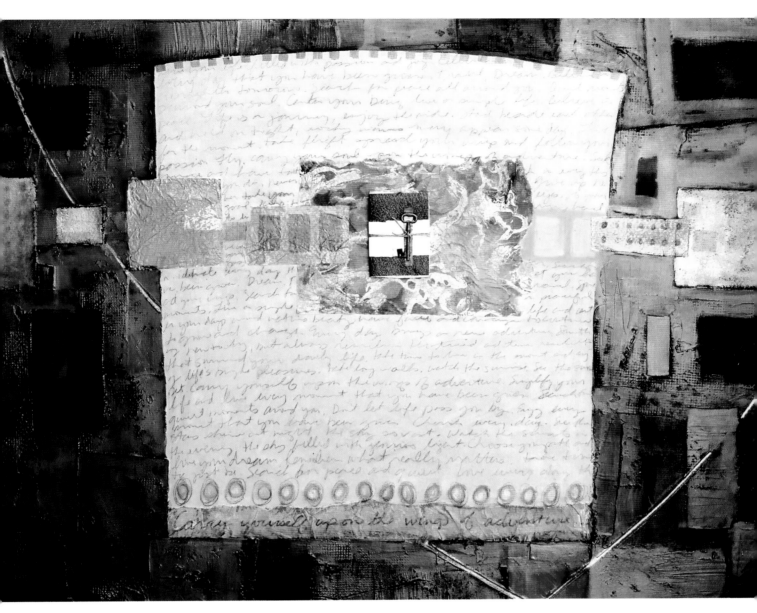

Carry Yourself Upon the Wings of Adventure • Ginnie Cappaert, NWS, ISAP
Mixed media on canvas • 30" × 40" × 2" (76cm × 102cm × 5cm)

Helen Wheatley

This painting was created with transparent watercolors on Arches 140-lb. (300gsm) cold-pressed paper, through a multiple-step process.

In the initial step, I use primary colors (red, yellow and blue) and liquefy the tube paints by squeezing them into small spray bottles, adding some water and shaking well. Then I randomly place items on the watercolor paper and spray over them. Some items are solid—keys and small wooden blocks—while others include open spaces, such as doilies, woven mats and washers. I also use some of these items as stamps. In this way, you can change their image from positive to negative. After spraying them, turn them over and press onto the paper. You can reuse items to create some repetition. There are dozens of things around the house that are perfect for this technique. It just takes an open mind and a little time to look around, and you will find lots of things to use. After allowing everything to dry completely, I have a crazy, mixed-up page full of wonderful shapes, patterns and colors. There are different colors created wherever the sprays of primary colors overlap.

The second step is done independent of the first step. On a separate piece of paper, I create abstract designs involving geometric shapes and some straight and curved lines. I use a small sketch book to create thumbnail-sized designs. I've done many more of these than I've used, because I just enjoy doing them. I reproduce each drawing several times, because the next step is to fill them in with shading to create a value sketch. I only use three values—light, medium and dark—but I place them in different areas in each version of the sketch. Then I look at all of the variations and select one that reads as the strongest and most interesting.

Once I've selected the version of the sketch with the best value plan, I transfer the drawing to the spray-painted paper using chalk. (I use chalk because I can easily wipe it off later, and I paint those lines white.) The reproduction of the sketch does not have to be perfect, and I never try to make it work with the underlying painting in any way. In these paintings, I decided to assign the values specific colors. So the light value became gold, the middle value became red and the dark value became purple. I allow myself to vary the value of the color within the space, and sometimes I leave some areas unpainted. This is when I finally start working with the background, emphasizing some shapes, shadowing some, and creating some shapes within shapes. I really take my time deciding what to do in this step because it is these details that really make the paintings interesting.

Finally, I outline most of the abstract design in white using multiple layers of watercolor. I don't use opaque paint, so the layering is necessary to make the white show.

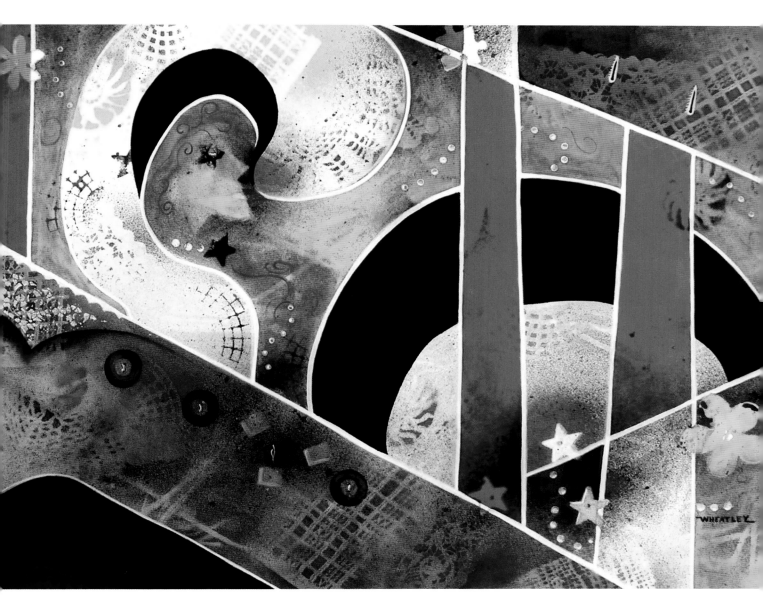

My Fair Lady • Helen Wheatley
Transparent watercolor on Arches 140-lb. (300gsm) cold-pressed paper • 22" × 30" (56cm × 76cm)

Victoria Lenne

What If? began as an underpainting in watercolor, allowing the colors to flow and mix at will on the heavily wetted Arches paper. I used earth tones to set the mood for what was to become a landscape. After the initial washes were allowed to dry, I used vine charcoal in white and black to block in structural elements with lines, which might suggest human habitation. Knowing that the integrity of the lines would be impacted with further washes, I did not worry about suggesting anything recognizable.

Using Liquitex gesso thinned with about 50 percent distilled water, I washed the gesso across the entire surface of the painting. I decided to use water vs. medium to thin the gesso, as it tends to create a more matte surface. Watercolor began to mix with the gesso, and the vine charcoal lines softened. Using a hake brush to apply the gesso mixture, I was careful not to use too many strokes in the application, maintaining the watercolor and charcoal lines. Get in, get out, and let it dry. Because Liquitex uses a greater percentage of marble dust in its compound, I end up with a better visual texture of strokes and grittiness.

Once everything was thoroughly dry, I came back into the painting with acrylics thinned with water. I re-wet the entire surface and began to wash in colors that built the intensity and value of the subject matter. I allowed some of the washes to flow, and other areas I sprayed with 91 percent isopropyl alcohol to texture the washes. When I was satisfied with the overall movement of color and texture, I let it all dry.

I began to see suggestions of distant hills, brokenness and a blue vase in the foreground. I enhanced these by direct painting, adding the suggestion of dried cattails and leaves. Having been fortunate enough to live all over the USA and overseas, I have experienced many types of climate and terrain. This seems to manifest in my work repeatedly, and the bird came about for that reason. It is not an elegant, beautiful bird, but an ordinary and common bird. It was looking outwardly, to leave once again, perhaps. Contrary to "good design," I placed the figure of the bird as I wished it to be. I finalized the painting by adding Native American designs using stamps I carved myself. Then I used the linear elements in pen across the center section, suggesting woven threads. Perhaps this alludes to the overall Native American sensibility that I feel this painting communicates.

What If? • Victoria Lenne, GWS, ISEA ❯
Watercolor and mixed media on Arches 300-lb. (640gsm) cold-pressed watercolor paper • 26" × 20" (66cm × 51cm)

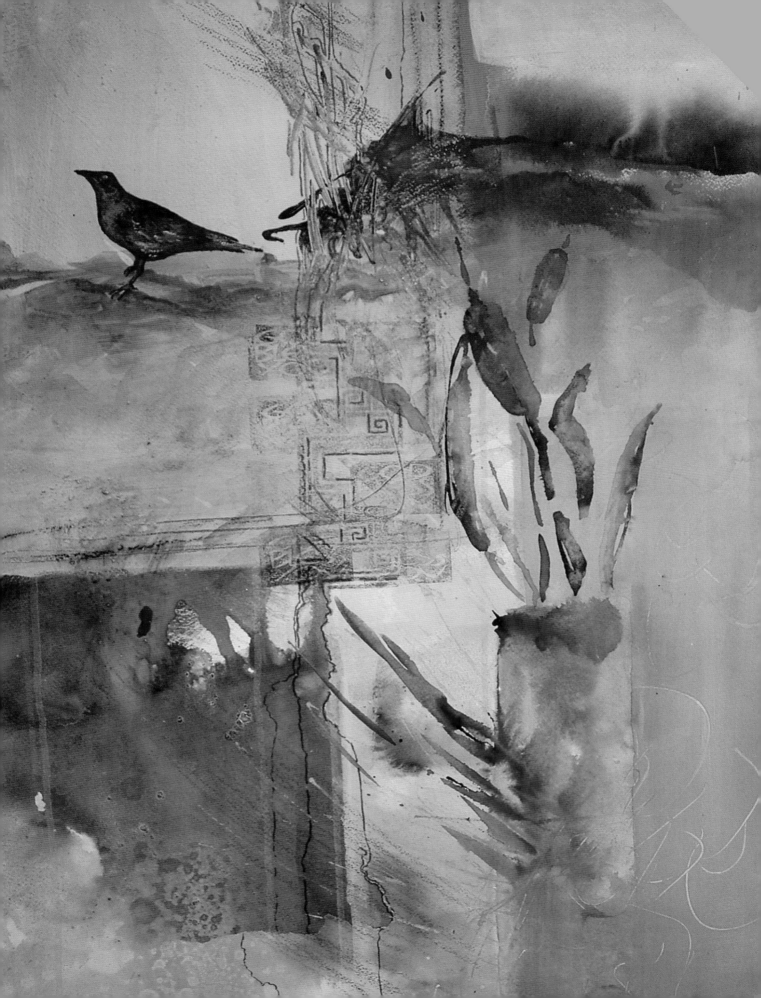

nell Livingston

The new series I am working on is called *Poems of the Desert*. It is a series based on ideas about the desert as an actual place, or a metaphor for a stage in the creative process. These visual poems are collected abstract shapes, and color impressions from the desert. It is here I invite the viewer to join me in the endless dream, for I have found anything is possible in the desert.

Charting the grid: I begin with Arches 140-lb. (300gsm) rough watercolor paper. I use a Prism colored pencil, which acts as a resist to put my drawing on the paper. I might use a white pencil or a complementary color to the finished painting. When you work with watercolor in the traditional way, first you put the drawing on the paper, then you wet the paper with a sponge. You often lose your drawing this way, but with the use of a resist, the drawing remains.

Wetting and reclaiming the paper: The paper must be perfectly wet on both sides. Then the paper is "reclaimed" and all excess water is squeezed out from underneath. There should be no shiny spots or reflections on the paper when it is held up to light. This way, when the paint is applied, it will not spread.

Beginning the painting: Gouache is mixed with water to the consistency of thick cream. Using a 2-inch (51mm) German wash brush, the underpainting is applied. Then the painting is finished with a combination of Winsor & Newton watercolor and gouache paint.

︿ Desert Poem #234 • Annell Livingston
Gouache on Arches 140-lb. (300gsm) rough watercolor paper • 8" × 8" (20cm × 20cm)

Get free desktop wallpaper and a bonus demo at artistnetwork.com/journeystoabstraction.

B.J. Adams

Starting with a small piece of 12-ounce cotton canvas, I began to stitch in an unplanned manner with size 50 thread count on my sewing machine. I wanted to use my industrial machine freehand, so to speak, so the satin or zigzag stitching just wandered filling in with colors I enjoy. I did not plan to use subtle colors as I wanted an explosion of color.

I stopped stitching once I had filled the canvas with a composition I thought was effective. Since machine stitching distorts any fabric, I needed to trim the embroidered canvas to an even rectangle. After the canvas and thread were trimmed, I added Fray Check (a liquid-plastic solution that prevents fabric fraying) to the cut edges and let that dry.

I decided the piece would look better with some sort of an extended background. I painted a larger piece of canvas with a combination of acrylic paints and Aquarelle watercolor crayons. I planned the painting to extend the stitched colors to form a sort of frame. I placed the small embroidered canvas in the center of the larger painted canvas and proceeded to stitch it down. Some of the stitched lines in the small piece were extended out over the painted canvas and that held it to the background.

To finish the artwork I stapled the painted and embroidered canvas to wood stretchers so it could be hung by wire.

⌃ Plot Twists • B.J. Adams
Mixed media and fiber on canvas • 16" × 18" (41cm × 46cm)

ə St. John

I began this painting on the soft surface of Rives BFK printmaking paper. I was experimenting with stencils cut out of old mat board. The idea was to cut a stencil that looked like a window. I used a ruler to draw the exact size and number of window panes. I cut each section out with an X-Acto knife.

Next I used ½-inch (12mm) blue painter's tape and taped a border 1-inch (35mm) inside the edge of the paper. The use of painter's tape for delicate surfaces will protect the paper from tearing when it is removed carefully.

Using my pre-cut stencil, I placed it on the paper off-center to the left side. In *Rusty Window*, I used minimal color. By using a limited palette, I maintained the soft texture. I mixed Cobalt Blue with water and placed in a spray mister, testing the color to make sure it was very light blue. I sprayed through the stenciled window panes very lightly on a hit-and-miss basis. Next I spray-misted the edges of the paper where the painter's tape was placed.

After this dried, I removed the stencil. Using a ½-inch (12mm) flat, I painted areas within the window panes with Cobalt Blue, making some panes a little darker than others, and also saving the whites in areas. A charcoal pencil and a no. 2 pencil were used in the upper left corner and the middle of the top, as well as in the lower right corner and up the side of the painting. With the pencils, I formed small circles and ovals in varying sizes connecting some of the shapes. This takes some time to get it to look just right. The goal is to vary the soft and hard edges. Most of the edges are straight with the exception of the Burnt Sienna watercolor that seems to flow down from the rust.

The fun part was when it was time to glue on the pieces of rusty metal to achieve the texture of an old worn-out window and an interesting accent. The shapes and forms that emerge are more varied and interesting than anything I am able to paint. A thick tacky glue will hold the rusty pieces firmly in place. I added one larger piece of rust in the lower right corner of the painting. Three tiny pieces of rust were glued on the window's three hinges. Using Burnt Sienna, I brushed paint under each piece of rust on the hinges and a larger area under the upper rust pieces. In the lower right corner, I painted in a little Burnt Sienna broken-square shape.

The finishing touches include the collage of three 1-inch (25mm) blue squares from a failed painting that I had cut up. This painting really came together in the last stages.

See the Demonstrations section for Sue's step-by-step process to creating an abstract painting.

Rusty Window • Sue St. John, KWS ›
Watercolor and collage on Rives BFK paper • 30" × 22" (76cm × 56cm)

Georgia Mason

This is a mixed-media and collage painting which was done on a stretched canvas as the support. I began the piece with the upper left side, putting down the washi (rice) paper and the house. At that point, I had no particular theme in mind. The house gave me the thought of leaving home and travel. I started looking at my photographs and collected collage items to continue the theme. Several of the photos are from my trip to Italy with my daughter Miranda. Another one was taken in a cathedral in Santa Fe, New Mexico. I scanned the photographs and printed them on copy paper.

I used a mixture of half Golden matte medium with half Golden polymer gloss medium for adhering the papers to the support. The support was coated with this mixture at the beginning. Using this mixture allows me to layer over the items with other papers as well as paint over them.

In this piece, I used various washi papers, ink-stained tissue papers, and a few images cut from a magazine. I found a Camel matchbook on one of my daily walks and used the cover in this piece to represent travel. There is also a train ticket from Europe in the lower left corner. A piece of yarn adds a touch of line and possibly suggests a rail.

At the bottom is a paper doily. The layered image over the doily was created in the following manner: I scanned the photo of my daughter in Venice looking out across the water at St. Mark's Square. This image was printed on a piece of very thin washi paper that I adhered to a piece of freezer paper, which was cut in 8½" × 11" (22cm × 28cm) size, so that it could be used in the printer. With an iron, I sealed the outside edges of the washi paper to the shiny side of the freezer paper. The rice paper was then peeled off the freezer paper and layered over the paper doily with a coating of the mixture.

I used a variety of Golden fluid acrylic paints in the center of the piece to give an ancient feeling to the whole painting. I used several layers and allowed some to drip.

When I thought that the painting was done, I put a coat of the medium mixture over the entire piece to protect and seal it.

This painting is in the collection of LaVern "Skeet" Schmidt.

∧ Leaving Home to See the World • Georgia Mason
Mixed media and collage on canvas • 24" × 24" (61cm × 61cm)

Marie Cummings

Inside The Box was started on an old painting that was not working. Sometimes it is easier to have color down on paper or canvas rather than staring at a blank white sheet of paper. There is also an attitude that frees up your mind; you have something that is not working, so loosen up and play.

The yellow was the original color. I used blue painter's tape and tore it so that the edges would not be a straight line. I also put tape down on other parts of the painting. I used a glaze of Quinacridone Crimson covering the whole paper. I took the tape off after the layer was dry and moved it to another part of the painting, leaving the tape covering the yellow line across the top until the painting was done.

I made diamond shapes out of contact paper. I used the positive shape and put it down on the paper before covering the area with paint. The diamonds at the side of the painting were the negative part of the contact paper. I used it as a stencil and applied glass bead gel. The fan was made using an old credit card to move wet paint around. I try not to make these shapes uniform. Variation is important in a painting.

There is some fake writing that looks like symbols at the top of the painting. I use oil pastels for color and resist. I continued to layer paints, Quinacridone Gold and Phthalo Turquoise, letting each layer dry completely. I blocked out shapes of rectangles and squares. Also, I used isopropyl alcohol to make dots and a chopstick to draw into the paint. As the painting progressed, I intuitively knew where to add color or what to leave. In this process I used corrugated cardboard, put gesso on it and then I pressed it onto the top and bottom of the painting. The shadows around some of the shapes add depth to the painting. At the very end of the process, I carefully removed any blue tape or contact paper that was left.

I like the Golden fluid acrylics because they are transparent. They are also highly pigmented. They can be used either full strength or diluted with water or matte medium. If you have not tried these paints, the three colors I mentioned are great ones to start with. Unfortunately Golden does not make Quinacridone Gold any more. The new color is Quinacridone Nickel Azo Gold.

Inside the Box • Marie Cummings
Acrylic on Arches 140-lb. (300gsm) hot-pressed paper • 30" × 22" (76cm × 56cm)

Get free desktop wallpaper and a bonus demo at artistnetwork.com/journeystoabstraction.

Mira M. White

This artwork is on 4-ply museum board. Initially it was to be a sampler of a variety of resists, innovative templates and stenciling techniques.

Ripped masking tape, packing tape, letter stencils, paraffin and handcut templates were applied at intervals and sprayed with watercolor. I have used a variety of small sprayers and keep most of my colors in liquid form in sprayers just for this purpose. I also keep a group of acrylics in sprayers, and they have to be frequently unclogged.

I coated the piece with acrylic medium when I began applying collage materials, such as papers that have been altered by the application of water-based solvents. I then completed the piece with acrylic in sprayers and a final coat of polymer medium.

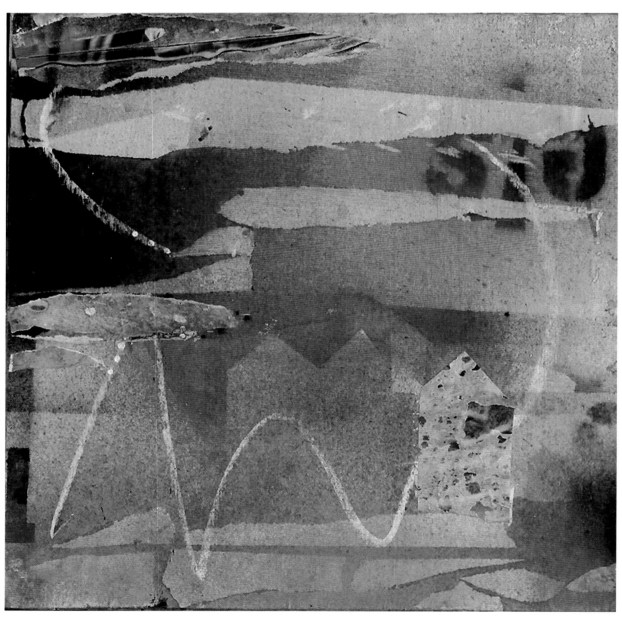

∧ Playful Moments • Mira M. White
Watercolor and mixed media on 4-ply museum board • 13" × 13" (33cm × 33cm)

Marilyn Gross

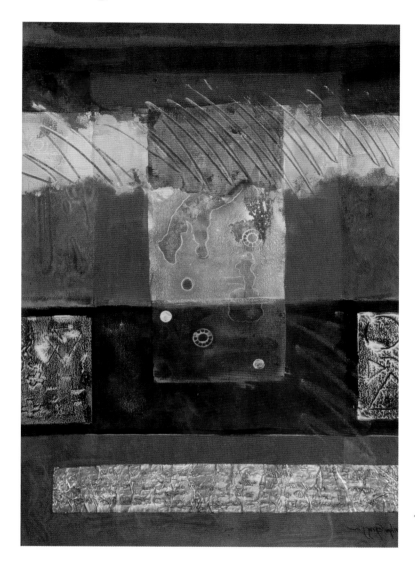

<Form & Meaning • Marilyn Gross, ISEA, SLMM
Mixed media on 140-lb. (300gsm) cold-pressed
watercolor paper • 30" × 22" (76cm × 56cm)

This painting was begun as I begin all of my work—by intuitively choosing a color and making a mark, which leads to the next color and the next mark, and on and on. The painting unfolds as a conversation between myself and what is happening on the paper before me. When I begin, I have no preconceived idea of what the painting will be, nor do I use any reference materials.

The pigments used in this painting are mostly fluid acrylics. The top light passage was done with thick white gesso. While the gesso was still wet, I scratched through it with my brush handle and left it to dry. A lighter, much thinner passage of gesso was painted vertically in the middle of the painting. After this was dry, parts of these shapes were glazed with color.

On either side toward the bottom half of the painting, I stamped two rectangular shapes using gesso and stamps that I had carved from pieces of mat board. The light band near the bottom of the painting is a piece of aluminum foil. I etched the foil with a dry ballpoint pen using abstract calligraphic shapes. The foil was supported on a lightly padded surface while etching. When complete, the foil was attached to the painting using gel medium. The foil was then glazed with color to integrate it into the painting.

After some additional glazing to balance the colors, the painting was complete.

Sharon Stone

Usually I have a concept or a partial plan or idea when I start a painting. Often it's a specific composition or structure, such as a cruciform or wedge or grid. I lean toward a grid composition, probably because I love lots of texture, color and pattern. The hard parts for me are the big shapes and the quiet spaces.

Occasionally, however, I just have to throw paint with no plan in mind. With this painting, I chose to pour ink instead. I started with Arches 140-lb. (300gsm) hot-pressed paper, brushed on some water and started pouring red, yellow, orange and turquoise ink. I let it blend, pushed it around some with the brush, and picked up the paper and let it run in different directions. When it reached the point of being totally wild with wonderful patterns and colors, I let it dry.

Once dry, it went up on the mantle of my living room fireplace so that I could study it every time I walked by. I decided it needed darks woven through it, so I added some. Then I studied it more. Most of the white paper had ended up in the top third of the painting, which was too much. There was a large piece of white in the middle of the top with small lines of color running through it, which made wonderful shapes that I didn't want to lose. There wasn't much white in the bottom, so I added more white shapes in Titanium White acrylic. I loved the white shapes! After that, I added a few turquoise shapes into the white areas and a few other places to make it weave through the painting.

Finally, some of the white in the top had to go, including most of my big white shape in the center. It was really wild and I loved it; however, I knew I had to calm it down some. So I went over some of the areas with a wash of red acrylic, and it all came together.

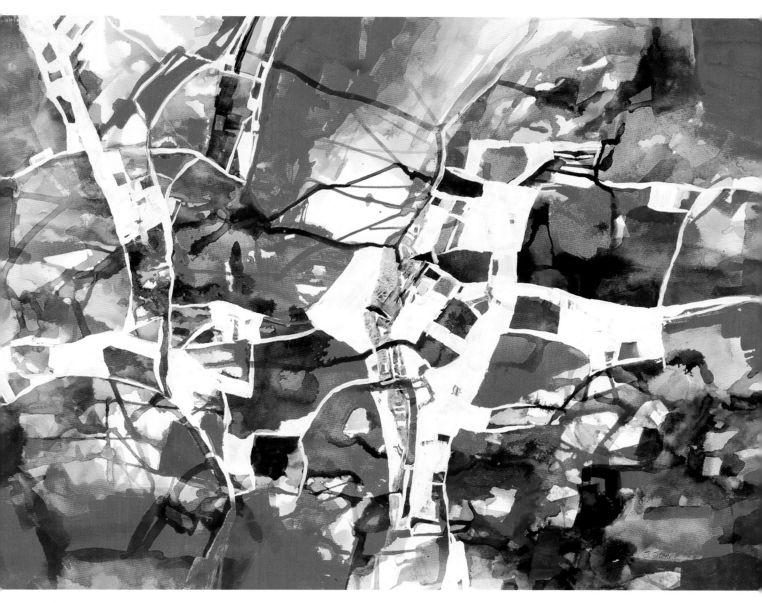

▲ **Passageways** • Sharon Stone, SWS
Mixed media on Arches 140-lb. (300gsm) hot-pressed paper • 22" × 30" (56cm × 76cm)

Betty Braig

The inspiration for *Hot for Mars* came from a fascination with the universal spiral. The spiral is found in deep space movements and in creatures from the ocean depths. The visual content of this abstract painting focuses on that connection.

I started the painting by using paraffin to wax the edges of a 20" × 30" (51cm × 76cm) Strathmore hot-pressed watercolor board. Then I prepared a Liquitex acrylic wash in 6 oz. plastic bottles of one-third paint and two-thirds water. I used the same palette as I did for the painting *Archives*, also found in this book. The mixture was shaken well to the consistency of thin cream. I added water if needed. I often make larger batches of this paint mixture and let it age. The aged pigments separate better from the water on the hot-pressed board, resulting in interesting texture.

While vertically tilting the board over a plastic wallpaper tub, I gently poured a horizontal path of water over the surface. I then poured Yellow Oxide, Brilliant Purple and Cobalt Blue on the water path and watched it blend over the surface. In places where the poured acrylic was too opaque, I washed it off with water. While the surface was wet, I used plastic spatulas to start blocking out the design by gently scraping through the wash, creating light cubed spaces. Lines of gray-blues and gold were formed around the cubed edges. These served as organized layers of structure for the abstract design. A paper towel was used to lift off the horizon. For more texture, a spritz of isopropyl alcohol created white patterns, and a spatter of Scarlet Lake watercolor was lightly tapped over the damp panel. The board was laid flat to dry.

The nautilus was penciled in over the dry acrylic wash. At this point, the paint was changed from acrylic to watercolor using the same palette. My focus was on the random patterns created from the pouring process. Intuitively and instinctively, I enhanced the elements by darkening and lightening the values of color to animate the design. A Scarlet Lake linear vein was passed through the nautilus rooms and waved to the sky. The large inner window was contained and floated in an atmosphere of opaque acrylic variegated grays, then set in scribbled sea weeds. The finishing touch was placing the red-hot circle of Mars in deep space.

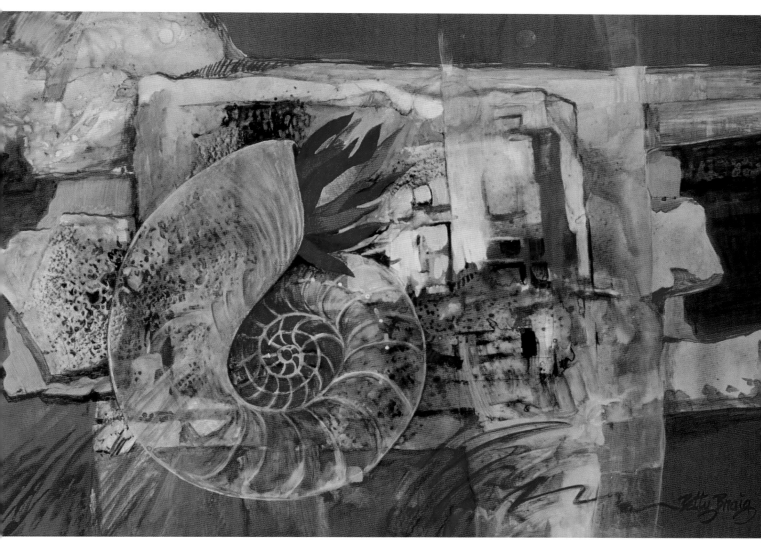

Hot for Mars • Betty Braig, ISEA, MOWS
Mixed media on Strathmore hot-pressed watercolor board • 20" × 30" (51cm × 76cm)

Katharine A. Cartwright

The Zeroth Law of Thermodynamics is part of *The Laws of Nature* series, which is a comment on the limitations of man's technological inventions by the physical laws that govern our universe. The zeroth law of thermodynamics states that if two bodies are both in thermal equilibrium with a third body, then all three bodies are in thermal equilibrium.

I selected a full sheet of Arches 140-lb. (300gsm) cold-pressed paper and soaked it in lukewarm water for a half hour, then stapled it to a board where it dried flat. Unlike other series paintings that I've done, I had no visual references for the paintings in this series. Therefore, I began designing the painting by first thinking about the meaning of the physical law I wanted to interpret, and then drafting a thumbnail sketch of the general design in only three or four forms. Next, I found the location for those forms by using the Rule of Thirds and began drawing the first form directly onto the watercolor paper in pencil. I had no preconceived notion of what my painting would be, and allowed my intuition to take over. Once I completed one form, my imagination lead me to create the next, and the one after, and so on. All the while I kept looking to establish variety, unity, visual flow and the meaning of the law. When the composition looked balanced in all directions, I stopped drawing.

Next, I selected three to five hues of transparent watercolor paint for my palette. This limited palette provided the advantage of unifying my work. There is no formula for the colors that I selected, but I always try to include warm and cool colors as well as complements. For this series, I added black as an additional hue.

Because all the paintings in this series required precision, I used clear packing tape to keep edges straight or to mask areas. This tape may only be used on Arches 140-lb. (300gsm) cold-pressed paper, since it's too sticky to use on other papers and weights and it will destroy the surface of the paper. I laid the tape down in strips and cut along the edges of the forms with an X-Acto knife. I was very careful not to cut through the paper. Next, I peeled away the residual tape. I learned this process from artist Susan Webb Tregay.

I painted one small area at a time, first wetting the paper in that area and then dropping in paint and mixing hues when necessary. This helped me avoid a muddy look. I moved along the entire painting, using this process until all the areas were painted. Once all areas were completed, I applied washes over broad areas that needed to recede more into the background.

The Zeroth Law of Thermodynamics • Katharine A. Cartwright, NWS, MOWS ›
Watercolor on Arches 140-lb. (300gsm) cold-pressed paper • 26" × 20" (66cm × 51cm)

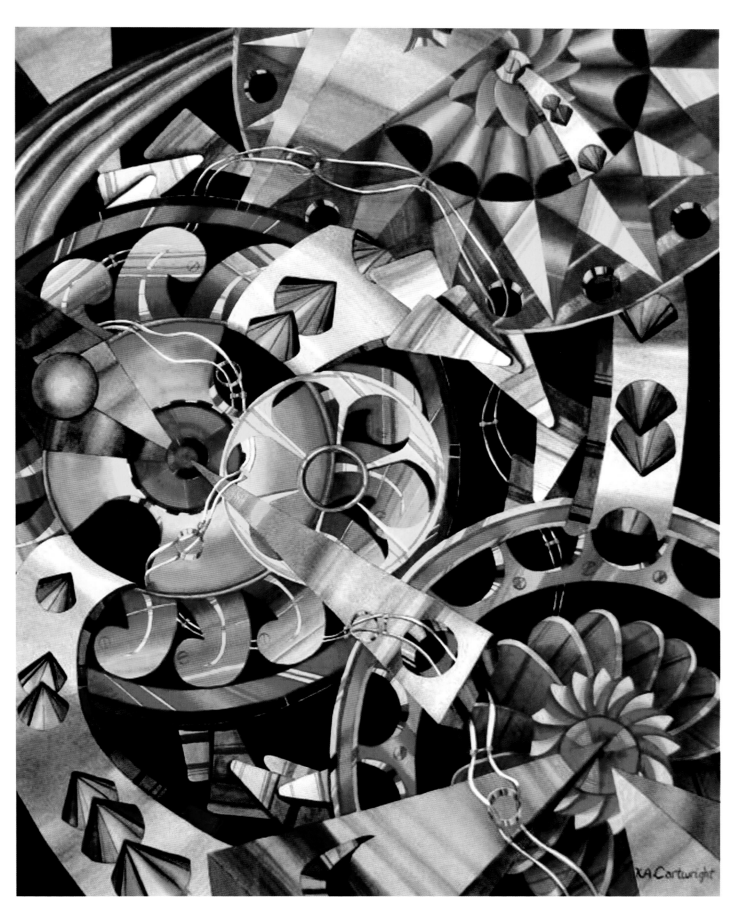

Carol Staub

<Environmental Series No. 4 • Carol Staub, ISEA
Mixed media on Aquarius watercolor paper •
30" × 22" (76cm × 56cm)

This particular piece stemmed from having just completed teaching a workshop. I wanted to use the sample papers and demo pieces that I had taught in class.

I started with a full sheet of Aquarius watercolor paper. This whole painting is collage, and all the papers were pre-painted and then torn to form the final painting/collage. I used Golden heavy gel gloss medium to adhere the papers to the paper.

After all the papers were adhered and totally dry, I used a palette knife to apply a very thin coat of molding paste to the upper portion (in the center) of the painting. While that was still wet, again using the palette knife, I applied a medium spread of Golden Crackle Paste, connecting it with the molding paste and continuing down the painting. You can see in the lower left that the painting has some medium granules. This was done in the prep stage of making the papers. What you're looking at is Perlite, a texturing additive for paint. I took the Perlite, mixed it with Liquitex gloss medium, and painted it onto paper.

When that paper was dry, I painted it with a mixture of Burnt Umber and white acrylics. The Crackle Paste I applied to the final painting was applied right over some of the texturized surface from the prepped papers.

The final touches were completed by adding the black circles and the three diagonal pieces, along with the pencil work.

Elizabeth Ashauer

<Mystery Lady • Elizabeth Ashauer
Transparent watercolor on Arches 140-lb.
(300gsm) cold-pressed paper • 32" × 25"
(81cm × 64cm)

Mystery Lady is an abstract design called "scrunch." The painting is on Arches 140-lb. (300gsm) cold-pressed paper.

First, I found a picture in a magazine that had bright colors. Then, I laid the page on a flat surface and scrunched it together to create folds and sharp lines. I moved around a small paper frame with a ¾-inch (19mm) border until I found a composition that I liked. I then sealed the design with clear packaging tape.

Using four different transparent watercolors, I followed the lines of my design and started painting, leaving some white of the paper showing through.

When finished painting, I enhanced the sharp lines with a black magic marker to emphasize the shapes. This scrunch technique is one of my favorite forms of abstract painting.

Carole A. Burval

This unique painting developed from a continual fascination with fractals, in which the emergent patterns go from larger to ever smaller repetitive shapes related to a specific mathematical formula. Years ago, I read the book, *The Art of Composition*, based on the subject of design as it relates to the Fibonacci Sequence. I have been intrigued with using this theory, along with my love of reflections, in many of my paintings ever since.

Using a palette of complementary colors to create harmony, I began this painting by applying thick, sticky, slightly diluted watercolor paint to Yupo with mini paint rollers. (Yupo is plastic made into sheets that resemble paper. Due to its slick surface, paint sits on top instead of being absorbed. Colors are vibrant! When completed, the paint must be set with acrylic spray.) Because of the character of this surface, as the paint was being applied, it often came off. This process provided many interesting, unique passages, and I continued to play in this manner until I felt I had created an exciting overall light-and-dark pattern. At the same time, I was especially conscious of transitioning the values and integrating hard and soft edges to create an overall design. Having established this solid abstract design, I was confident it would carry the smaller, more intricate shapes and patterns which would come later. When this base was completely dry, I again used rollers to alternately pick up and reapply much more diluted paint. This step produced layers of color, which created both a sense of transparency and texture.

Then, with flat brushes and clean water, I carved out shapes and lines. Applying a dry mini roller over a tissue on a dampened area picked up some or all of the existing color, depending upon the amount of pressure that I applied. As the background was re-wet in a premeditated shape, a "shadow" or "ghost" was left of the former color and texture. Glazing new color into these lightened areas integrated them back into the picture plane. This method of adding and subtracting paint with a brush or roller was used continually throughout the development of this piece.

As I worked, I also rotated the piece of Yupo, allowing for alternating directional brushwork while developing pathways to entertain the viewer's eye. I remained conscious of the two-dimensional flat grid but wanted to surprise the viewers by giving them a sense of moving through a gallery of paintings on glass. Three realistic figures were added to the foreground early in the process, and then I carefully digitalized them into the convergent "glass" planes of the painting. I wanted the figures to look through but also become an actual part of the shards of broken glass laying on the surface. I truly love the process of painting; this surface and method are a perfect means to that end.

Watercolor palette: Burnt Sienna, Cobalt Blue, Permanent Orange, Phthalo Blue, Quinacridone Burnt Orange, Quinacridone Gold Deep, Ultramarine Blue

A Few Thoughts • Carole A. Burval, TWSA, WHS, MOWS
Watercolor on Yupo • 20" × 24" (50cm × 61cm)

Helen Wheatley

This painting was created with transparent watercolors on 140-lb. (300gsm) Arches cold-pressed paper, through a multiple-step process.

In the initial step, I use primary colors (red, yellow and blue) and liquefy the tube paints by squeezing them into small spray bottles, adding some water and shaking well. Then, I randomly place items on the watercolor paper and spray over them. Some items are solid—keys and small wooden blocks—while others include open spaces, such as doilies, woven mats and washers. I also use some of these items as stamps. In this way, their image can be changed from positive to negative. After spraying them, turn them over and press onto the paper. You can reuse items to create some repetition. There are dozens of things around the house that are perfect for this technique, and it just takes a little time to look around with an open mind before you find lots of things to use. After allowing everything to dry completely, I find a crazy, mixed-up page full of wonderful shapes, patterns and colors. There are different colors created wherever the sprays of primary colors overlap.

The second step is done independent of the first step. On a separate piece of paper, I create abstract designs involving geometric shapes and some straight and curved lines. I use a small sketchbook to create thumbnail-sized designs. I've done many more of these than I've used, because I just enjoy doing them. I reproduce each drawing several times, because the next step is to fill them in with shading to create a value sketch. I only use three values—light, medium and dark, but I place them in different areas in each version of the sketch. Then I look at all of the variations and select one that reads as the strongest and most interesting.

Once I've selected the version of the sketch with the best value plan, I transfer the drawing to the spray-painted paper using chalk. (I use chalk because I can easily wipe it off later, and I paint those lines white.) The reproduction of the sketch does not have to be perfect, and I never try to make it work with the underlying painting in any way. In these paintings, I decided to assign the values specific colors. So the light value became gold, the middle value became red, and the dark value became purple. I allow myself to vary the value of the color within the space, and sometimes I leave some areas unpainted. This is when I finally start working with the background, emphasizing some shapes, shadowing some, and creating some shapes within shapes. I really take my time deciding what to do in this step, because it is these details that really make the paintings interesting.

Finally, I outline most of the abstract design in white using multiple layers of watercolor. I don't use opaque paint, so the layering is necessary to make the white show.

Enigma • Helen Wheatley
Transparent watercolor on Arches 140-lb. (300gsm) cold-pressed paper • 22" × 30" (56cm × 76cm)

Toni Young

‹ Day in the Sun • Toni Young, ISEA, ISAP
Acrylic on canvas • 30" × 22" (76cm × 56cm)

Day in the Sun is the type of painting I call a "readable abstract." It was created from a still life that I arranged in my studio. I used an artist's wooden mannequin and a bronze bird statue as my starting point. My inspiration was the feeling of a warm, tropical day in Florida, which helped me choose my colors.

On a gallery-wrap stretched canvas, I used a limited palette of acrylic paints consisting of warm yellows to oranges, complemented perfectly with their color-wheel complements of cool greens, blues and purples. I began with these colors in the largest shapes I saw in the still life, while also creating my own background from my imagination, again with shapes and colors. Then,

I gradually progressed to the smallest shapes in my design.

In this painting, I used white gesso to make the colors pop, create movement and establish a focal point. My final details and linework were done with black Pitt artist pens. I enjoy this unique style that emphasizes the shapes. The linework unifies the painting and adds a new element.

In closing, there are recognizable aspects in this painting, but it is far from realistic. It is the feeling from my inspiration combined with the color, shape and line that reads abstract.

Betty Jo Fitzgerald

<Rites of Spring • Betty Jo Fitzgerald, NCS, NWWS
Acrylic and collage on birch doorskin panel • 38" × 25"
(97cm × 64cm)

I wanted to do an abstract painting that reflected my feelings about spring, renewal, rejuvenation and rebirth.

I primed the panel with Kilz primer and then painted it with two coats of gesso using a roller. While that was drying, I painted several Japanese papers—unryu, silk tissue, Tengucho, and Kinwashi—with acrylic paint in this manner: Place the papers on white plastic garbage bags and tape them down. Thin acrylic paint with medium to the consistency of cream, then paint, spatter, splash, spray or stamp. Let dry overnight, then peel the paper carefully off the plastic bag. You should have some pieces that look like translucent stained glass.

I played with the placement of the papers on the panel until I liked the design, then glued them down with acrylic medium. While the paper was drying, I made several taxonomic drawings of fruit and flowers from my college notebook. I drew in ink on the rice papers. I adhered these drawings and some gold and copper foil to strategic areas on the panel.

I put the painting away for several days, then spent some time adding paint here and there and drawing with colored pencils over the top of the painting in several areas. To finish I covered the entire painting with two coats of self-leveling clear gel.

Visit artistsnetwork.com/newsletter_thanks to download free bonus material.

Susan Adamé

My collage projects begin with the search for materials, which is the most time-consuming part of the process. In my collages, I often use paper that has been made from scans of fabric that have been altered in scale and color tone. For each pattern, I make a series of prints in a wide range of color tones. My best results are from my Epson Stylus Pro 4880 that prints 17" × 22" (43cm × 56cm) giclée-quality paper. I sometimes find old handwritten letters on the Internet that I scan and print to many times their original size. If the project has a particular theme or emphasis, I will collect a variety of materials that reflect that emphasis. The collection stage can also have a color theme that will direct my search. I gather a variety of new papers from local sources and online as well. The success of the finished project relies heavily on the materials gathered in this search.

At this point, if I don't already have a color direction in mind, I choose the color I want to use in the background. This color will show through the transparent papers and bridge the gap between other papers. I can either contrast the papers, or I can make the transition more subtle with a background similar in color tone and value. I make a large watercolor painting in the color tones and values that I have chosen.

Next, I look at the papers I have and make choices as to which ones I will use. I make a dry mock-up with the papers laid on the watercolor background, without attaching anything. I make sure that none of the papers are too dominating. I like contrast, but I don't want any one part to overpower the composition. I tear or cut the papers to reflect the direction I wish to establish. My work usually has a flow from one side to the other that directs how the papers are placed. After the more dominant shapes are placed, I will usually add a few more transparent shapes behind the first pieces, as well as on top.

When I am pleased with the composition, I cover the piece with Plexiglas and wait until the next day to attach the materials. I wait a day so that I have the opportunity to return to the work with fresh eyes and make necessary adjustments. I find that by stepping away from the work and returning with a fresh perspective, I am able to make changes that I had not seen the day before. I return to this stage until I am satisfied with the work.

To assemble this painting, I attach the materials with any artist's medium using a wide, disposable brush. I gently lift each piece and cover the entire watercolor paper, as well as applying medium between papers.

After the collage has dried, many of the papers will have changed, and the piece will look different. I have the option at this point to make additions to the work. I can simplify by adding a large simple shape, or I can add details. I will also add details of hand-painted gold accents, as well as gold leaf at this time. Most collages are part of a process where I reflect and make changes over a series of days or weeks.

Lastly, I seal the entire collage with a polymer UVLS sealer made by Golden to protect it from light. This sealer can be removed if needed and does not change the finished product.

Choices • Susan Adamé >
Mixed media and collage on Arches 300-lb. (640gsm) cold-pressed watercolor paper • 28" × 22" (71cm × 56cm)

Robin Colodzin

La Mort de Mme. Blanchard was born of a flea market find—*La Voleur* (*The Thief*), a French publication from the 1890s with a cover illustration of Madame Blanchard, who died in 1891 when her hot air balloon caught fire.

The collage plays with opposites. There is tension between the rigid structure of the column and the more relaxed elements that break through that structure. The cheerfulness of the pastels contrasts with a story of a rather dramatic death. The dynamic of the fire and the falling woman are confined by the antique architectural drawing—a drawing of something meant to build up juxtaposed with someone crashing down.

First I prepared my substrate, acid-free mat board. I painted it, choosing a neutral color, as I never really know where a piece will take me and that leaves more options open. Then I coated it with acrylic medium and let it dry. For the columns in the background, I scanned in the architectural drawing, cleaned it up in Photoshop, and then reversed it in preparation for doing a photo transfer. I printed the reversed image out on transfer paper and transferred it onto the mat board.

Then playtime began. I had printed out the image of Madame Blanchard from the Internet, and coated it with acrylic medium in advance. I began cutting out pieces to fit within the column structure. I used some of the text in the actual article about the event from *La Voleur*. Because the central image from *La Voleur* was black and white, and the columns were just black lines, I worked to introduce enough color into the work to bring it to life. A failed experiment with adding red paint sent me back to the drawing board. Thanks to the Internet, I was able to find and download a brighter color illustration of the same scene. I expanded my palette further, using paint sample chips cut with pinking shears and a hole punch. I used some gold leaf here and there as well.

I assembled the various pieces, and when I achieved a satisfactory composition, I protected it with release paper and used heat from a tacking iron to fuse the layers. This method was developed by Jonathan Talbot, and I find it frees me up to make and remake a composition without the difficulty of having to take it apart to glue it together. The compositional elements adhere beautifully without wrinkles or air bubbles. To complete the sense of columns, I cut some pieces of balsa wood, painted them, then adhered them to the mat board.

When my collage was finished, I coated it with another layer of acrylic medium to seal it. When the medium had dried I varnished the piece with satin acrylic varnish by Golden with UVLS (ultraviolet light screen). This protected the finished work from fading and gave it the appropriate sheen.

La Mort de Mme. Blanchard • Robin Colodzin >
Mixed media and collage on acid-free mat board • 9" × 9" (23cm × 23cm)

Rita Crooks

Countryside is part of a series of paintings called *Rural Architecture*. Living in Wisconsin gives me many opportunities to enjoy the rural scene—its barns, silos and animals. In particular, the textures of the weathered wood on the outbuildings and the stone foundations inspire me to add a variety of textures to my paintings.

My technique is to use acid-free mat board for paintings executed in acrylics. This allows collage material to be applied if, during the painting process, the piece would be enhanced by such additions. However, there was no collage material used in this painting.

The first application to the mat board was acrylic medium. After that was dry, I layered three contrasting colors, beginning with the lightest. I allowed each layer to dry before adding the next color. Then, I added a coat of matte medium.

It was at this point that I began to figure out what the shapes would be. I do not plan a composition and transfer it onto the board, but rather use chalk and sketch a rough plan as I go along. The chalk can easily be rubbed off the surface, and I can change things as I go along. In this painting I planned the largest shapes first and then decided how those areas would be broken up into smaller units, using the motifs of a Midwestern farm. I did some texturing by using a brayer and other tools in my studio.

Using isopropyl alcohol and a little elbow grease, I wiped some of the paint off certain areas as my composition became apparent to me. In other areas of the painting, I added more paint playing against lights and darks. The places where I rubbed the paint off gave a different look to the surface. When I needed to keep a straight or hard edge, I used delicate surface blue painter's tape, which pulled up easily without damaging the surface of the painting. It was not until quite close to the end of working on this painting that I decided where I would put the parade of calves.

The process I use for building a painting is sometimes slow, but it gives me a sense of accomplishment when things fall into place. Every painting is a challenge, because I make decisions as I go along and do not have a preconceived idea of how it will look at the end. Working this way reminds me of the saying, "Making art is running away without having to leave home."

Countryside • Rita Crooks, NWS, WHS >
Acrylic on acid-free mat board • 31" × 23" (79cm × 58cm)

Selma Stern

Return of the Phantom • Selma Stern, AWS
Acrylic on Rives BFK printmaking paper •
30" × 22" (76cm × 56cm)

This painting was started by putting down glazes of color over the entire sheet of Rives BFK print-making paper. First I painted gold, then reds and next blues. While the paint was still wet, I used a knife to scratch out various designs within the format.

Once the paint had dried, I put in different things to achieve a textured surface. With a tooth-brush, I spattered color in several areas. Using a dry brush, I painted in large amounts of color in different places. More areas were scratched out whenever the newest application of color was still wet.

Next, I mixed up a dark glaze using a mixture of reds, blues and Payne's Gray. I applied this glaze over the background. The figure of the *Phantom* emerged. I emphasized this further by applying several more dark glazes.

Betty Jo Fitzgerald

A Walk in the Park was inspired by the many beautiful parks I visited while traveling in Europe.

I started with a 24" × 24" × 2" (61cm × 61cm × 5cm) gallery-wrap stretched canvas that was gessoed. I used acrylic to paint random blocks of green, brown, black, and turquoise, accented by Golden Yellow, Burnt Sienna, Orange and Hot Pink. I also painted the edges, since I did not intend to display this piece in a frame.

I added some tree shapes to the center of the painting, which was originally green. I covered those partially with some transparent rice paper that I glued on with acrylic medium. Then, I scumbled pale turquoise paint over the top. I covered the left side of the painting with a collaged canvas (trees) cut from another painting. I used heavy gel to adhere the two together.

Using more paint, watercolor crayons or ink, I added details throughout the painting.

I set the painting aside for several days, knowing it still needed something. Looking through my stacks of unfinished paintings, I found the appropriate piece to collage to this new work. I cut it out and adhered it upside down to the right side of the painting. Two final coats of self-leveling gel sealed the artwork.

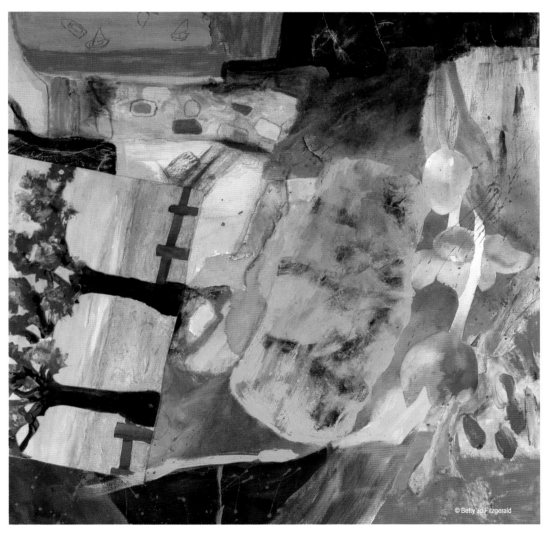

∧ A Walk in the Park • Betty Jo Fitzgerald, NCS, NWWS
Acrylic and mixed media on canvas • 24" × 24" × 2" (61cm × 61cm × 5cm)

Cheryl D. McClure

My usual mode of painting involves *not* knowing exactly where I am going. I may decide I want to paint a cool or warm painting, or use a particular palette of color, or an orientation that is one I have not used for a time. Other than that, I prefer to be told where to go by the individual painting and the relationships the colors or shapes make as I work.

One thing I do use a lot is the application of a light texture paste to the canvas or wood panel. Over time I have found this works for me and the kind of surface I like in a painting. I used to add gel mediums to each of the colors, but found this time-consuming and also wasteful of the medium and colors I laid out to work. Having a slight organic texture under the paint works just as well for me. I use both palette knives and brushes to apply the texture. I also usually tone the canvas with some color—sometimes arbitrarily and sometimes on purpose—like a beautiful red or orange under a painting that I think will be dominated by greens or gray-greens.

Excavation started out as the left side of a diptych that never ended up working for me. I like working in multiples as it facilitates larger paintings that are easier to break down to ship to a gallery or store. It has been some time now, but I think I just started the painting with leftover color from an old palette. The color combinations are unusual for me. This is a low-key painting with a lot of grayed and low-intensity color. I have to remind myself that not all paintings need to have the full range of values or light, bright coloration.

After I finally decided this painting was finished, and that I liked it, I realized I had captured some vague imagery of what had been surrounding me a lot over the past couple of years—that is excavation of the land. Near where I live, there are great natural resources of clay, coal, oil and natural gas, as well as beautiful land. There is excavation of the coal with the huge machinery it takes to do that work, as well as the drilling platforms for oil and gas in pastures where I live. I absorbed these visual stimuli and now recognize them when I look at this painting.

Get free desktop wallpaper and a bonus demo at artistnetwork.com/journeystoabstraction.

Excavation • Cheryl D. McClure, SWS, TVAA
Acrylic on canvas • 30" × 30" × 2" (76cm × 76cm × 5cm))

B.J. Adams

After the initial terror of jumping off a bridge in New Zealand, bouncing and swinging and finally hanging upside down by my ankles, I was taken by the beautiful, albeit weird and disorienting, view of cliffs with wild river above and sky below. This experience became the theme for an unusual artwork, an upside-down abstract landscape.

This art was begun in much the same manner as *Plot Twists*, also found in this book, except I wanted the colors to flow with a sky below and the colorful landscape above, so I blocked in some colors on the canvas before I began stitching. With size-50 thread count on my industrial sewing machine, I freely laid down the satin or zigzag stitching, placing them randomly within my loose plan. I wanted a burst of color for the landscape at the top that reminded me of the New Zealand bush and waterfalls, flora and fauna.

After filling this rectangle of canvas solidly with thread, it was distorted into a haphazard diamond shape. I needed to trim the embroidered canvas to an even rectangle. After the canvas and thread were trimmed, I added Fray Check to the cut edges and let that dry.

I decided the piece would look better with some sort of an extended background, so I painted a larger piece of canvas with a combination of acrylic paints and Aquarelle watercolor crayons. I planned the painting to extend the stitched colors to form a sort of frame. I placed the small embroidered canvas in the center of the larger painted canvas and proceeded to stitch it down. A few of the stitched lines in the small piece were extended out over the painted canvas, which held it to the background.

To finish the artwork, I stapled the painted and embroidered canvas to wood stretchers so that it could be hung by wire.

Bungy Attitude • B.J. Adams >
Mixed media and fiber on canvas • 26" × 19" (66cm × 48cm)

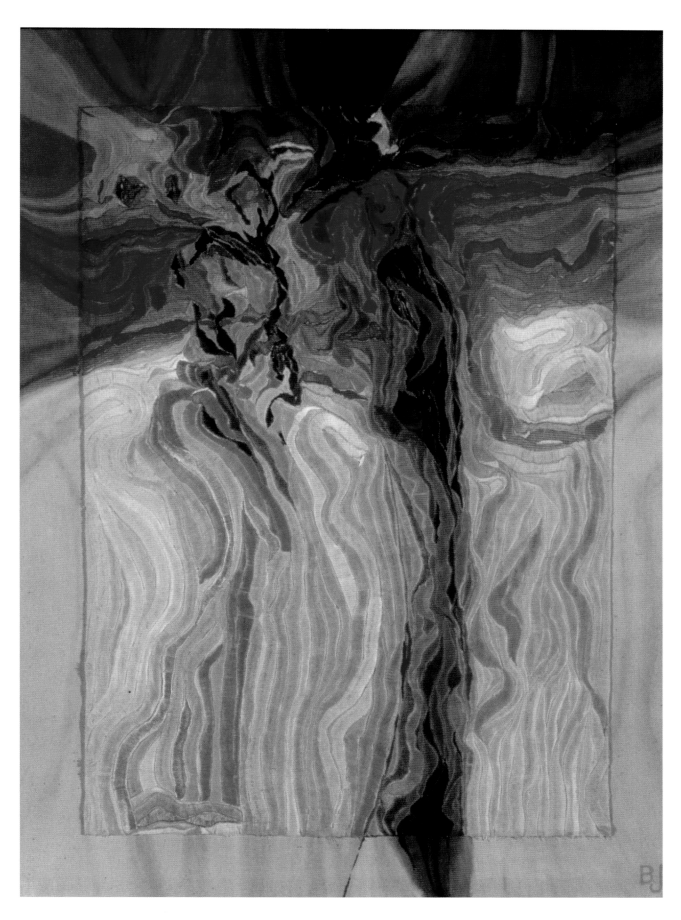

Joan Burr

I started this painting on Arches 140-lb. (300gsm) watercolor paper with a broken grid. I applied hot wax to the grid lines with a Tjanting tool. I thought the line would be an important part of the composition, creating an interesting interplay with the shapes to come. When I start a painting, I am not conscious of what I am going to paint. After I prepare a background, something starts to emerge and I develop it from there.

I randomly applied watercolors to index paper with a large watercolor brush. I wet the paper but left dry areas for soft and hard edges. I placed a 4" × 5" (10cm × 13cm) mat around the paper to find a color combination and exciting composition.

I cut out a 4" × 5" (10cm × 13cm) card—my spirit card. I get many spirit cards this way for future paintings. This method gives me a challenge to interpret a mood and idea that only abstraction can invoke. I find this prevents me from using the same favorite tried-and-true colors. Many lovely combinations appear that would not have been considered before.

I applied the colors and shapes from my spirit card onto the watercolor paper, creating my background. It was springtime, and the colors and light suggested a flower. I outlined an abstract flower with the hot wax and began painting negatively with opaque watercolor paint to bring out a flower shape. The wash of the background colors was left as the major colors of the flower. Rich pigments were added in small areas for visual excitement.

After the paint was dry, I turned the paper over and covered it with craft paper. I then ironed the back side to remove the wax, leaving textured broken lines. This is truly a fun way to do experimental abstract art that brings out unexpected surprises to the finished painting.

Spring • Joan Burr
Watercolor on 140-lb. (300gsm) Arches watercolor paper • 20" × 30" (51cm × 76cm)

Barbara Millican

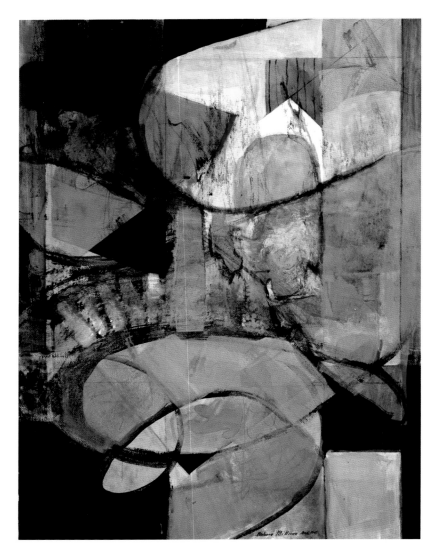

❮ Windows Verde • Barbara Millican, AWS, NWS
Acrylic on Arches 140-lb. (300gsm) cold-pressed
watercolor paper • 30" × 22" (76cm × 56cm)

Often I am asked, "How do you start your abstracts?" I began this painting by employing an commonly used device of composing by drawing large letters randomly over my watercolor paper with charcoal or a small brush using diluted black watercolor. Vine charcoal is preferred because it can be easily erased or changed.

I use script lettering, sometimes large block letters and sometimes lowercase letters, always overlapping them to create interesting shapes.

I did not deliberately set out to paint an image of stained-glass windows. After I started adding color, many of the black lines were left, and the overall effect resembled the look of stained glass. I find these unpredictable results exciting.

In this work, I used mixtures of green acrylic paints—Hooker's Green, Phthalo Green, and a mix of Yellow Oxide and Black. In places, the yellow paint is left to simulate sunlight. I add glazes, both transparent and opaque, changing colors and adding textures and patterns to avoid a static-looking painting.

I nearly always use Arches 140-lb. (300gsm) cold-pressed watercolor paper, but occasionally venture into different brands or hot-pressed paper. Most of my paintings are painted on full sheets of watercolor paper, although I enjoy painting on square-sized paper occasionally.

Edee Joppich

I began taking pictures of my skylight three years ago. The lines and planes of the walls interested me. The shadows and value patterns varied, but what really fascinated me was the window itself. The textures of snow, rain, ice and the luminous, blue summer sky are all endlessly worthy of recording.

In December 2009, I spread out the hundred-plus photos on my studio floor and began selecting and arranging them into a grid-based design. The ground they are glued on is a textured black rice paper mounted on a mat board. I cut narrow strips of photos and glued them randomly over the grid design to create a rhythmic line pattern. The piece of red rice paper is placed in a diagonal direction to add variety, tension and a little surprise. To achieve a uniform matte finish to the photos, I coated them with brushed-on thick Elmer's glue, which dried to a crystal-clear finish with a subtle texture.

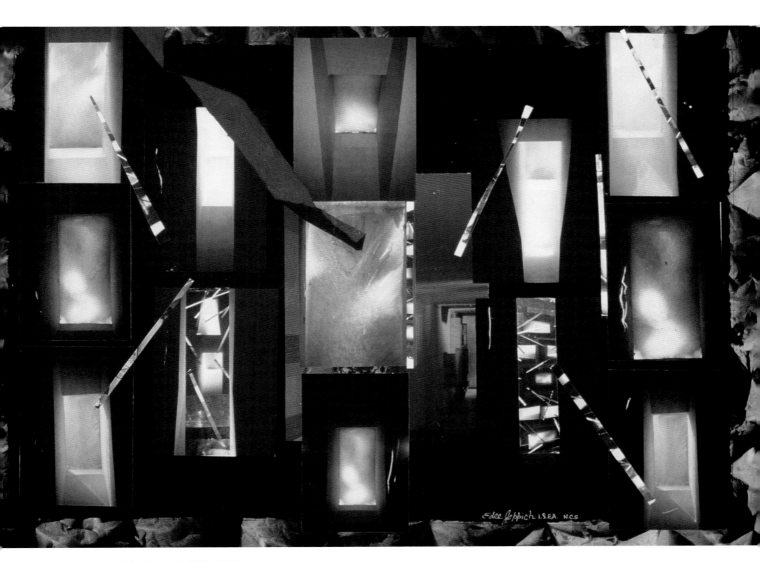

⌃ Openings • Edee Joppich, ISEA, NCS
Photo and collage on mat board • 24" × 34" (61cm × 86cm)

Karen Kierstead Miller

Fascination with water media has led me to recent paintings that incorporate an interplay of watercolor, acrylic and collage as mediums to explore experimental painting techniques.

Selecting a comfortable palette of lime, white, purple and black was the first step in painting this abstract. My paper is always Arches 140-lb. (300gsm) hot-pressed watercolor paper. Paint is easily moved around on the hard surface, allowing many textural choices while providing an appropriate flat surface for gluing collage pieces.

Using a brush and crumpled paper, resist maskoid was applied to create botanical images, lines and textures on the white paper to introduce the theme. After drying, subtle high-key tones were blocked in to start the initial backdrop of light and medium values of watercolor fluid and tube acrylic colors. The maskoid was rubbed off after application of the initial tones of paint had dried.

A leaf stamp was used to create a strong vertical movement through the abstract. Designing and carving original rubber stamps has added an interesting whimsical component for my paintings. Repetition of stamps is often used to build a pathway or movement. Theme can also be enhanced by the use of the stamping process.

At this juncture in the painting, collage takes over. Purple tissue paper was blocked in to create the medium values important to a balanced composition. Negative spaces around the leaf shapes of black printing paper weighted the left side of the painting. Black-and-white lined collage paper direct the eye inward and repeat the botanical theme.

In conclusion, poppies were printed as a monoprint on black Rising Stonehenge printing paper with water-based oil paints. (Made from 100 percent acid-free cotton, this paper is especially nice to use for collage as it is intensely black and highly fade-proof.) Carefully selected sizes and shapes of torn-edged pieces of the monoprint were glued in place to carry out the theme and create a striking focal point.

Playing with unfinished edges, unusual textures, asymmetrical compositions, and an unexpected viewpoint made painting *Gucci Poppies* fun and a bit unpredictable.

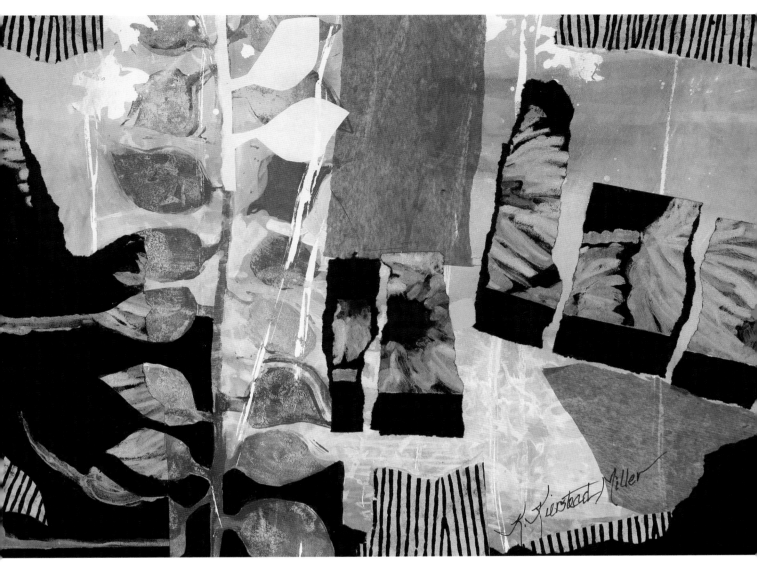

▲ **Gucci Poppies** • Karen Kierstead Miller, ISEA, LWS
Mixed media on Arches 140-lb. (300gsm) hot-pressed watercolor paper • 10" × 14" (25cm × 36cm)

Shirley Wilson Blake

In starting this painting, I picked out the colors that I wanted to work with for dominance. *After Coffee* color dominance was green and purple with pops of blue, maroon, and coral. I did not use an underpainting for this piece.

One of the reasons I love abstract is that you have only your shapes, colors and style to bring forth in your work rather than the realistic approach of making things as they appear.

My first layer, whether I have an underpainting or not, is to cover the surface with mid-tones of my dominant colors. Most are very soft-edged and blend well with the color next to it.

The second stage is to develop where I would like my focus and begin to layer color over color to establish shapes and have more contrast in colors. Acrylic is a wonderful medium for working in this manner. Most of my work has numerous layers in it; however, I'm not attempting to texturize with products as I feel that I would rather establish patterns via paint quality and style.

The layers are intentional in terms of keeping your eye moving over the surface of the painting. I find I usually pick the golden section composition in my work with the focal point being towards the middle of one of the quadrants of the paper or canvas. The small bits of color and shape in my work are achieved by pulling color off when a fresh coat is layered over a dry coat, scratching through a layer to reveal undercolor, or by painting a positive shape over the dry layer. I choose to use very little obvious technique such as cheesecloth or bubble wrap, as it is more interesting to me to invent the shape and texture in the piece.

The final stage is to use the top layers of color and shape to help define the large shape in the piece. Mine seem to almost always veer towards a geometric shape. I tone down the bounce of color with more structure and usually a deeper value in the final stages of the painting.

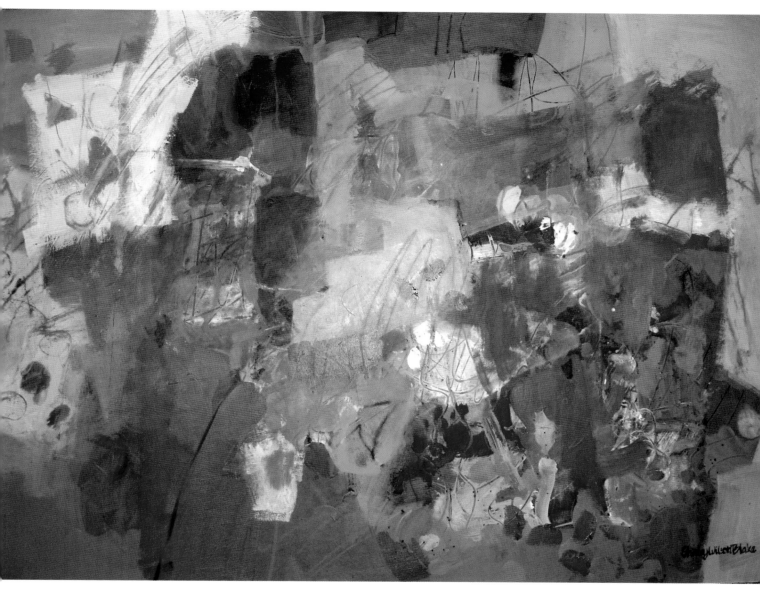

∧ **After Coffee** • Shirley Wilson Blake. ISEA
Acrylic on Crescent board • 22" × 30" (56cm × 76cm)

Sheila Grodsky

Ever since I spent some time traveling in the Southwest, I have been intrigued with the desert landscape. As a native of the Northeast, which has a totally different aspect, I wanted to express my memory of the gorgeous colors, textures and shapes of the desert with its dunes, mesas, mountains and space seemingly without end.

Using a sheet of 3-ply Crescent illustration board with a vellum finish, I laid out several tissues (no lotion) torn into a variety of shapes in a random fashion on the board. (Kleenex brand seems to work the best for me.) I then mixed up a selection of Winsor & Newton tube watercolors with water to the consistency of milk in small plastic containers with lids. My palette consisted of Alizarin Crimson, Burnt Sienna, Gamboge, Sap Green and Mauve. As I poured my colors over the surface and tissues, the paint seeped through, creating fantastic shapes. I carefully tilted my board to make the paint run and blend in some areas. As the surface became less shiny, I sprinkled some kosher-style salt with my fingers in a few places for texture and sparkle. Some areas of the board were left white. Before the work was completely dry, I removed the pieces of tissue. If left alone, they would adhere to the board and be very difficult to remove. The painting was then set aside to dry thoroughly.

Referring to the many photos I had taken on my desert journey, as well as my memory bank, I began to paint rock forms negatively, using gouache in a tint of Golden Ochre. My goal was to take advantage of the textures caused by the tissues and salt. I varied the rock shapes and edges as much as possible. At the same time, I was aware of the color flow throughout the composition. I studied the dark-and-light pattern as it emerged and decided that for a dramatic effect, I should create a dark sky with distant mountains in the background. This also suggested aerial perspective and vast space. I added more lines to create links between shapes with a rigger. When working with gouache, do not make the layers thick as this will produce a cracking effect. If desired, acrylic mixed with gesso would do the job as well.

To complete the work, I used an acrylic marker in Metallic Copper to delineate the mountains. I also added some dark glazes in the right foreground to balance the arrangement of values. Because of the exciting surface of the underpainting, I totally enjoyed the work. It seemed to paint itself as if I were actually there in this imaginary landscape.

For me, this painting has a sense of mystery. The emphasis is on the effects of time, wind and water on the Earth over millennia. It has the essence of a sacred place.

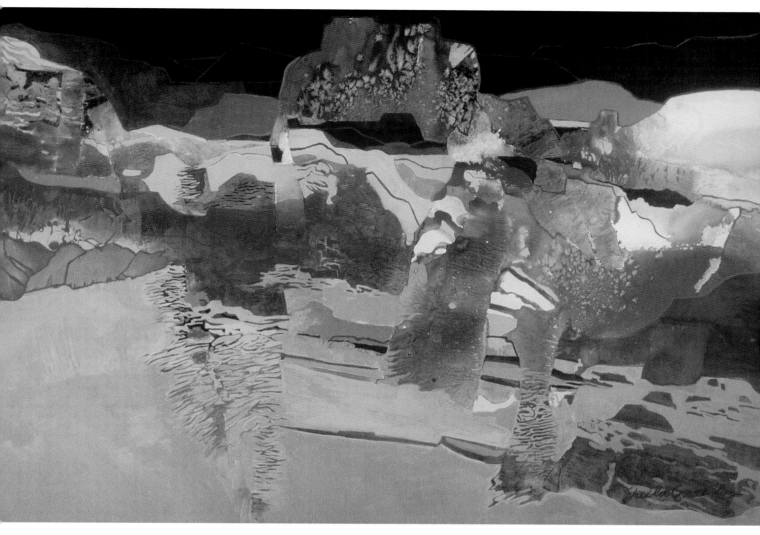

Sacred Rock • Sheila Grodsky
Watercolor and gouache on Crescent illustration board • 22" × 30" (56cm × 76cm)

Carole Kauber

<Nocturne • Carole Kauber, NCS
Mixed media on watercolor paper •
30" × 22" (76cm × 56cm)

In this painting, I used symbols (spirals and circles) that represent the night sky. My abstraction of this scene grew out of experimentation and happy accidents. I began the painting by spraying water onto the surface of the watercolor paper. Flat washes of various types of blue (Phthalo, Ultramarine and Cobalt) were painted over the semi-dry areas. In several of these areas, wax paper was placed over the wet application, and the application was then allowed to dry. This helped to produce interesting and varying textures.

In order to obtain sharp edges, I placed blue painter's tape on the paper before the color was applied. I like to place sharp edges next to forms that are more organic. It creates a visual tension that adds to the mood of this painting. To enhance the textural surface, I used some of my linoleum plates to create different linear effects. I used a sprayer and acrylic paint to apply these relief images to the surface of the painting. In several areas I also used watercolor pencils to create some jagged lines. The repeated spiral shape was cut out of foam, then printed onto the surface. The textural surface was further embellished by spattering inks or fluid watercolors.

Edith Marshall

Echo: The Whisper • Edith Marshall, ISEA
Mixed media and collage on Arches 140-lb.
(300gsm) cold-pressed paper • 30" × 22"
(76cm × 56cm)

In an effort to create a new technique for expressing my originality and nonobjective vision, I started this *Echo* series using only the materials I had on hand: Arches 140-lb. (300gsm) cold-pressed paper, F+W acrylic liquid inks, a yardstick, a sheet of clear acrylic, *National Geographic* magazines, computer paper, a Sharpie pen and Elmer's glue.

I first coated pages from the magazines with solvent, and rubbed the images on the pages to show only the colors and let them dry. I then cut out the color shapes from the pages. I arranged and glued the shapes onto an 8" × 10" (20cm × 25cm) sheet of computer paper to form a cohesive design.

I marked an 8" × 10" (20cm × 25cm) clear acrylic sheet into 1-inch (25mm) squares with a Sharpie pen and placed it on top of my design. On a 22" × 30" (56cm × 76cm) clear acrylic sheet, I marked 2-inch (51mm) squares and placed the sheet on top of the cold-pressed paper. That was my guide for transferring the small design onto the large paper.

The design on the small paper was duplicated by painting it onto the large paper. The small collage was then adhered to the painting using Elmer's glue, weighted down and allowed to dry.

Jan Filarski

This painting was done on a full sheet of Fabriano Artistico 140-lb. (300gsm) cold-pressed watercolor paper. I applied a layer of thin acrylic paint all over the paper and allowed it to dry. I then added another thin layer of a different color on top of the first. It is best to use transparent colors in this layering process, but I also used opaque colors thinly. About four more layers of other colors were added, but selectively, allowing some of the bottom colors to show through untouched.

This method of layering color produces some very beautiful rich tones. By not covering the entire paper with each color, interesting shapes are formed. When I got to the point of being satisfied with color and design, I sealed the paper with a layer of Minwax water-based polycyclic clear gloss finish, which I brushed on carefully and evenly, going in one direction.

On a separate piece of medium weight white Yupo, a plastic synthetic paper, I painted a small watercolor painting. I worked from real life but very abstractly. I liked the painting, but thought I could use it better if it were cut and used as collage. I cut it into two interlocking pieces and glued it onto the watercolor paper with acrylic gel medium. I sprayed the painting on Yupo with UV spray to protect it from fading. When dry, I sprayed it with Minwax polycyclic gloss spray to seal it.

I kept seeing mouths and fish forms in looking at the two elements together. I drew a couple of fish and began to paint them in with acrylic paint. I felt I was going back to a time when my paintings were humorous and playful. I tried to make fins, tails and bubbles look transparent. When I was done, I applied another layer of Minwax, painting in the opposite direction. This coating made the painting look wet and as if it was underwater. It was an enjoyable painting to finish, and I hope to paint this way again.

△ Pisces • Jan Filarski
Mixed media and collage on Fabriano Artistico 140-lb. (300gsm) cold-pressed watercolor paper • 22" × 30" (56cm × 76cm)

Fredi Taddeucci

Ancient Dwelling Place was painted on Kilimanjaro 140-lb. (300gsm) cold-pressed watercolor paper. My first application of color was done with Robert Doak fluid watercolors. I started by randomly choosing colors and squirting the color straight from the bottle onto very wet watercolor paper. To get the colors to flow into one another, I sprayed more water from a spray bottle. I then applied pieces of plastic wrap and wax paper, wrinkled or flat, onto the wet watercolor and allowed it to dry.

After the plastic wrap and wax papers were removed, I turned the paper in all four directions to determine from which orientation I would begin painting. (That does not mean it remained in this orientation.) I also had to decide which parts to leave alone and which parts to paint out.

I began painting with Golden fluid acrylics. I used Quinacridone Crimson, Phthalo Turquoise, and Quinacridone Gold plus Titanium White. The darker reds are a mixture of Quinacridone Crimson and Phthalo Turquoise. The lighter, brighter reds are Pyrrole Red Light or a mixture of Quinacridone Crimson and Quinacridone Gold. The cream color is a mixture of Quinacridone Gold and Titanium White. The grays are a mixture of all three colors plus white.

Stamping was done all over the painting, using a large foam stamp. I also used a zigzag stamp that I made from cut pieces of sheet foam glued onto foam core. Foil ribbon, which has small circular holes cut into it, was used as well.

The painting took on a look of hills and buildings, and I proceeded to develop it in that way, carving out shapes with the cream colors and grays. The reds were adjusted, darkened in places and brightened in others. This back-and-forth process continued until I was happy with the way the colors looked.

I used a checkerboard stamp to make the windows, and I carved out the doorway in the lower gray building, faintly adding more doorways in the bottom buildings. I wanted to leave it as a suggestion of hills and buildings with windows and doors, giving it a look of ancient dwellings. The stamping done on the underlayers gave the painting a shimmering look.

Get free desktop wallpaper and a bonus demo at artistnetwork.com/journeystoabstraction.

∧ Ancient Dwelling Place • Fredi Taddeucci, ISEA
Watercolor and mixed media on Kilimanjaro 140-lb. (300gsm) cold-pressed watercolor paper • 22" × 30" (56cm × 76cm)

Kristine Wyler

Work to create *Captivation* began with a process called a *watercolor pour*. The pour is designed to give intense color and texture to the paper. I usually do the pour indoors in my basement rather than outside, because even the slightest breeze can send the paper into the neighbor's yard. I began the pour with four sheets of paper placed on large plastic sheets on the floor.

Texture is the first thing to consider, and I have a collection of objects used to create texture on watercolor paper. These objects include but are not limited to: plastic mesh with a variety of hole sizes cut into a variety of shapes (purchased in a craft store in the sewing area), embossed ribbon, string, tissue separated into single plies (no lotion), pieces of paper towels separated into single plies, pieces of textured terry cloth towels, and paper doilies. I place the objects on the paper imagining what texture the object will create after it has been saturated with paint-laden water and dried. I crinkle the tissue and paper towel pieces and try to cover the entire paper.

Color is the next thing I consider. The colors are going to run together, so the color wheel is in my thought process. I select three or four tubes of watercolor paint, paying attention to transparency and granulation properties. I don't get too bogged down at this phase because the pour will take on its own life.

I assemble four 4 oz. plastic beverage cups and squeeze about a quarter-size blob of each color of paint in the bottom of each cup. I fill the cups with water and use a small wire whisk to thoroughly dissolve the paint into the water. I want the color of the water intense, and adjust the amount of

paint to create the desired intensity. I begin pouring the colored water over the objects on the paper. The water runs, the colors mix, and it looks like a big wet mess—that is what I want. The process of mixing and pouring is repeated until all the papers are covered. I lift a few of the objects on the paper to ensure that the watercolor paper is wet and the color has reached it. This is very important.

The most difficult part of this process is waiting for the papers to dry. It can take up to twenty-four hours. If lift too early when there is a lot of wetness on the paper, the texture can dissolve into puddles. If I lift when it is too dry, the tissue will stick to the paper. It is best to wait until the objects are almost dry before removing them from the paper. (If using a textured terry cloth towel, it won't dry but should be removed anyway.) After the objects are removed, the beautiful texture and color is left on the paper.

For the final phase, I select one of the papers for the base of the painting. I tear the remaining three sheets, both towards and away from me, into a variety of shapes and sizes. This tearing creates either a colored or white edge. I then begin arranging the torn pieces onto the base paper. This process can take weeks, since I watch for shapes to appear and begin to work with those shapes. I carefully consider the elements of design and study the work from a variety of angles. When I am finally satisfied, I use a spray adhesive to attach the torn paper to the base paper. I have overlapped some, and left some areas with only the base paper showing.

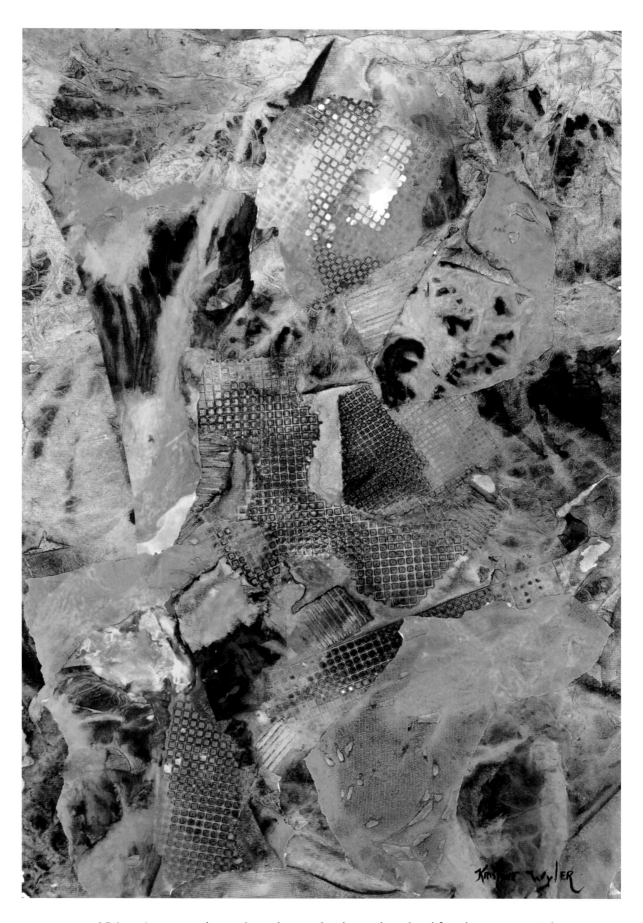

Lynne Kroll

Using Arches 140-lb. (300gsm) cold-pressed watercolor paper, I randomly folded the 22" × 30" (56cm × 76cm) paper several times, deliberately scoring it both horizontally and vertically. I then drew with a wax candle on some of these lines, as well as other random places. This is an intentional step I always employ at the start of my watercolors to create a resist, resulting in areas of pure white paper.

Birds and circles are symbols that prevail in my artwork. I roughly penciled in two birds and three circles on the paper in a simple composition, only to direct the placement of watercolor areas.

My first step was to employ a process that I invented years ago, which creates unexpected patterns, textures and forms on the watercolor paper. Using an iron on a high setting and placing the watercolor on a granite or fireproof base, I applied a variety of papers between the iron and the floated watercolor pigment. My first wash was a variety of warm and cool blues, employing the iron technique to achieve all of the initial delicate layering. Aluminum foil, crumbled copy machine paper and tissue paper were used between the watercolor paper and the iron to create fascinating, mysterious surfaces that I could not create with a paintbrush.

After creating the initial layer using the above technique, I began to use a variety of stencils to remove color and expose more of the white substrate. Since this is a transparent watercolor, I repeatedly floated colors in the areas where I needed depth, sparkle and contrast. I also created happenings by spraying watercolors from spray bottles and dripping dish-washing liquid diluted with water to create puddling. This pushes the paint in loose undefined patterns and adds more mystery.

As the layers dried, I lifted color using stencils and began to duplicate those patterns to form a cohesive composition. After many successive layers of transparent watercolor, I began to place several neutral dark value verticals balancing the composition. I repeated the above processes emphasizing color complements, values and positive and negative elements until the painting was complete.

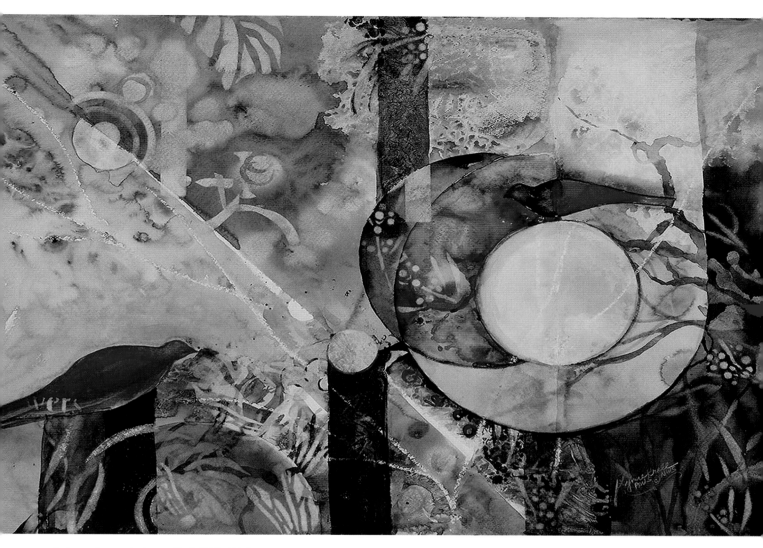

Lunar Renewal • Lynne Kroll, AWS, NWS
Watercolor on Arches 140-lb. (300gsm) cold-pressed watercolor paper • 22" × 30" (56cm × 76cm)

Pat San Soucie

I prefer not to stretch paper, so I simply lay Arches 140-lb. (300gsm) hot-pressed watercolor paper on a board or table. Often I paint on the reverse side of unsuccessful paintings, or on top of them.

I mix watercolor paints in clear plastic cups, then place tissues or rice papers on a sheet of Arches paper and pour the paint on top of the tissues or rice papers. The paint filters through the paper, leaving a pattern.

Generally I allow the paint to set for about thirty minutes; at other times I let it soak over-night. If the pigments stick to the edges of the paper, I use a spatula to lift it. I see what I've got and take it from there, adding more colors and pouring more paint.

Finishing a painting involves adding Aquarelle crayons, pastels, charcoal and graphite sticks to incorporate color, texture, lines and other effects to unify a piece.

Pouring paint is a great way to loosen up and get your creativity flowing, plus it is a lot of fun!

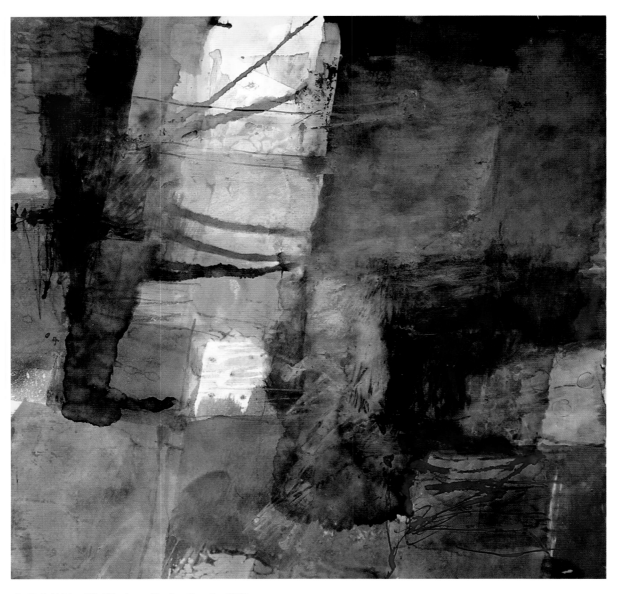

⌃ Quilt With a Silk Window • Pat San Soucie, AWS
Watercolor on Arches 140-lb. (300gsm) hot-pressed watercolor paper • 22" × 22" (56cm × 56cm)

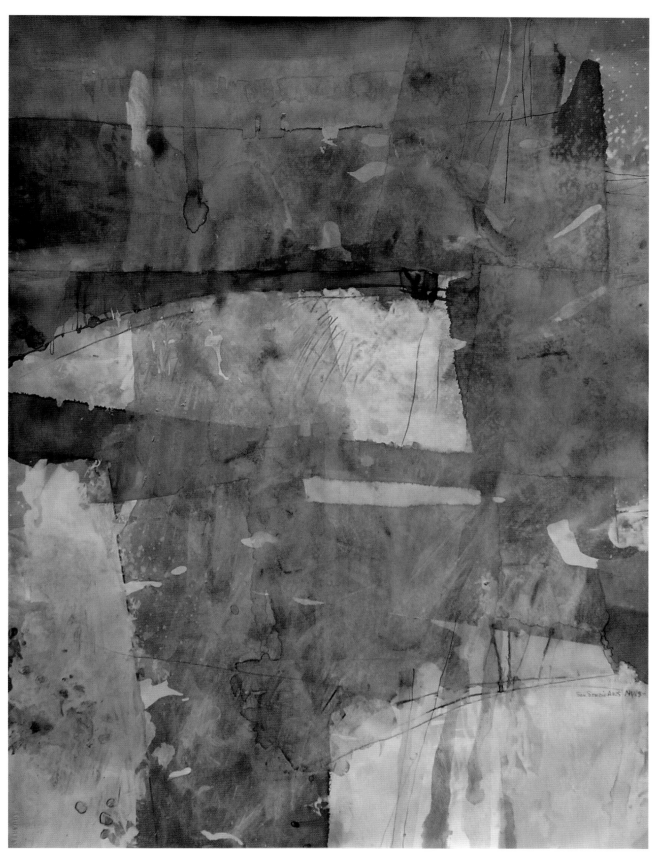

Lana Grow

This painting began as a demo for one of my classes.

I had my paper wet and added Golden fluid acrylic colors randomly. I try to begin with a limited amount of colors, maybe three to five at the most. I pushed and pulled the paint over the surface, moving the paint with anything other than a brush. I am always careful to leave some areas white. I added isopropyl alcohol to the wet paint to give it some texture and mix with the paint. I just play and move paint around, mixing some, but also allowing the paint to mix on its own.

When the painting was dry, I especially liked the center area. I began to cover up the areas I didn't like and saved the areas I did like. The painting began to evolve in a cruciform design. This was a process of putting on paint, and taking paint off if I didn't like it. I used isopropyl alcohol and an elephant-ear sponge to selectively remove paint in some areas, adding larger areas of color that I wanted to repeat from the center area.

I try to keep the thought in my mind of touching the painting in a different way each time I bring paint to the surface. I followed that lead thought and brought in Golden opaque colors that were introduced to me with the center colors. I added small light opaques against the darker colors.

This painting continued to lead me to more organic shapes flowing throughout the surface. I added black lines and dark shapes to make the light shapes pop out. Bringing in a warm beige settled down the chaos. I love adding the scraping lines and having the painting actually seem like a dance. The white lines were the last addition, and I allowed the lines to move from the top and lead my eye through the painting and out at the bottom. It seemed to give me the finish I needed to say, "This piece is done."

My objective with this kind of start is to have the original painting lead me through to the finish. I finished it up with a thin layer of Golden polymer medium thinned down with water. This gave the piece an even sheen. Then I sealed it with Golden UV varnish.

Centered Energy Escape • Lana Grow, AWS, ISEA ❯
Mixed media on Fabriano Artistico hot-pressed paper • 30" × 22" (76cm × 56cm)

Marie Renfro

To begin this painting, I generously wet the paper with a large brush, Robert Simmons Big Daddy, and then began to apply color starting at the top right corner of the paper. I did some washes of pale yellow using Golden fluid acrylics Hansa Yellow Light, and had decided on a cool color scheme, so I introduced some pale Ultramarine Blue and some pale washes of Phthalo Turquoise. I also laid in some small areas of Raw Sienna and Naphthol Red, as well as Alizarin Crimson.

After these colors were dry, I glued on some collage paper that I colored with acrylic colors in the same color family as the underpainting. I used a Japanese fiber paper called sekishu, which I purchase in white and then color with leftover paint in my palette. I also glued on some textured rice papers, as well as a few strips of marbleized bookmaking paper.

My composition was to be a shapes-within-shapes format, a framed-in rectangle with dark edges around the outside and the center of focus in the lower left, leading to a secondary point in the top right. I always try to design a pattern with my light values as well as my dark values that will carry the viewer's eye into and around the painting.

After the collage papers were dry, I began to glaze with the colors that I had started the painting with, but used a weaker strength in some places and a richer strength in others. I like to "gray-down" a painting if it is too raw and increase the intensity if it is too dull. For the glazing, I use a Robert Simmons Skyflow or Goliath brush.

As a final step, I painted negatively (or behind) some of the areas to define foliage or tree shapes. For some of the areas I used gesso mixed with a tiny bit of yellow to warm the white. In other areas I painted with pure Ultramarine Blue or mixtures of Alizarin and blue for a deep purple-blue. My goal was to have several different values of blue, green, and deep blue-purple to contrast the small amounts of red and light warm green.

My Blue Haven • Marie Renfro, SWS, TVAA >
Acrylic and collage on Arches 300-lb. (640gsm) cold-pressed paper • 30" × 22" (76cm × 56cm)

ane E. Jones

While on a train ride from Durango, Colorado to Silverton, Colorado, I took a photograph of the mountains, trees and water. Although it was the fall season, I decided to paint a cool painting with touches of warm for contrast.

I drew the realistic image with a fine-point Sharpie pen onto 90-lb. (190gsm) index paper the size of my watercolor paper. An abstract image was also drawn on another sheet of index paper the same size as my watercolor paper. This particular abstract image was drawn from a split rock called a geode. The lines and shapes from the geode gave me the rhythm needed for this mountain scene. Next, I put these two images together using a light box to see if the shapes were repeated with variety, and if the two images related to each other. On my watercolor paper, I drew the realistic image with an extra-fine Sharpie pen. With a 2B pencil, I drew the abstract image on top of the realistic image. After wetting both sides of my paper thoroughly with a natural sponge, and making sure there were no dry spots or bubbles underneath, I laid the paper on a smooth Formica board, also called tile board. I didn't remove the excess water with the sponge, but instead left the paper untouched until the glisten or shine was off. I used a tissue to take the water off of the very edge of the paper; otherwise I would get bleed-backs, also called blooms.

Using a 1½-inch (38mm) or 2-inch (51mm) natural-hair flat, I applied the paint very loosely. I used analogous colors of red violet, violet, blue-violet, blue and blue-green, as well as the complement of the blue-violet, which is yellow-orange, and two discords on either side of the complement, skipping orange and yellow and using red-orange and yellow-green. I used all of these colors in the underpainting, making sure I did not go over a no. 3 value.

While the paper was still pretty wet, I found only the abstract shapes using blue-violet and blue, painting around these abstract shapes and losing the edges. I thought of a color dominance in each area: blue-violet for the sky, blue mountains, blue-green background trees, yellow-orange and yellow-green foreground trees, and blue-green water.

Next, I found the sky, using blue-purple and a light touch, painting around where the mountain top hits the sky. I then painted around the background trees with the blue, separating the trees from the mountains. Next, I painted around the foreground evergreen trees with blue-green. I painted at the base of the foreground trees with yellow-orange, red-orange and yellow-green to separate the water from the trees. All of this was done very lightly (drybrush onto wet paper).

I thought of where my lights and darks would go, and where the focus would be. I was conscious of the function in each plane, such as the rocks being a different dominant color than the trees or the mountains.

Separating the real from the abstract using gradations in every shape and color and value was the real fun. I never mixed the colors on the palette—only the pure hue. I layered each one, working only wet-into-wet. I wanted the realistic image to be more dominant with the abstract subordinate.

Get free desktop wallpaper and a bonus demo at artistnetwork.com/journeystoabstraction.

△ Train Ride • Jane E. Jones, NWS, SWS
Watercolor on Arches 140-lb. (300gsm) cold-pressed watercolor paper • 22" × 30" (56cm × 76cm)

Mary Lou Osborne

The process I used for *Energy* is the same method of pouring paints that I used in *Balloon Sail*, also in this book.

I work in my garage, which is set up for pouring paint. For this painting I used Arches 140-lb. (300gsm) watercolor paper. I soak the paper with water before laying it in my canvas "hammock." The hammock allows me to pick up the watercolor paper and turn it quite easily for more pours.

I also use the viewfinder to decide where I want to pour. I put a mat over the art to see how it will look framed. This helps me see if I need to crop the painting.

After completing the work on paper, I mat and frame the piece. This is such an exciting way to create a piece of art that can never be duplicated.

∧ Energy • Mary Lou Osborne, ISEA, SWA
Acrylic on Arches 140-lb. (300gsm) watercolor paper • 22" × 30" (56cm × 76cm)

Mira M. White

Under Construction is painted on Crescent watercolor board. This piece involved many different applications over several months. I work in a variety of media and find that I work best with many pieces in varying stages. They all seem to inform each other.

The first layers were sprayed with watercolor through templates. I found the surface of the watercolor board very unsatisfactory and started to build up the painting with multiple layers, after having cut the initial piece into three smaller pieces. This one is the only completed piece of the three.

After continuing the spraying-template-layering process with acrylics, I began applying collage materials, magazine scraps and papers dissolved by water-based solvents. These papers were scraped and sanded.

I used Novaplex medium and sealed the surface, continuing to incorporate collage and spraying processes. The graphic elements were drawn with a power Dremel tool. I continued creating shapes by scraping with an X-Acto knife and sprayed more acrylic elements until the piece felt complete.

∧ **Under Construction** • Mira M. White
Watercolor and mixed media on Crescent watercolor board • 10" × 15" (25cm × 38cm)

Jane Gates

The Anniversary was painted on a stretched, heavyweight, primed cotton canvas. My process was to create a heavily textured surface before applying the final layer of paint. I used acrylic paint to allow for a thicker build-up.

I created an underpainting to sketch in the general composition by brushing broad strokes of several colors onto the canvas. Some of the underpainting is evident at the right—the orange blurry triangle peeking out from under the light blue. I also squeezed fat lines of paint from the tube that were partially covered during the painting process. They helped create a heavily textured surface. I was thinking of lines and shapes that cross the width and height of the canvas. I visualized the lines as ridges. Eventually a top layer of paint slid across these ridges and collected on them. The lines flow in every direction.

While I waited about a week for the prepared surface to dry, I worked on other paintings in various stages of completion and mixed acrylic paint for the top layer of this painting. I mix my paint in plastic containers of various sizes with lids. First I add a little paint to the container and then thin it with GAC 100 medium, a multi-purpose acrylic polymer made by Golden, and a little water. If you add more than 25 percent water to acrylic paint, it can become dull. By adding just enough GAC 100, the paint has a beautiful but subtle shine. I mix the paint to approximately the consistency of honey.

For the final layer, I began with three colors plus black, white, and iridescent tinting medium.

I knew that I would later add smaller dabs of other colors straight from the tube. I mixed Napthol Red, Crimson Red, Cadmium Yellow Medium, and light blue mixed with Ultramarine Blue and white. When I began painting the final layer, I continually made color and line decisions based on what the piece needed at any given moment.

I applied the mixed paint by scooping it up with my hands and gliding it over the dried textures. I also used large long-handled flat brushes (nos. 10 and wider). I constantly watch the consistency of the paint I am applying. If it is too thin, it will have long drips. If it is too thick, it will not drip at all, so I have to keep in mind the desired effect.

Compositionally, I thought of the canvas divided into large geometric shapes tied together with fat, wet lines of paint running across the canvas. I am not afraid of squeezing paint into or on top of the wet-brushed paint. I also love to place the iridescent tinting medium and Titanium White paint next to each other for a variation in white as shown in the large circle on the top left.

Finally, I dug into the wet paint with the end of my brush and with my fingers. You can see the light violet underpainting around the circle at the top left made from my finger marks.

My intent in painting *The Anniversary* was to capture and convey a sense of the melancholy that I had felt during a time of sadness and loss in my life.

∧ **The Anniversary** • Jane Gates
Acrylic on heavyweight primed cotton canvas • 50" × 60" (127cm × 152cm)

Toby R. Klein

I began the painting process by using a variety of water media paints on 140-lb. (300gsm) watercolor paper. I used magenta, turquoise and metallic colors to paint and texture the paper in an intuitive manner. I always paint several different papers at the same time to have for future pieces of art.

Since I am an experimental artist, I worked out my design on a piece of white paper prior to cutting on the original piece. This also gave me time for my painted papers to dry. My next step was to decide the size of my completed piece.

I cut the painted paper to the size needed and started measuring and drawing the lines for each V-shape onto the backside. Using an X-Acto knife with a new blade, I carefully began to cut the paper also using a ruler to follow the lines. As you can see, I cut three V-shapes in one direction and the other three in the opposite direction, leaving space for the center of interest.

After folding back every other V-shape, I added a piece of archival board under the tip before I painted and textured the exposed backside of the paper with metallic paint. When the paint was dry, I glued down each tip. Again using the archival board I cut and glued pieces to fit under the back of this piece to raise it from my background. I then painted the support and all of the raw edges of the paper to match the colors of the paint on the front side of this piece.

I hand-dyed textured paper using purple, and left it to dry. I then glued the hand-dyed paper, in a large enough piece to fit under the mat, to an archival piece of foam core. Next, I glued the piece of art to the hand-dyed paper.

Seeing Both Sides was embellished with brass, copper, purple-painted paper and blending threads. I frayed mesh brass, then textured and heated the diamond-shaped piece of copper to get these complementing colors. The center of interest was what this piece needed to tie it all together.

Seeing Both Sides • Toby R. Klein, ISEA, ISAP ❯
Mixed media on 140-lb. (300gsm) watercolor paper • 24" × 16" (61cm × 41cm)

Jane R. Hofstetter

This painting was finished after a visit to Yosemite National Park in California. I used a 21" × 30" (53cm × 76cm) sheet of heavyweight Yupo plastic synthetic paper and my watercolors.

I enjoy the paint-resistant quality of Yupo paper. I use it in a great number of my paintings. It allows the artist to work freely with paint, letting the brush strokes show on a non-absorbent surface. But it also allows one the ability to clean up messy edges, or bring other areas back to white paper when desired. It does take a while to get the hang of using Yupo.

My wish after seeing this glorious country was to paint the beautiful Half Dome as she appeared to me, like a goddess with a waterfall for a heart, and a tree as a scepter as she walked the land.

∧ **She Walks In Beauty** • Jane R. Hofstetter, NWS
Watercolor on Yupo • 21" × 30" (53cm × 76cm)

Dolores Ann Ziegler

<Passionate Landscape •
Dolores Ann Ziegler, AWS, NWS
Acrylic on Arches 140-lb. cold-pressed
watercolor paper •
30" × 20" (76cm × 51cm)

In this painting I had a desire to express the atmosphere of a landscape in acrylic on Arches 140-lb. (300gsm) cold pressed paper versus using watercolor, a medium I had pursued for years.

In painting I found that acrylic was more suited to what was being referred to as my "spontaneous breezy" style.

With no plan in mind, just knowing I wanted an abstract landscape done in acrylic, I started the sky with broad strokes using a 2-inch (51mm) watercolor brush. I find this type of brush gives a smooth effect that I like.

One of my traits I use consistently is what I call "the bridge," which is when one color peeks out from the other composition-wise. I always use light against dark. If I see light, dark has to appear next to it.

The upward random strokes are trees and the white expresses water. It is an emotional landscape, especially using an exciting color like red as the focal point.

I have done a series of this type of painting with all that acrylic has to offer with its various use of textures and styles.

Susan Adamé

My collage projects begin with the search for materials which is the most time-consuming part of process. In my collages I often use paper that has been made from scans of fabric that have been altered in scale and color tone. For each pattern I make a series of prints in a wide range of color tones. My best results are from my Epson Stylus Pro 4880 that prints 17" × 22" (43cm × 56cm) giclée-quality paper. I sometimes find old handwritten letters on the Internet that I scan and print to many times their original size. If the project has a particular theme or emphasis I will collect a variety of materials that reflect that emphasis. The collection stage can have a color theme that will direct my search. I also gather a variety of new papers from local sources and online. The success of the finished project relies heavily on the materials gathered in this search.

At this point I may have a color direction in mind, but if undecided, I then choose the color I want to use in the background. This color will show through the transparent papers and bridge the gap between other papers. I can either contrast the papers or make the transition more subtle with a background similar in color tone and value.

Next I make choices as to which papers I will use. I make a dry mock up with the papers laid on the watercolor background without attaching anything. I make sure that none of the papers are too dominating. I like contrast, but for me I don't want any one part to overpower the composition. I tear or cut these papers to reflect the direction I wish to establish. My work usually has a flow from one side to the other that directs how the papers are placed. After the more dominant shapes are placed, I will usually add a few more transparent shapes behind the first pieces as well as on top.

When I am pleased with the composition, I cover the piece with Plexiglas and wait until the next day to attach the materials so that I have the opportunity to return to the work with fresh eyes and make necessary adjustments. I find that by stepping away from the work and returning with a fresh perspective I am able to make changes that I had not seen the day before. I return to this stage over and over until I am satisfied with the work.

To assemble this painting, I attach the materials with any artist's medium using a wide disposable brush. I gently lift each piece and cover the entire watercolor paper as well and lift each piece to apply medium between papers.

When the collage dries the next day, many of the papers will have changed and the piece will look different. I have the option at this point to make additions to the work. I can simplify by adding a large simple shape or I can add details. I also add details of hand-painted gold accents and I will add gold leaf at this time. Most collages are part of a process where I reflect and make changes over a series of days or weeks.

Lastly, I seal the entire collage with a polymer UVLS sealer made by Golden to protect it from light. This sealer can be removed if needed and does not change the finished product.

Field of Grace • Susan Adamé
Mixed media and collage on Arches cold-pressed watercolor paper • 28" × 22" (71cm × 56cm)

Sue St. John

Composing this painting on Yupo was a new experience for me. Artists had just started using Yupo to paint on. State and national shows were trying to decide if they would accept paintings painted on Yupo. It was, after all, a "plastic synthetic type of paper." I asked the person in charge of one show if they accepted paintings on Yupo. She said, "Bring it on, girl!" It is accepted now in most shows.

My goal was the suggestion of groups of figures that would result in an abstract overall pattern. *Between Two Worlds* is about communication between two cultures. I started by wetting the Yupo surface with a wet sponge. The background was created by applying transparent watercolor in various shades of greens from light to medium with a brush. As the colors mingled they produced an unusual but interesting surface. While the paper was still wet, I used a spray mister with diluted magenta watercolor and misted in a few areas for contrast, allowing the paints to react as they merged. Further texture was created by spray- misting some isopropyl alcohol all over the surface. This helped to convey the vague image of leaves in the background. I attribute this accomplishment to the slick surface of the Yupo. The soft shapes that emerged are varied and interesting.

After this was dry, I studied the work at a distance. I then began to develop the concept of figures. I took a file folder and sketched a group of three figures. Then, I took my scissors and cut out the figure form to use as a stencil. When satisfied, I laid the stencil down on my painted background on the left side. Using a spray mister with deep indigo watercolor mixed with water (so it would spray out of the mister), I saturated color in the foreground figures. I concentrated the stronger indigo at the head and half way down the figure, and lightly sprayed at the bottom half and feet area. Next, I moved the same stencil to the right side of the painting and repeated the same process. As the color mingled with the background, I allowed the colors to react as they merged, giving an illusion of depth. I noticed the figures on the right side looked different than the ones on the left side as the paints mingled.

Once it was dry, I studied the painting. This did not need any finishing touches. The work maintains an abstract quality that remains personally unique. Yupo was a new and enjoyable experience for me and the secret to this painting.

See the Demonstrations section for Sue's step-by-step process to creating an abstract painting.

Between Two Worlds • Sue St. John, KWS
Watercolor on Yupo • 20" × 26" (57cm × 66cm)

Vera M. Dickerson

My paintings are acrylic on watercolor paper. With the technique I use it really does not matter which paper you choose. This is a great way to make use of papers that are not your favorites, or old paintings that have been gessoed over.

The surface does need to be an even white, so use gesso or white acrylic paint to cover any traces of old paint. After this dries, use a thin coat of acrylic gloss gel over the entire paper surface. I use a paint scraper or old credit card to spread this over the paper. Little ridges of gel are fine.

Before the gel dries, stamp textures into the wet surface using citrus bag netting, corrugated cardboard or rubber stamps. Let this dry thoroughly.

Now, select some of your dark value transparent acrylic paints, such as Phthalo Blue and Phthalo Green, Quinacridone Crimson or Purple, and Transparent Red or Yellow Iron Oxide. Brush these in a random manner over the paper. Do not thin them with water too much. Just make the paint spreadable so it sinks into all the low spots. Do not mix the colors to a single hue, but allow the individual colors to be seen.

Using a paint rag or paper towel, wipe out a few large light areas. The gloss gel lets you clean this paint back to the white of the paper and the transparent paints allow for a beautiful glow of light in your colors.

I think about a grid composition, a focus of strong light and dark, and big, bold shapes in this early birthing of a painting.

When this paint is dry my next step is adding opaque lights over the darks. I cut paper shapes to try out an idea and use masking tape to edge those forms and fill in with acrylics. Here I use paint straight from the tube because I want to cover over darks. While the lights are wet, scratch little lines and marks or spray water and blot to get a change in edges. Make it interesting.

These paintings were done during a very cold January and February when fresh greens were my antidote to the white outside my window. I thought about seeds germinating, birds nesting and the rebirth ahead. That helped me to find shapes to use, symbols for what brings hope each spring.

Sounds of Spring •
Vera M. Dickerson, AWS, NWS
Acrylic on watercolor paper •
22" × 30" (56cm × 76cm)

Wings of Spring • >
Vera M. Dickerson, AWS, NWS
Acrylic on watercolor paper •
30" × 22" (76cm × 56cm)

3 Demonstrations

In this section, you will follow the special techniques of a few of the artists in this book, as they demonstrate what makes their work unique. Detailed step-by-step instructions will help you to complete your own abstract paintings.

∧ Bits and Pieces • Sue St. John, KWS
Watercolor and collage on Arches 140-lb. (300gsm) cold-pressed watercolor paper •
22" × 30" (56cm × 76cm)

Create an Abstract Painting With Watercolor and Mixed Media

Follow along as artist Dottie Holdren recreates the steps for producing her watercolor and mixed-media piece, *Study In Pink*.

MATERIALS

SURFACE
Rives BFK printmaking paper

WATERCOLORS
Cobalt Blue
Hansa Yellow
Permanent Rose

OTHER
4 oz. spray bottles, cassette tape, circle shapes, iron, mat board, tissue paper, watercolor pencils

1 Prepare the Surface
Unravel an old cassette tape and place the tape down on the paper in an interesting pattern. Cover the entire surface with art tissue paper. Go over the tissue paper with an iron on medium setting to flatten the tape. Make sure the iron is not too hot or it will melt the cassette tape. Remove the tissue paper.

2 Paint the Background

Mix Hansa Yellow with some water in a spray bottle and mist it over the tape only. Then mix some Permanent Rose with water and spray it over the yellow. Leave some yellow showing through.

3 Lay Down the Shapes

Lay down circles of different sizes and straight edges of mat board in an interesting pattern. Spray mist the Cobalt Blue into the corners of the paper and around the shapes. This will make dark purple and red-wine shades.

Once dry, lift all the shapes and the tape. Evaluate the painting. Add more red and blue for a purple hue if necessary.

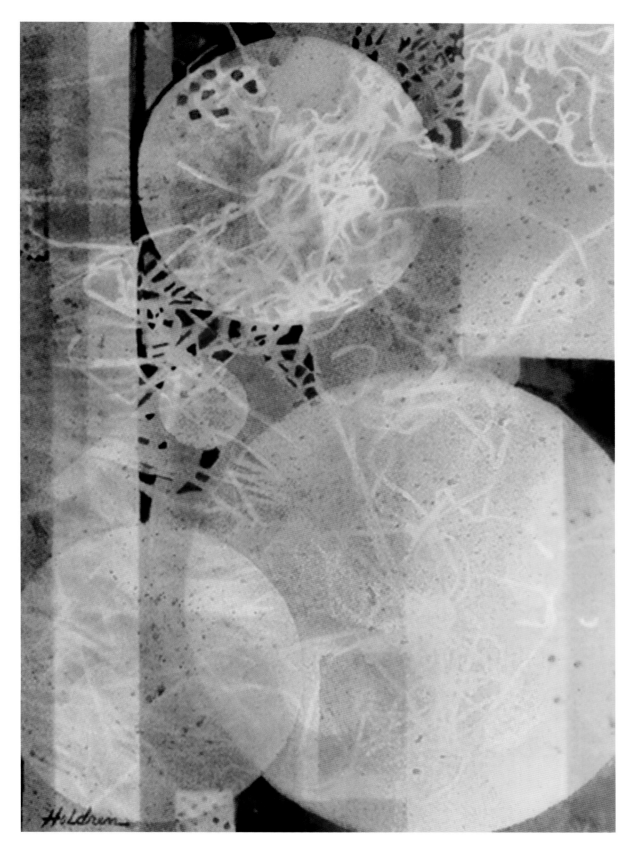

4 Add Final Touches

Use colored pencils to add texture and small details to finish the painting.

∧ *Study in Pink* • Dottie Holdren
Watercolor on Rives BFK paper •
30" × 22" (76cm × 56cm)

More Practice With Watercolor and Mixed Media

Follow artist Gracie Rose McCay's steps to creating an abstract painting in watercolor and mixed media. Gracie used Robert Doak watercolor paints for this piece because they are concentrated and very bright in color.

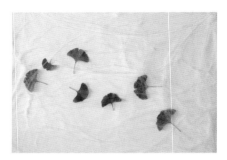

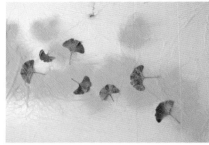

1 Place Leaves and Webbing
Wet the Yupo paper with water using a sponge. While the paper is wet, place the gingko leaves in an interesting pattern. Stretch a small piece of cobweb webbing across the gingko leaves, attaching it to all four corners of the paper. This will help hold down the leaves. Apply water over the webbing with a 2-inch (51mm) flat or spray bottle.

2 Apply the Paint
Mix the paints with water in spray bottles and spray paint on top of the paper and webbing. Start with yellow, then add red and finally blue. Intensify pigments in certain areas as needed.

MATERIALS

SURFACE
medium-weight Yupo

BRUSHES
2-inch (51mm) flat

WATERCOLORS
blue
red
yellow (Robert Doak paints)

OTHER
4 oz. spray bottles, colored pencils, cobweb webbing, fixative spray, gingko leaves, sponge

3 Remove Leaves and Webbing and Protect the Surface
Let the paint dry completely before carefully removing the webbing and leaves from the paper. Spray the paper with a fixative to protect the paint and prevent it from rubbing off of the slick surface.

4 Apply Colored Pencil
Starting at the top of the painting, apply colored pencils in the same pigments as the watercolors you used. Carefully enrich the shapes and colors in the painting. Cover some of the white areas left by the webbing, adding to shapes or creating new ones. Work over the entire surface of the painting.

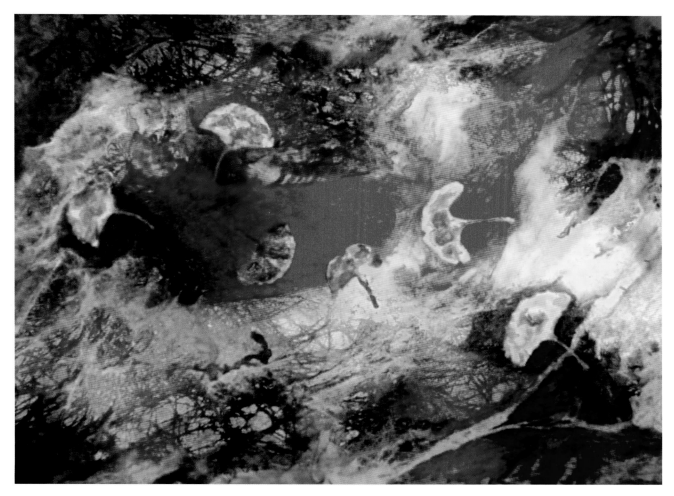

5 Evaluate Your Work
Step back and inspect your painting. Make any adjustments you feel are necessary to tie it all together.

∧ *Spirit of the Ginko* • Gracie Rose McCay
Watercolor and mixed media on Yupo • 20" × 26" (51cm × 66cm)

Create an Abstract Piece in Watercolor and Graphite

Follow along with Sue St. john as she recreates the steps for *Rusty Window...*

1 Create a Stencil and Mask Off Borders

Draw a light pencil guideline 1 inch (3cm) inside the edges of the paper on all four sides. Following the pencil line, tape a border around the entire sheet of paper using ½-inch (13mm) art tape or masking tape.

With a piece of mat board, create a window-pane stencil. Use a ruler to draw the size and number of window panes you wish, and cut each pane section out with an X-Acto knife. Place the window stencil on the paper, slightly off center to the left side.

MATERIALS

SURFACE
22" × 30" (56cm × 76cm) Rives BFK printmaking paper

GRAPHITE
no. 2 pencil
charcoal pencil

WATERCOLORS
Burnt Sienna
Cobalt Blue

OTHER
½-inch (13mm) art tape, 1-inch (3cm) blue pieces from a failed painting, 4-oz. spray misters, hair dryer, mat board, ruler, small pieces of rusty metal, small watercolor brush, thick tacky glue, X-Acto knife

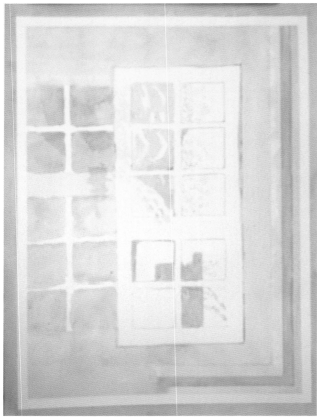

2 Apply Paint

Using a spray mister and Cobalt Blue + water, lightly spray through the stenciled window panes on a hit-and-miss basis. Move the stencil to the right side of the paper and spray lightly again with the same mixture. Then spray over the tape on the edges of the paper.

Once the paint is dry, remove the tape. If the paper starts to pull up, use a hair dryer to melt some of the glue on the tape before carefully removing it.

3 Add Rust Elements
Use thick tacky glue to add on three window hinges and small pieces of rusty metal at the top left and bottom right of the piece.

With a charcoal pencil, make circles and ovals of various sizes in the upper left corner, middle of the top and lower right corner, and up the side of the piece. Draw some smaller circles and ovals in other random places with a no. 2 pencil. Connect the shapes.

With Burnt Sienna and a small brush, paint under each piece of rust and at the lower right corner. Paint a larger area with Burnt Sienna under the rust pieces at the top left to make it appear as if the rust has run over time. Let it dry.

4 Finish With Collage Elements
Use thick tacky glue to add in a final collage element to the piece. In this case, I used three blue squares from a failed painting.

Evaluate the painting and add any other finishing touches you wish.

Rusty Window • Sue St. John
Watercolor and collage on Rives BFK paper •
30" × 22" (76cm × 56cm)

Behind the 8 Ball

Create an Abstract Painting in Acrylic

Follow the steps to Sue St. John's process for creating an acrylic abstract painting.

1 Cover the Surface and Begin Adding Paint

Lay small pieces of a light-weight clear plastic drop cloth over wet watercolor paper. Let the plastic have air pockets and creases. Do not smooth the plastic out with your hands.

While the paper is still wet, squirt small amounts of liquid acrylic paint from a color applicator bottle under the plastic at the air-pocket and creased areas.

2 Add More Paint and Lift the Plastic

Keep adding additional colors of paint in various spots under the plastic at the edges of the paper. Tilt the paper and let the pigment run over the surface. Let it dry.

After the paper is dry, remove the plastic. Evaluate the design. Start turning the piece to see what new patterns have developed.

MATERIALS

SURFACE
Arches 140-lb. (300gsm) cold-pressed watercolor paper

BRUSHES
Small rounds, 1-inch (25mm) flat

ACRYLIC PIGMENTS
Black
Burnt Sienna,
Naples Yellow,
Yellow Ochre

OTHER
no. 2 pencil, bubble wrap, circle stencils, clear plastic drop cloth, collage papers, color applicator bottles, colored pencils, rubber stamps, scissors, thick tacky glue, T-square

3 Add Lines to Form New Shapes
Draw straight lines with a pencil and T-square. As you work, turn the piece, trying to form other shapes to break up the surface. Continue developing the composition using rubber stamps, bubble wrap, circle shapes of various sizes, and collage paper strips for texture. Glue the strips down using thick, tacky glue.

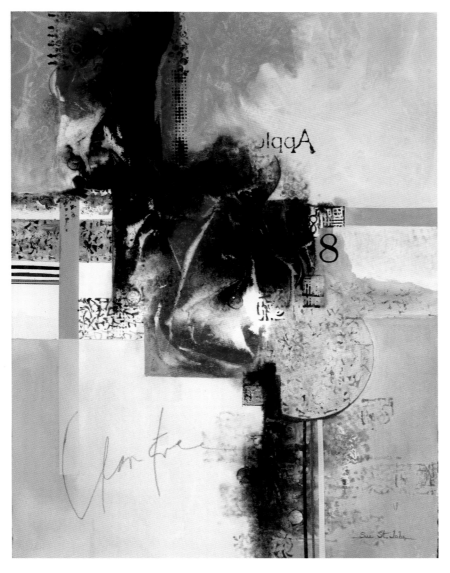

4 Add Final Touches
The piece should look balanced if you turn it in all directions. Add details and finishing touches with colored pencils. Make adjustments to tie it altogether.

< **Behind the 8 Ball • Sue St. John**
Acrylic on Arches 140-lb. (300gsm) cold-pressed watercolor paper •
30" × 22" (76cm × 56cm)

Directory of Artists

Charlene Edman Abele
63 Wood Duck Drive
Ocean Pines, MD. 21811
abele.char@mchsi.com
abele.char@nchsi.com
443-856-8179

Susan Adamé
1235 Garfield Avenue
Albany, CA 94706
susanadameart@gmail.com
www.susanadameart.com

B.J. Adams
2821 Arizona Terrace NW
Washington, DC 20016
bjfiber@aol.com
www.bjadamsart.com
202-364-8404

Elizabeth Ashauer
561 Casa Belle Drive #404
Cape Canaveral, FL 32920
heronhous@att.net
321-784-5839

Laura Barbosa
3293 Churchill Drive
Toms River, NJ 08753
laurabarbosaart@gmail.com
www.laurabarbosaart.com

Shirley Wilson Blake, ISEA
269 Meadowood Lane
Vadnais Heights, MN 55127 or:
13341 Bridgeford Avenue
Bonita Springs, FL 34135
swblake@comcast.net
www.shirleyblake.com

Betty Braig, ISEA, MOWS
5271 South Desert Willow Drive
Gold Canyon, AZ 85118
bettyzart@aol.com

Carol Z. Brody, NWS
801 Caraway Court
Wellington, FL 33414
czbrody@carolzbrody.com
www.carolzbrody.com
561-792-0806

Joan Burr
P.O. Box 286
Joseph City, AZ 86032

Carole A. Burval, TWSA, WHS, MOWS
129 S. Kainer Avenue
Barrington, IL. 60010
carole@watercolorcards.com
www.caroleaburval.com
847-840-7731

Ginnie Cappaert, NWS, ISAP
W4363 G-12 Road 352
Stephenson, MI 49887
info@gcappaert.com
www.gcappaert.com
906-753-4754

Katharine A. Cartwright, NWS, MOWS
19 Mill Creek Road
Spruce Head, Maine 04859
kcartwright@kacartwright.com
www.kacartwright.com
207-593-9363

Robin Colodzin
8B Clark Avenue
Rockport, MA 01966
robin@colodzin.com
www.colodzin.com
978-546-2169

Rita Crooks, NWS, WHS
1510 Adams Court
Wausau, WI 54403
Prcrooks@charter.net
715-845-6030

Marie Cummings
P.O. Box 283
Treadwell, NY 13846
marieh2oart@yahoo.com
www.mariecummings.net
607-829-2206

Vera Dickerson, AWS, NWS
148 W. Arrowhead Court
Troutville, VA 24175
vera.dickerson@me.com
www.signature9gallery.com

Carol DeBolt Eikenbery, AWS, NWS
726 Vanderbilt Avenue
Virginia Beach, VA 23451
caroldebolt2@aol.com
www.caroldebolt.com
757-428-4364

Jan Filarski
16740 Apple Lane S.
Ray, MI 48096
Jfilarski@comcast.net
www.bswpainters.com
586-781-5270

Betty Jo Fitzgerald, NCS, NWWS
3327 Windolph Lane NW
Olympia, WA 98502
bettyjoart@hotmail.com
www.bettyjoart.com
360-866-4607

Jane Gates
515 Golden Lane
Milton, WI 53563
janegatesart@yahoo.com
www.janegatesabstractpaintings.com
608-808-4379

Sheila Grodsky
1 Hillside Drive #B212
Mt. Arlington, NJ 07856
201-213-2103

Marilyn Gross, ISEA, SLMM
374 Mac Ewen Drive
Osprey, FL 34229
marigro@comcast.net

Lana Grow, AWS, ISEA
1745 Chatham Avenue
Arden Hills, MN 55112
lanagrow@mac.com
www.lanagrow.com
651-633-5085

Jane R. Hofstetter, NWS
308 Dawson Drive
Santa Clara, CA 95051
jrhofstetter@comcast.net
www.janerhofstetter.com
408-248-4425

Judy Hoiness, NWS
1840 NW Vicksburg Avenue
Bend, OR 97701
jhoiness@bendnet.com
541-382-8697

Dottie Holdren
2580 Coosa Co. Road 49
Goodwater, AL 35072
dottiek66@hotmail.com
256-377-4918

Betty Jameson, ISEA, TWS
7100 Valburn Drive
Austin, TX 78731
jamesonad@aol.com
www.yourart.com/betty.jameson
512-345-4546

Jane E. Jones, NWS, SWS
5914 Bent Trail
Dallas, TX 75248
janejonesart@yahoo.com
www.janejonesart.com
972-407-1566

Edee Joppich, ISEA, NCS
7259 Somerby
West Bloomfield, MI 48322
www.edeejoppich.com
248-661-1020

Carole Kauber, NCS
629 Normandie Boulevard
Bowling Green, OH 43402
cakauber@wcnet.org
419-373-6022

Toby R. Klein, ISEA, ISAP
1910 Paulette Drive
Hoover, AL 35226
toby@tobykleinart.com
www.tobykleinart.com
205-823-3376

Lynne Kroll, AWS, NWS
3971 NW 101 Drive
Coral Springs, FL 33065
butterflynne@myacc.net
www.lynnekroll.com

Victoria Lenne, GWS, ISEA
7808 Mare Haven Lane
Knoxville, TN 37920
digitaleye@comcast.net
www.victorialenne.com
865-579-0136

Annell Livingston
HC 74 Box 21860
El Prado, NM 87529
annell@taosnet.com
www.annelllivingston.com

Edith Marshall, ISEA
52440 Hwy. M-203
Hancock, MI 49930
edithmarshall@chartermi.net
www.edithmarshall.com

Georgia Mason
7219 Archers Creek Drive
Emerald Isle, NC 28594
bluecrab@ec.rr.com
www.georgiamason.com
252-354-5020

Gracie Rose McCay
3912 No. Whitewood Way
Bloomington, IN 47404
g.mccay@comcast.net
812-323-8638

Cheryl McClure, SWS, TVVA
8239 State Hwy. 323 West
Overton, TX 75684
cdm@cherylmcclure.com
www.cherylmcclure.com
903-918-1387

Mark E. Mehaffey, AWS, NWS
5440 N. Zimmer Road
Williamston, MI 48895
mark@mehaffeygallery.com
www.mehaffeygallery.com
517-655-2342

Karen Kierstead Miller, ISEA, LWS
4280 Conifer Circle
Okemos, MI 48864
kmillerartist@gmail.com

Barbara Millican, AWS, NWS
5709 Wessex
Fort Worth, TX 76133
b.millican@att.net

Nancy Egol Nikkal
Media Loft, Studio 1F
50 Webster Avenue
New Rochelle, NY 10801
nancy@nikkal.com
www.nikkal.com

Mary Lou Osborne, ISEA, SWA
1932 Fall Creek Trail
Keller, TX 76248
mlosborne01@/verizon.net
marylou@mlosborne.com
817-656-0864

Kendra Postma, ISEA
409 Scarborough Court SE
Ada, MI 49301
fabkap@comcast.net
616-682-0366

Marie Renfro, SWS, TVAA
606 Keith Drive
Allen, TX 75002
mrenfroart@aol.com
www.gallery8.com/renfro.html
972-727-5426

Pat San Soucie, AWS, NWS
11777 SE Timber Valley Drive
Clackamas, OR 97086
pat@sansoucie.com
www.patsansoucie.com
503-698-6202

Delda Skinner, NWS, SLMM
8111 Doe Meadow Drive
Austin, TX 78749
deldaart@sbcglobal.net

Carol Staub, ISEA, ISAP
531 Elizabeth Avenue
Somerset, NJ 08873
carolcando@aol.com
www.carolstaub.com
908-803-9229

Selma Stern, AWS
3367 Maplewood Drive So.
Wantagh, NY 11793

Sue St. John, KWS, ISEA
5379 Carnoustie Circle
Avon, IN 46123
info@suestjohn.com
www.suestjohn.com
317-386-8020

Sharon Stone, SWS
5859 Frankford Road #411
Dallas, TX 75252
smstone8@sbcglobal.net
www.sharonstoneabstractart.com
972-248-6520

Fredi Taddeucci, ISEA
45684 Superior Road
Houghton, MI 49931
freditad@up.net
906-482-4656

Dianne S. Trabbic, AWS, OWS
825 E. Dean Road
Temperance, MI 48182
trabbic@aol.com

Helen Wheatley
4720 Hartville Avenue
Cocoa, FL 32926
wheat@bellsouth.net
321-690-1260

Mira M. White
2500 Lucy Lane #306
Walnut Creek, CA 94595
miramwhite@earthlink.net
www.miramwhite.com
925-947-5773

Kristine Wyler
1205 Stone Crossing NE
North Canton, OH 44721
kriswyler@gmail.com
www.wylerartstudio.com

Toni Young, ISEA, ISAP
8221 64th Street North
Pinellas Park FL 33781
tyoung01@tampabay.rr.com
www.toniyoung-artist.com
727-546-1270

Dolores Ann Ziegler, AWS, NWS
Flagstaff, AZ 86001

Index

About the Author

Sue St. John has been painting for more than forty years. Like many Midwest artists, she began with painting rural landscapes, barns and flowers in oil. Having lived for several years in the beautiful hills of Brown County Indiana, this was natural.

Over the years Sue began working more in watercolors and moving toward more abstract paintings. She found the challenge of watercolors and abstracts to be a wonderful outlet for her creative talents. She loves abstract art where color flows freely giving the effect of stained-glass colors.

"We who create are very blessed to put something into this world that is totally and uniquely us," she says. "It completes the circle to be able to share it."

Sue is a Signature Artist Member of the Kentucky Watercolor Society.

Other fine North Light Books are available from your favorite bookstore, art supply store or online supplier. Visit our website at fwmedia.com.

16 15 14 13 12 5 4 3 2 1

Distributed in Canada by Fraser Direct
100 Armstrong Avenue
Georgetown, ON, Canada L7G 5S4
Tel: (905) 877-4411

Distributed in the U.K. and Europe
by F&W Media International LTD
Brunel House, Forde Close, Newton Abbot,
TQ12 4PU, UK
Tel: (+44) 1626 323200, Fax: (+44) 1626 323319
Email: enquiries@fwmedia.com

Distributed in Australia by Capricorn Link
P.O. Box 704, S. Windsor NSW, 2756 Australia
Tel: (02) 4577-3555

Edited by Christina Richards
Designed by Laura Spencer
Production coordinated by Mark Griffin

Acknowledgments

I would like to thank my husband, Danny, for his patience and support in the creation of this book. I would also like to thank my parents for their constant encouragement throughout my painting career. Many thanks to Kyle DeWeese, Mary Ann Beckwith, Karlyn Holman, and Barbara Gingell for their professional guidance. Special thanks to editorial director Pam Wissman and to my editor Christina Richards, as well as the rest of the staff at North Light Books for cheering me along as my work progressed. Finally, to all the talented abstract artists whose works make this possible— thank you for freely sharing years of experience and a deep appreciation of abstract art.

Dedication

This book is dedicated to my family whose unfailing love and support provides me a soft place to land.

Metric Conversion Chart

To convert	to	multiply by
Inches	Centimeters	2.54
Centimeters	Inches	0.4
Feet	Centimeters	30.5
Centimeters	Feet	0.03
Yards	Meters	0.9
Meters	Yards	1.1

Ideas. Instruction. Inspiration.

Find the latest issues of *The Artist's Magazine* on newsstands, or visit artistsnetwork.com.

These and other fine North Light products are available at your favorite art & craft retailer, bookstore or online supplier. Visit our websites at artistsnetwork.com and artistsnetwork.tv.